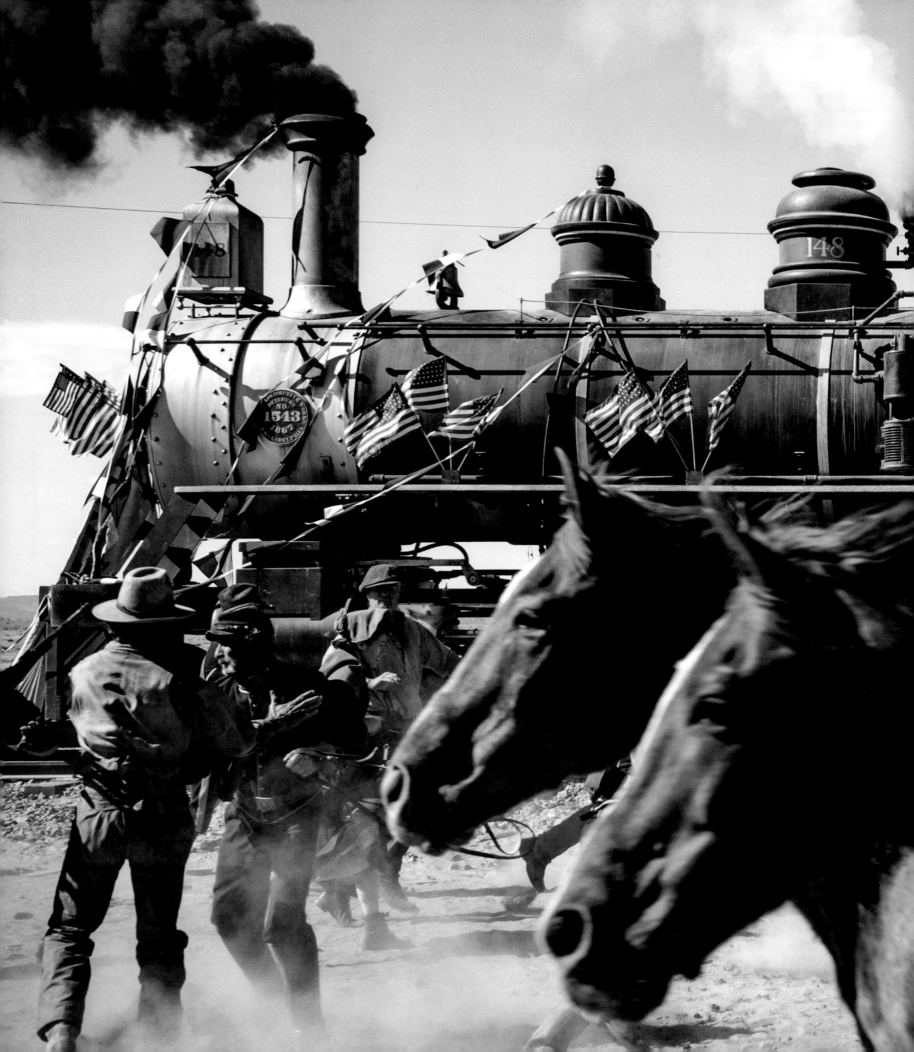

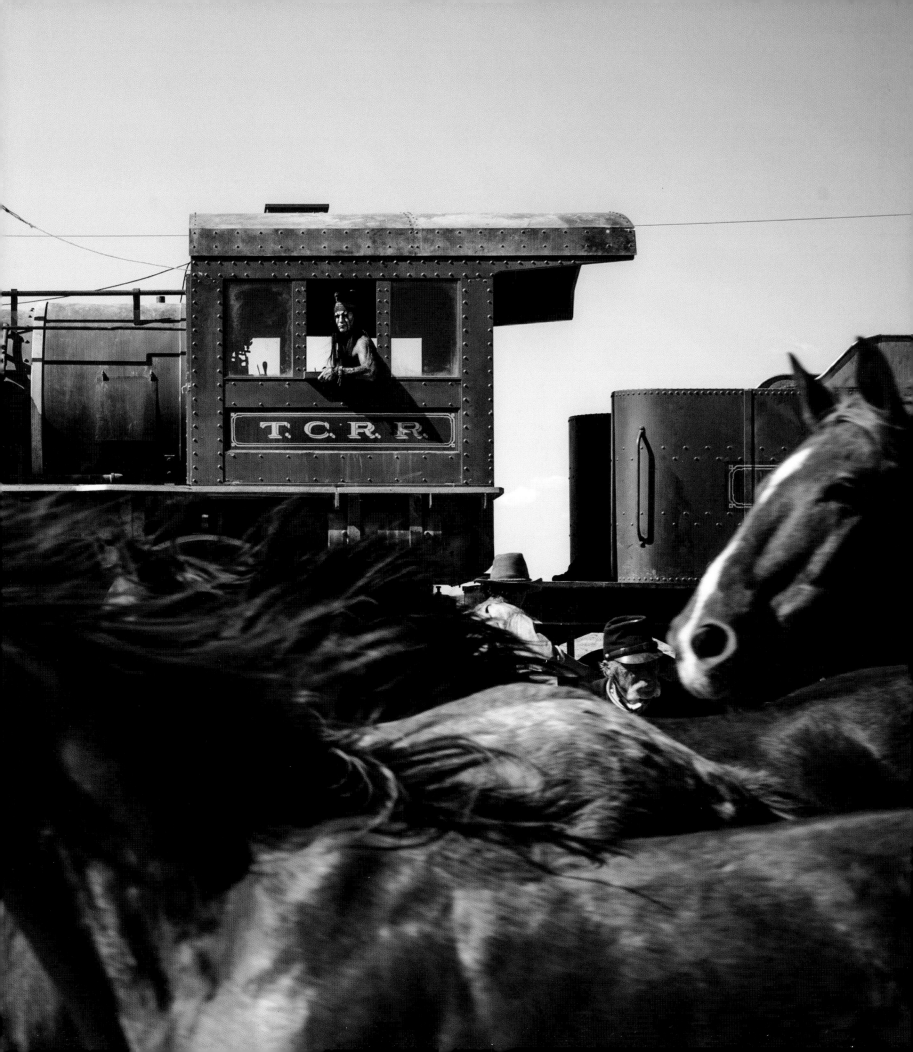

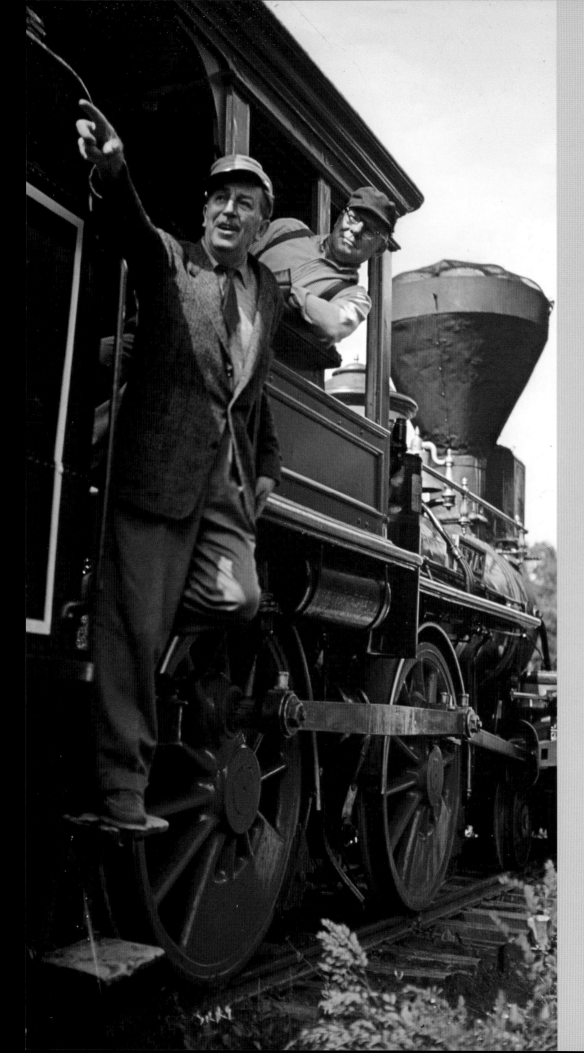

ALL

Walt on location during the filming of
The Great Locomotive Chase.

ABOARD

The Wonderful World of Disney Trains

BY **Dana Amendola**

FOREWORD BY **John Lasseter**

EDITIONS

LOS ANGELES • NEW YORK

Dedicated to Marco, Julia, and Maryellen, who have been dragged to countless abandoned freight yards, forced to wait at railroad crossings to count every last train car, and had their vacations hijacked to chase a train whistle in the distance.

Contents

Photo capture from The Brave Engineer

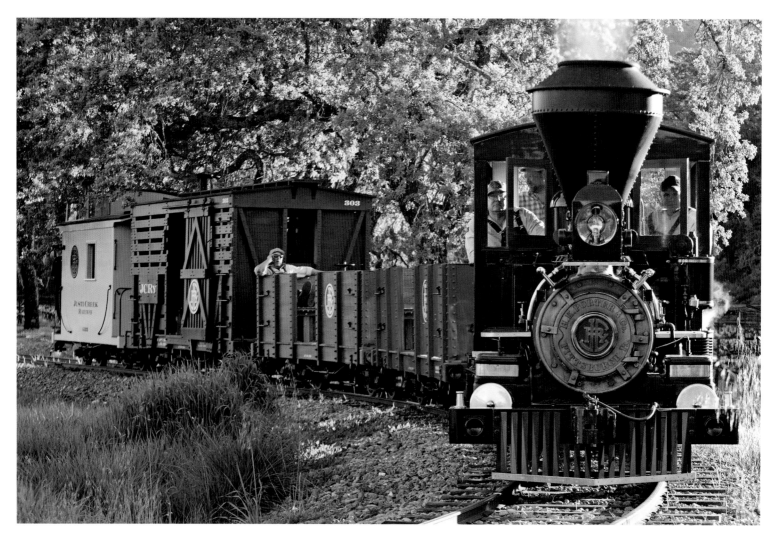

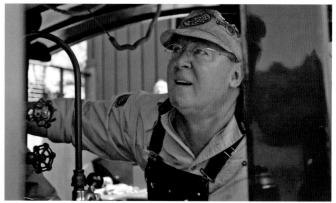

Top and above: John Lasseter
piloting the restored "Marie E."
Left: Casey Jr. from Dumbo

Foreword

AS THE SON of a Chevrolet dealership parts manager, and a Southern Californian born and raised, there were many more cars in my life than trains while I was growing up. From the moment my mentor Ollie Johnston first introduced me to trains, though, I was hooked.

A steam train is alive—you can feel it as you're standing next to it. Coal or wood or oil powers the fire in the firebox, which heats up the water inside the boiler, which builds the steam pressure that powers everything on the train. Its breath, like a person's, has moisture to it. And its sounds—the resonating whistle; the chugging pistons that first walk, then run; the musical rhythm of the metal wheels moving over the tracks—carry you away to another place and time.

Once you've been bitten by the bug, it never leaves you.

Steam trains were an important part of Walt Disney's life. They were the main form of transportation as he was growing up, and though they had already started to die out as Disney built his studio, he captured them for future generations in his work. From *Casey Jr.* to the Disneyland Railroad (inspired by Walt's own backyard railroad, the Carolwood Pacific), many of the trains we remember most vividly are the Disney ones.

Dana Amendola has put together a loving look at the trains of The Walt Disney Company, from the earliest short films to the steam trains keeping the railroad tradition alive in Disney parks around the world.

All aboard!
John Lasseter

Introduction

How I Came to Love Trains

ONE OF MY mother's favorite sayings was, *"I'd neva go out with so much as a curlar in my hayer."* Her Boston accent skillfully clipped each wayward "r" that tried to roost upon her sentence structure. Putting regional colloquiums aside, it was true: my mother always looked her very best and carried herself exceptionally well.

This was always a bit problematic for our family as my father was just the opposite. Brown shoes looked perfectly fine next to blue trousers and plaids ties could work with stripes in a pinch. Perhaps if my father were around a bit more often some of my mother's fashion sense would have rubbed off, but he was not.

My dad was away for a good part of my early childhood. I was always reassured that he was doing "important work." I was a Cold War baby, and the perceived threat from the former Soviet Union was a very real thing, especially for those of us living in the colder climes of the Northeast.

Later in life I would discover that the important work my dad was doing was constructing Bomarc and Nike Hercules missile sites for the United States government throughout Maine. They were built to counter the inevitable Soviet missile attack that was sure to be arriving over the North Pole at any moment. The irony of the entire enterprise was that most of the weapons systems installed were already outdated, long before they were even completed. Still this was all very top secret, hush-hush, remote undisclosed location stuff, and certainly not the ideal place to raise a family. So I stayed home with Mom, while Dad went off into the wilds of northern Maine to keep us safe from Communism.

Home was a modest little Vermont town complete with iconic New England images found on most bank calendars. White church steeples, a trout stream, volunteer fire department, and an antiquated iron cannon, rumored to be from the Battle of Bunker Hill, guarded a small but neatly appointed town common. The annual strawberry festival and chowder cook-off were the highlights of the social calendar. We had a textile mill and a quarry; we also had the mainstay of every small town: gossip, lots and lots of gossip.

My family was new in town, new in the sense that we didn't arrive on the *Mayflower* and had a last name that ended with a vowel. We lived in a modest little saltbox house and tried to fit in. This proved difficult at first, especially as my mother loved flashy clothes and even flashier cars. Her current car of choice was a 1956 Cambridge blue Buick Roadmaster convertible, which for some unknown reason she always referred to as robin's egg blue until the day she died. It was a stunning

automobile, the last of the truly elegant and big American cars. It was the car to see and to be seen in. My parents could hardly afford it, but Mom still played it to the hilt, much to the chagrin of the locals.

Never quite content with the sleepy little routine of our community, Mom loved to get "dressed to the nines," plop me in the backseat of the Buick, and off we would drive to "wake up the bumpkins."

Everything my mom did with me was an adventure. My very favorite of all was when we would go on a picnic. Mom would pack up the Redmon plaid picnic basket, which she always referred to as "the Cadillac of picnic baskets," put on her white lace driving gloves, and her horn-rimmed tortoise-shell sunglasses, and tie the appropriate scarf du jour around her flaming red hair. I would inevitably be dressed in some sort of matching shorts and jacket — gabardine in the summer, switching to flannel in the fall, and then velour in the winter. It was always accompanied by some sort of ridiculous Peter Pan collar; or at least that's what I've been able to glean from the stack of Kodachrome slides every baby boomer has stuffed away.

Our destination was a small park by the rail-

The author, age four

road tracks. On our way there, if she timed it right, she could linger at the town's sole traffic light turning every head as she nonchalantly took a drag from one of her lavender-colored cigarettes, tastefully ignoring everyone while she coolly flicked her ashes onto the roadway before we sped off in a blur of robin's egg blue.

The park by the railroad tracks was a simple affair, with one iron bench, a flagpole, and a small plaque erected by the local VFW post honoring three local doughboys from the Great War. We would spread out a large blanket and enjoy our lunch while a diminutive steam locomotive called a "switcher" lazily nudged the occasional boxcar into place. If we were lucky, we might even get the occasional wave from the unseen engineer in the cab as the little switcher made its way back to the enginehouse.

It was quaint, it was peaceful, and it was predictable.

Then one day something very out of the ordinary happened. Something that left such an impression on me, that I can still recall every detail vividly some fifty years later. Just as we were packing up to leave, instead of heading to the

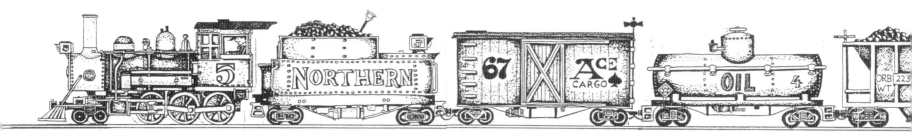

Train doodles by the author at age 13.

enginehouse, the old switcher stopped dead in front of us, with the sounds of the engine's boiler gradually slowing to a rhythmic "ping-ping-ping" as if she was resting after a hard day.

For me, time stopped.

Mom and I made our way to the rail fence that separated the park from the railroad tracks. I moved cautiously, almost afraid to startle the black-and-steel apparition before my eyes. At first steam enveloped the entire engine, but as it cleared I was able to get a good look at my mysterious engineer. He was much older than I had expected, gaunt with round spectacles, and he seemed to wear the weather-beaten demeanor of a Norman Rockwell character. He wore a gray denim jacket with a faded blue collar, and his pin-striped engineer's cap rested tightly on his head.

He acknowledged my mother with a touch of his hat brim and yelled something over to us. Unable to understand what was said over the noise of the still settling locomotive, my mom cupped her ear signaling for him to repeat the question. Then we both heard it, clean and clear: "Would the boy like a ride?"

My mom didn't even have to look at me: "YES" came her response. I squeezed her hand tightly in appreciation. My mother reached down and scooped me up, and in her periwinkle blue heels and ivory lace gloves she proceeded to carry me up a crushed stone ballast embankment, over two sets of rusty steel rails and creosote-soaked railroad ties to the waiting switcher.

This was the first time I had ever been this close to a working locomotive, and I was in awe. I distinctly remember that the dead steam had collected on the black metal, and it made me think that the engine was alive. My engineer looked at me for a moment then abruptly turned away to speak to someone else in the locomotive's cab. Suddenly a new face appeared in the cab's window; it was that of a younger man, considerably larger than the engineer and a man of color, another first for me. This was the locomotive's fireman. He smiled at me, squatted on the engine's floor, took off his tan work gloves, and reached down with his dark, muscular arm. I remember my little hand reaching out toward his and his strong hand lifting me up, up, up, and into the cab.

The excitement of ascending toward the heavens was far too much for my little brain to process. My mother would fill me in on all the details later, and it has become family folklore ever since. Apparently once I was safely aboard, she took hold of one of the locomotive's grab irons and was attempting to boost herself up into the cab, crinoline and all, when the engineer courteously stopped her, saying, "I'm sorry ma'am, but you can't come

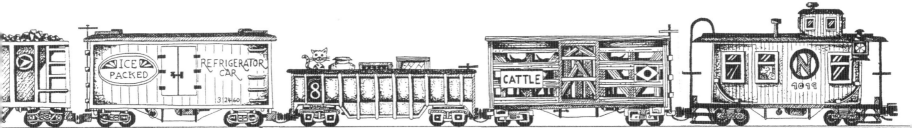

along; if my dispatcher sees a woman in the cab, I'm in for it." Sensing my mother's disappointment, he also added, "Besides, we're a bit underdressed for the occasion."

My mom reluctantly climbed down and looked up at me. Every maternal instinct told her to retrieve her child immediately, but when she saw how overjoyed I was to be seated at the engineer's window, his greasy cap now placed at a jaunty angle on my own head, she knew what she had to do. Blowing me a kiss, she backed away from the switcher as it let out a loud burst of steam and started off, my mother waving bye-bye to me as the engine gradually faded into the distance.

It didn't take long for the reality of what just happened to set in. She had put her five-year-old boy on a departing locomotive with two strangers without any idea of where they were going or how long they would be gone. How would she ever explain this to my father?

After the longest twenty minutes of her life, the little steamer reappeared and my mom would soon be together again with her only child. The engineer carefully carried me down and I was reunited with my mother. He took off his hat and introduced himself as what I thought sounded like Mr. *Finney*. I was covered in soot and ash and was beaming from ear to ear. Mr. Finney [sic] then tussled my hair and gave me a quick wink. Before I

knew what was happening he was back in the cab steaming away.

Needless to say overnight the gabardine suits and Peter Pan collars were immediately discarded in favor of pin-striped overalls and railroad caps. That summer we came back to the little park often to look at the trains; my dad even came with us once. But sadly we never saw Mr. Finney or the little steamer again.

Many years later I would come to discover that I was in fact the last "passenger" to ride the little switcher, as the next day after my adventure the little engine was scrapped.

Mr. Finney had wanted her last run to be a special one. And it was.

Dana Amendola
New York, 2014

1 Keep Moving Forward

Walt Disney Works on the Railroad

*Walt Disney with director
Francis D. Lyons between
takes during the filming of
The Great Locomotive Chase.*

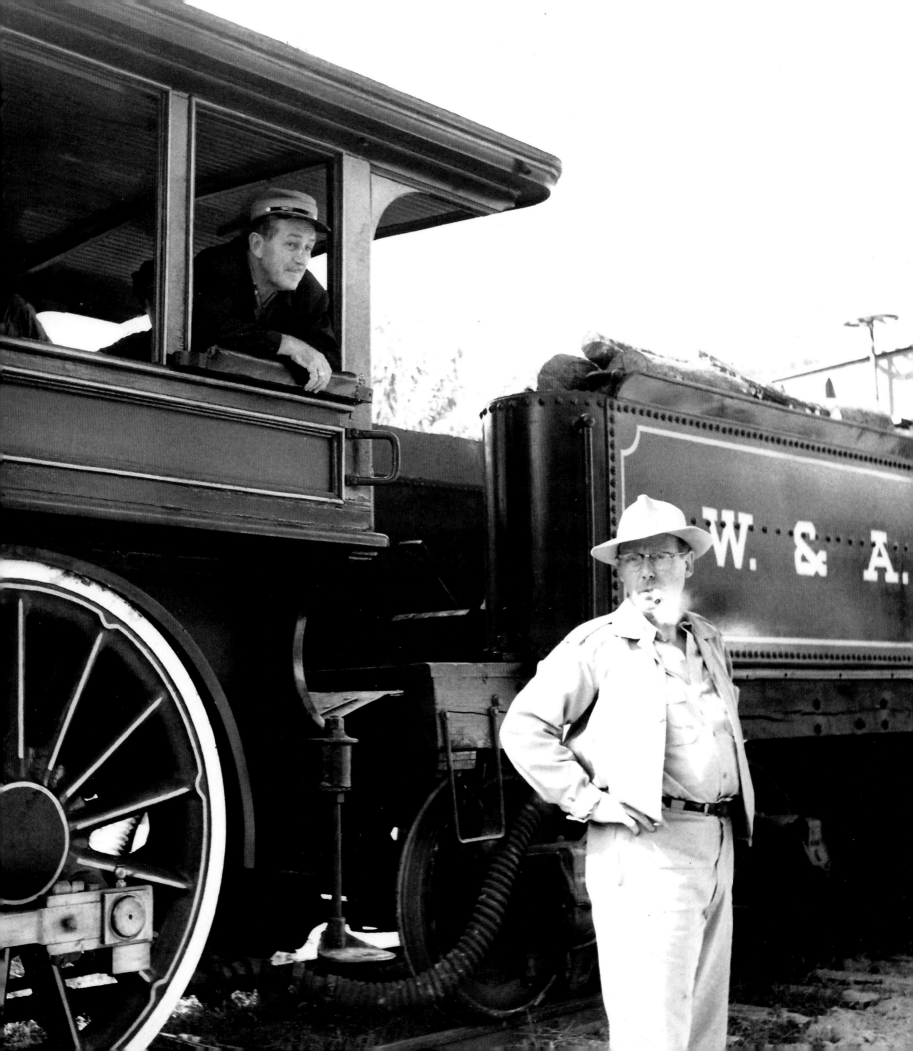

To tell the truth, more things of importance happened to me in Marceline than have happened since—or are likely to in the future. —Walt Disney

I T W A S in the small Missouri town of Marceline that a young Walt Disney would spend the most formative years of his life. Geographically speaking, it was just a little dot on the map, nothing distinctive in terms of natural or man-made wonders; no soaring mountain ranges, towering primeval forests, or raging rivers nearby. Still, it was an important little dot for the ever-expanding Atchison, Topeka and Santa Fe Railway, as its location marked a major dividing point between Kansas City and Chicago.

It was the railroad that actually built the town in 1888 for use as a terminal and layover location. Initially, it was called "Marcelina," after the wife of one of the railroad's directors. But then company officials later "Americanized" it and changed the name to Marceline.

It was to this small railroad town that in 1906 Elias Disney would relocate his family, leaving behind an unsuccessful construction career in Chicago to try his hand at farming. For his five-year-old son, Walt, it was an idyllic location. The small town had everything a young Midwestern boy could hope for: plenty of cottonwood trees for climbing, swimming holes, a band gazebo for open-air concerts, wide open fields, and long, lazy summer days. Although his father would never become the successful farmer he had hoped to be,

the four years that Walt spent in Marceline would define his life. Main Street Marceline would be re-created time and again as Main Street, U.S.A. in all of the Disney theme parks across the globe, and the daydreams of youth would become the reality of his adulthood.

Then there were the trains.

To a young boy growing up at the turn of the last century, trains were synonymous with adventure. Walt and an older brother, Roy, would sit by the gazebo in the town's Ripley Park and watch the large steam locomotives slowly rumble past with their hulking boxcars emblazoned with the logos of far-off railroads. Trains with names like the New York Central, Western Pacific, Rock Island, and Pennsylvania—along with brightly painted refrigerator cars packed with oranges and grape-fruits from California, stock cars carrying steer from Oklahoma, hopper cars bursting with grain from Iowa, and black lumbering tank cars from the rich oil fields of Texas—streamed by through-out the day. Later, while lying awake in his bed at night, a young Walt would have heard the haunt-ing whistle of a late-night express passenger train, perhaps even catching a glimpse of the gaslight-illuminated interiors.

He would think of his Uncle Michael Martin, (ac-tually his father' cousin), a seasoned engineer on the Santa Fe, pushing hard to keep on schedule as the

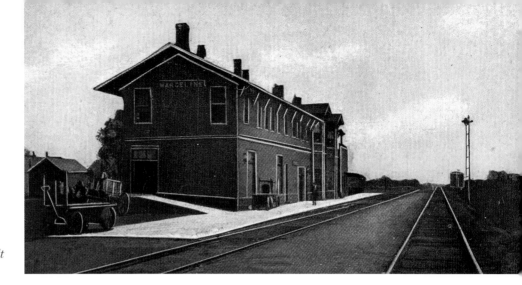

Marceline station as it appeared when Walt Disney was a boy.

light from his locomotive's large arc headlamp sliced through the Missouri darkness. Walt would always look forward to when Uncle Mike had a layover in Marceline and would listen attentively as he shared his stories of life on the rails. Later he would recall:

> *As a small boy living on a farm near Marceline, I had a unique claim to fame: my Uncle Mike was an engineer on Santa Fe's accommodation train that ran between Marceline and Fort Madison, Iowa. That was something to brag about to my schoolmates at a time when railroads loomed large in the scheme of things and steam engines were formidable and exciting.*

Immersed in all things railroad at such an impressionable age, it comes as no surprise that Walt dreamed about becoming a locomotive engineer himself, working for one of the exotic lines whose names he'd read countless times before on the passing boxcars.

Walt's first and only job with the railroad, however, would not be as a locomotive engineer but as a "news

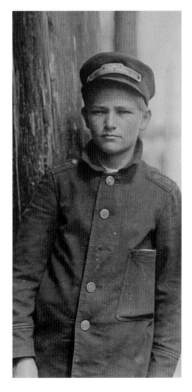

butcher." Inspired by an older brother, Roy, who was already employed as a butcher for the Santa Fe, Walt saw it as a splendid opportunity to see the world, while getting paid. With his older brother's recommendation, he was hired by the Missouri Pacific and assigned to a local commuter train running from Kansas City to Jefferson City, the state's capital. It was a fairly simple run that wouldn't even merit a paragraph in the *Railroad Gazette*, compared to such notable runs as the ones taken on a regular basis by the *the California Limited, the Broadway Limited*, and the *20th Century Limited*. But to Walt it was the gateway to Shangri-la, and one he would not pass up.

Holding the position of a railway butcher was a quick in for a young man with plenty of ambition and a knack for sales. The job entailed hawking various sundries from car to car along the route. The butchers actually played an important role for the railroads as they took the place of a dining car or lounge car on what were more often than not the less than glamorous runs, offering travelers some light refreshment.

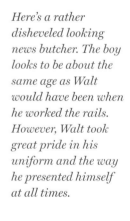

Here's a rather disheveled looking news butcher. The boy looks to be about the same age as Walt would have been when he worked the rails. However, Walt took great pride in his uniform and the way he presented himself at all times.

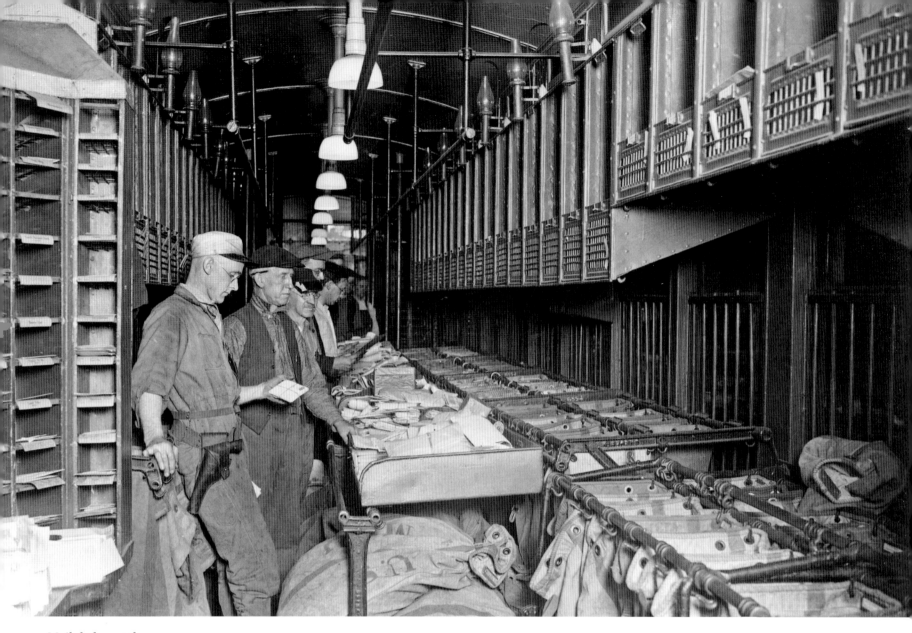

Mail clerks sort the mail inside a Railway Post Office. Note the sidearm carried by the first agent. (courtesy Library of Congress)

In later years, Walt would speak fondly of his time as a butcher, noting that it left him this way:

> *...feeling very important wearing a neat blue serge uniform with brass buttons, a peaked cap, and a shiny badge on my lapel. As the train rolled into one station after another, I stood beside the conductor on the car steps to enjoy the envious stares of youngsters waiting on the platform.*

He would have carried a standard butcher's kit—essentially a large wooden box carried at waist level with a canvas strap that would go around his neck. The kit included a large segmented tray that would in all likelihood hold all of the butcher's wares, including candy, sodas, newspapers, magazines, fresh fruit (in season), tobacco, and cigarettes. When full, the entire box would weigh about forty pounds.

But young Walt's first foray into business, which this was, was an unqualified disaster. When he wasn't sampling his own wares, and thus eating into his own profits, unscrupulous station vendors would sell him spoiled fruit carefully hidden below fresh produce. On one occasion, after a particularly

ALL ABOARD

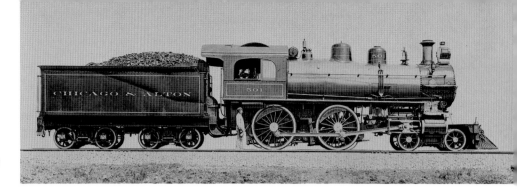

A typical passenger locomotive of the early 1900s.

robust day for soda sales, he left his empty bottles in a passenger coach that was actually uncoupled before he had a chance to retrieve them and collect the profit.

It turns out, however, that Walt wasn't really looking to make a profit in this endeavor, but rather to make contacts! And he did so with gusto. Within weeks every conductor on the commuter run knew of Walt, and perhaps more importantly, so did the railway baggage and postal clerks stationed in the "combine car and "railway post office" that literally held the keys to the gateway that Walt desired most.

The combine car, as the name implies, is really a combination of two cars. One half was arranged with standard coach seating, while the other was dedicated to mail and baggage. The placement of the combine directly behind the locomotive worked so well that railroads continue to arrange cars the same way today. When a train pulled into a station the baggage, mail, and railway express parcels were center stage. Station agents, mailmen, and porters did not have to travel to the far end of the train to load and unload items. The operation was a very public one so as to discourage any would-be thief from causing trouble.

There was also a more practical side to this arrangement. A steam locomotive is a smoky, oily, and noisy creature. It belches coal smoke and cinders through its smokestack and spits live steam

from its cylinder cocks. On a moving train, all of this debris blows back toward the passenger cars, and for those riders unlucky enough to have their windows open, there was the danger of getting a face full of smoke and cinders. To solve this messy problem, passenger cars were placed as far away from the engine as possible. The farther away from the locomotive the better the accommodations, with the last car of the train reserved for the elite set or even the president of the railway, where he could lounge in his observation car.

Walt Disney, however, often reminisced that his favorite location on the train was not the more glamorous cars, referred to as "varnishes" because

A brakeman performs his chores high atop a moving freight. (courtesy Library of Congress)

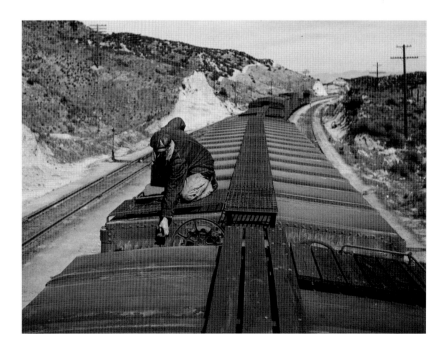

Members of a train crew joking, give the "highball" sign while exiting the Marceline train yards. (courtesy Library of Congress)

of their freshly oiled and painted appearance, but rather the simple combine. Besides being the area where the mail was sorted and the baggage was stacked, it was also the section where the train crew rested, ate, and swapped stories.

The compartments behind the locked interior door of the combine were actually bonded areas. It was a secure space, off-limits to the general public. The Wells Fargo agent housed inside would have carried a sidearm, a reminder of the old days of railroading when the possibility of a hold up wasn't just the stuff of folklore. One can imagine him with his ear tightly pressed up against the door straining to make out a conversation or the muffled delivery of an off-color joke, just wanting to find a way in to an area that only a very few were permitted to enter.

Yet he did have one item in his butcher's box that would make the roughest-hewn railroad man open the locked door for a moment: tobacco. So after peddling his wares, taking care to reserve some tobacco, Walt would find his way back to the combine. Casting aside the heavy butcher's box, he could then relax and swap a few stories with his newfound friends and mentors as they worked through the night. Once their work was complete, it was not uncommon for the clerks to have a last cigarette, a quick nip from a well-hidden flask, and then lower the gas lamps, and catch forty winks

between stations. Empty postal bags were hung between mail hooks and impromptu hammocks soon had sleepy occupants rhythmically swaying from side to side accompanied by the clickety-clack of the rail joints, responding in tune as the train moved forward over them. So in this dim, shadowy light, accompanied by a chorus of snores and snorts, a young Walt Disney quietly walked past his slumbering companions and opened the door that led to the coal tender.

Whoosh! Smoke, cinders, steam, NOISE! This was definitely not the same as passing between the neatly appointed varnishes. Wind blew in every direction as the train lurched side to side; even worse, there was no walkway between him and the hulking coal tender. Telegraph poles whizzed by accompanied by the clang-clang of the occasional crossing signal. It was clear to the young news butcher that if he wanted to reach the locomotive, he would have to "jump the knuckles."

"Jumping the knuckles" is an old brakeman's term for passing from one boxcar to another. The original role of the brakeman was one of the most dangerous jobs on the railroad. Spending most of his time atop a moving train, the brakeman would work his way back along the rooftops of a train's cars to activate large brake wheels located at the end of every car. Keeping them too loose would result in the freight cars slamming into each other;

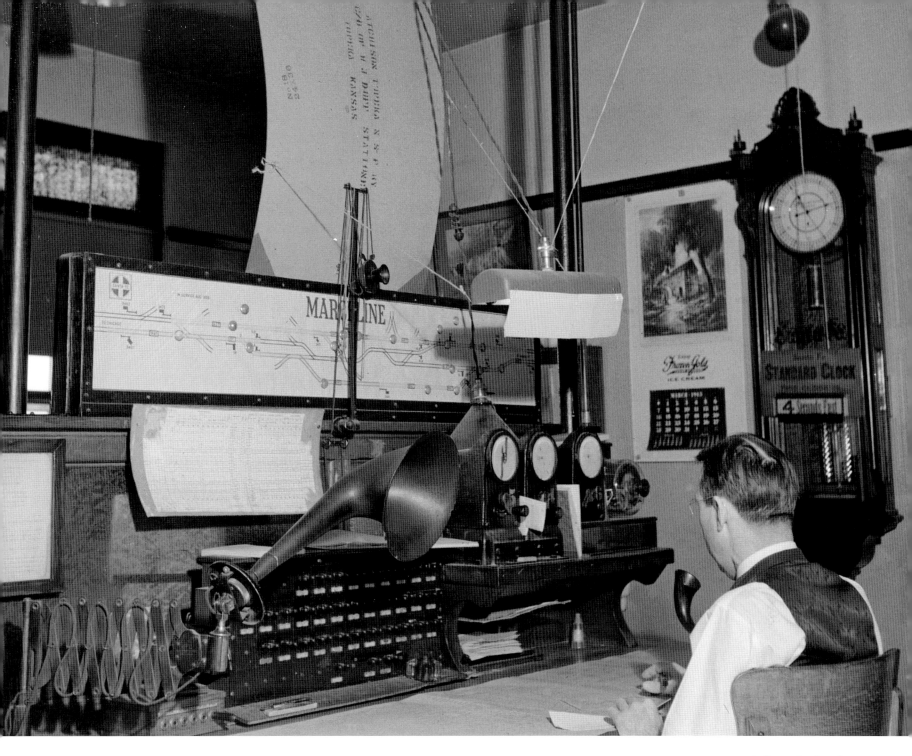

but if too tight, the wheels could lock up and the cars would jump the track. Brakemen performed this service both day and night and in all types of weather. Time was of the essence, and a brakeman would never waste time by climbing down one end ladder, cautiously crossing the knuckle couplers, and then ascending up another ladder. No, he simply would *jump the knuckles,* from rooftop to rooftop. This, to a degree, is what Walt had to do.

Walt looked down. The distance between the combine's platform to the rear of the engine's hulking black tender would be about five feet. Not a Herculean distance for an able young man to cross. But this would have to be a standing jump as there was no room to get a running start. The area he would be aiming for was a narrow ledge, six inches

A dispatcher hard at work at the Atchison, Topeka and Santa Fe Railroad offices in Marceline. (courtesy Library of Congress)

Formal portrait of a young Walt Disney sporting a "scally cap."

NEWS BUTCHER

WALT DISNEY wasn't the only railway news butcher to later attain fame. Half a century earlier, another ambitious youngster looking for excitement and a way out of his provincial lifestyle lied about his age—he was just twelve at the time—and took a job as a butcher working the Erie and Hudson line for the Grand Trunk Railroad between Port Huron, Michigan, and Detroit. Beginning in 1859, this person would continue with the railway for the next four years of his young life.

Similarly to Walt, he eventually befriended the baggage and mail clerks and wrangled himself into the combine car where he would open a small printshop and publish his own newspaper, *The Grand Trunk Herald,* which he would sell from car to car for three cents. He eventually was able to convince a kindly conductor to allow him to set up a mobile chemistry lab in the same combine. After he sold his wares and printed his newspaper, this young entrepreneur was able to sit and conduct experiments as the train rumbled along.

This, alas, would also be his undoing. On an express run ten miles out of Port Huron, the train sud-

denly lurched on a sharp curve tumbling the contents of his entire laboratory onto the floor. The assorted chemicals, including a stick of phosphorous, immediately burst into flames setting everything ablaze. Although he was able to extinguish the fire before the mail was severely damaged, the interior of the baggage compartment was completely ruined.

He was immediately ejected from the train, along with the shattered contents of his laboratory, at the next stop, Smiths Creek, Michigan. The same, kindly conductor who had allowed the young man to set up the lab on the train, brutally boxed his ears and literally hurled the boy onto the platform.

But don't feel too badly for the lad, as the he did go on to make something of himself in the field of science, eventually becoming one of the most proficient inventors in world history. After all, with well over one thousand patents to his name, including the motion picture camera, one has to wonder where would Walt Disney be without this particular news butcher Thomas Edison?

But that's another story.

deep that ran around the length of the coal tender. Even if he calculated the distance correctly he still had to deal with the motion of the train along with smoke from the stack. But Walt had come too far to turn back now. He focused his attention on one part of the narrow ledge and took a leap of faith.

Landing precariously on the slight spit of steel, Walt pressed himself tightly against the tender's cold walls; then, carefully, he inched toward the brakemen's ladder, his brass buttons clinking against the painted rivets. He scurried up the ladder to the top of the car. A thick, choking black wind of cinders, smoke, and oppressive heat would assault him as he looked toward the massive locomotive. He would have heard the water stored in the tender sloshing beneath him as he carefully made his way toward the coal bunker. Upon reaching the outer ridge of the bunker, he would have to throw both legs over the lip and cautiously make his way over a fourteen-ton pile of moving coal and into the locomotive's cab.

Inside the cab of a moving locomotive would be like nothing Walt had ever experienced. The sharp smell of burning oil, grease, and coal gas would flow into his nostrils. The dampness of the dead steam would hang heavy in the air, making his breathing difficult as his perspiration mingled with coal dust. But this was only a momentary distraction, as he would soon encounter an intense blast of two-thousand-degree heat as the fireman swung open the firebox door and scraped a large helping of coal into the insatiable inferno, temporarily illuminating the faces of the train crew and then plunging them back into darkness when the steel door slammed.

If Walt thought the confines of the baggage compartment were small, the lack of real estate in a locomotive's cab would seem claustrophobic. Space was at a premium, with an array of white-hot surfaces poised to burn the skin off a man if he's not alert. Everything and everyone had a precise location, and movement was contained to small, well-rehearsed choreography.

Imagine the locomotive crew's shock when into this exclusive world tumbled a gangly Midwestern boy, his face black with soot, his red hair tussled, and his blue serge damp, dirty, and disheveled. He may have been thrown back on the coal heap then and there had it not been for his outstretched arm offering a bit of "tobacco chaw."

With his meager offering accepted as a way of introduction, Walt, it can be surmised, would have made first contact with the fireman. Now, if the

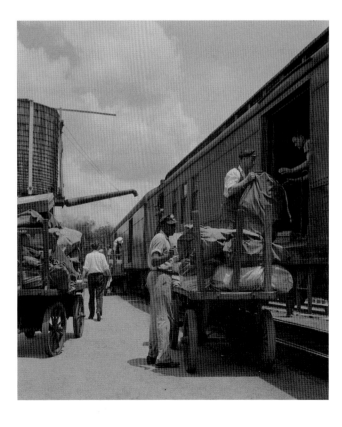

Mail and baggage being loaded onto a train. Note the water tank in the background.
(courtesy Library of Congress)

Feeding an insatiable giant. Firemen did much more than just shovel coal; it was their job to ensure that the fire burned clean, hot, and efficient at all times. (courtesy Library of Congress).

brakeman's job on a moving train was one of the most dangerous, the fireman's job was certainly one of the most laborious. He'd be responsible for shoveling approximately eight thousand pounds of coal into the train's furnace per hour just to keep the fire even and balanced. Too hot and the boiler could explode; too cool and the steam pressure would go and the train would come to a slow halt. It was an exhausting, repetitive job, so when an enthusiastic wide-eyed kid asked to try his hand at the shovel for a while, he didn't get too much resistance.

Walt knew from here it was only a matter of time before he was sitting in the engineer's seat, albeit temporarily, chasing adventure and seizing his destiny while racing through the blackness toward the future.

Much later in life, when asked about his railroad career, Walt would lament that it was "brief, exciting, and unprofitable"; and yet the lure of the railroads would stay with him forever, manifesting itself in almost everything he did. His love of the railroad gives new meaning to one of his most quoted comments:

We keep moving forward, opening new doors, and doing new things, because we're curious, and curiosity keeps leading us down new paths.

Walt and Mickey strike a pose in front of the E. P. Ripley the day after Disneyland opened. The schedule was a tight one as can be witnessed by the construction debris on the side of the Frontierland Station.

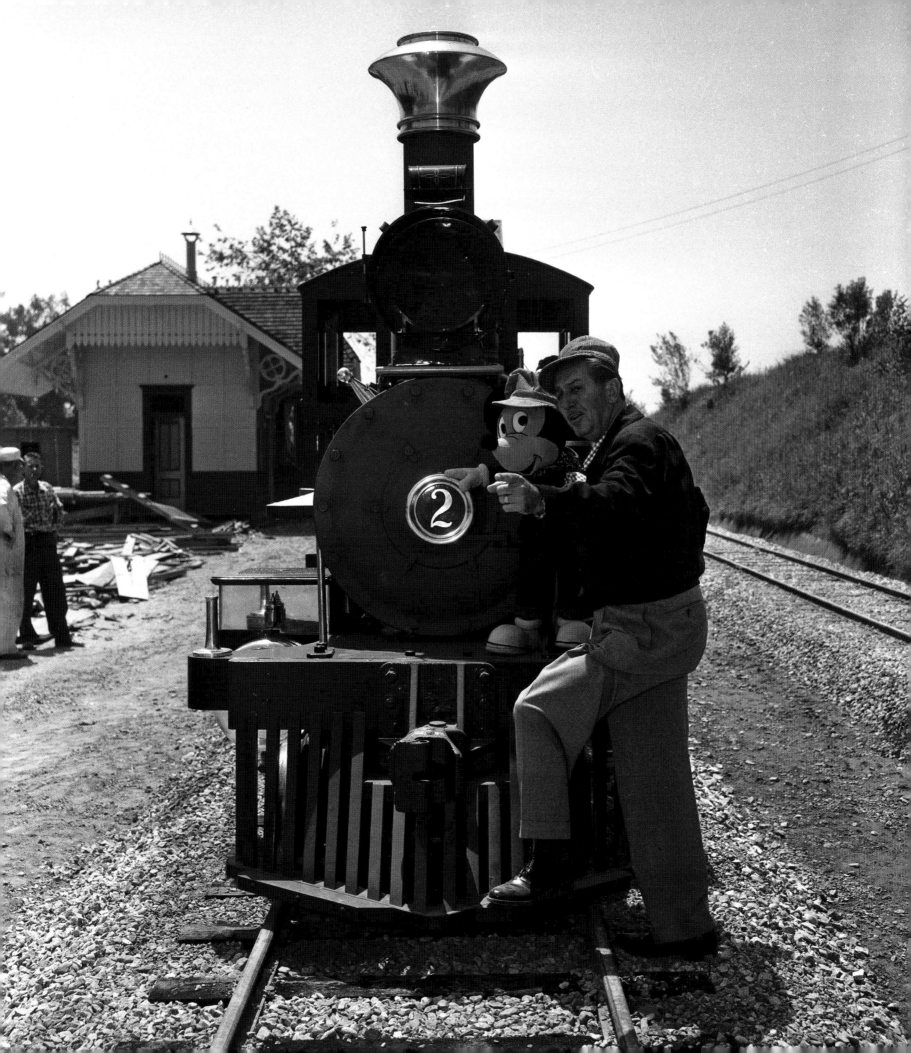

2 Born on a Train

The True Story of Mickey Mouse

The Atchison, Topeka and Santa Fe Chief en route to Chicago Far right: Overheasd view of La Grande Station in Los Angeles, circa 1899.

O N A C R I S P Southern California morning in early February 1928, an energized Walt Disney anxiously paced back and forth on the boarding platform at La Grande Station in Los Angeles. La Grande was a Moorish-inspired flight of fancy that looked more like Istanbul's Hagia Sophia mosque than a train station. (And it would remain the principal railway station for Los Angeles until 1939, when the now familiar Spanish mission-style Union Station was built.)

Disney, meanwhile, was awaiting the arrival of *The Chief* so he could jump aboard and head east. He was getting antsy.

The Chief was the nickname designated to the Atchison, Topeka and Santa Fe railroad's premiere transcontinental express—with its regular service between Los Angeles and Chicago. In addition to its easily recognizable moniker, the train also heralded a familiar slogan: EXTRA FAST—IT SHAVED OFF AN ENTIRE DAY'S TRAVEL ON ROUTE. EXTRA FINE—WITH FRED HARVEY DINING AND LOUNGE CAR SERVICE; ONBOARD BARBERS, BEAUTICIANS, MAIDS, VALETS; AND STEAM-POWERED LAUNDRY. AND EXTRA FARE—A $10 SURCHARGE.

Upon arriving at Union Station in Chicago, *The Chief*'s final stop, Walt would continue his journey by switching to the Pennsylvania Railroad's famed *Broadway Limited*, which headed toward his final destination, New York City's Manhattan. The *Limited* was a fast overnight train making the run to Manhattan in just less than sixteen hours. The train was composed of sleeping cars, one dining car, and an open-platformed observation car in the rear. Walt would have had his own private bedroom, paneled in dark walnut, with turndown service and fresh flowers delivered daily. Before retiring he would place his shoes in a small compartment by his door and they would be cleaned and shined before he awoke.

If it sounds magical, it was. This was the way Walt Disney liked to travel. As his wife, Lillian, would later recall, "Walt would always travel first class; even if he was penniless, he would somehow manage to scrape together enough fare."

Walt was traveling east to meet with his producer, Charles Mintz, who in conjunction with

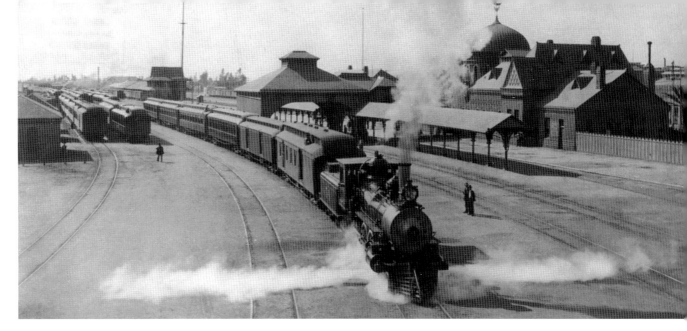

Universal Pictures was distributing his animated films. He was hoping to renegotiate a new contract for a well-received series he and his small team of animators had developed: Oswald the Lucky Rabbit. Oswald had already appeared in several features, including a delightful stint as a trolley operator in *Trolley Troubles*, and was quickly growing in popularity. Walt was so confident with the success of the series that he fully intended to pressure Mintz into agreeing to a hefty price increase per film from $2,250 to $2,500. He was convinced that he held every card, so much so that he even brought his new wife, Lillian, along so the two could celebrate with a sort of a second honeymoon.

Emerging into the sunlight from New York's Pennsylvania Station, the pair was immediately buffeted by a bitterly cold blast of winter air; yet this did not dampen their spirits in the least as they bundled up and headed toward a waiting taxi. Walt reasoned that he was in an excellent position to negotiate a contract that would not only benefit him, but his small staff of animators as well. His time had finally come.

But this feeling would be short-lived, for in the art deco offices of Charles Mintz, Walt Disney would get a cold dose of reality, one that he would carry with him for the rest of his life. After the required niceties, Mintz made it quite clear that he had no intention of increasing his payments per film! Quite the contrary, he offered less than what had originally been agreed upon. Mintz expressed his concern that Disney was spending far too much on creative development, far above the Studio's budget for an animated film, and the expenses had to be reined in.

Of course Walt refused to compromise on creativity and quality, so Mintz reduced the final offer by 20 percent to $1,800 per film. Instead of gaining an additional $250 per film, Walt

Left: New York City in the 1920s.

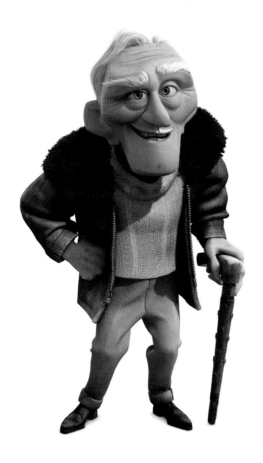

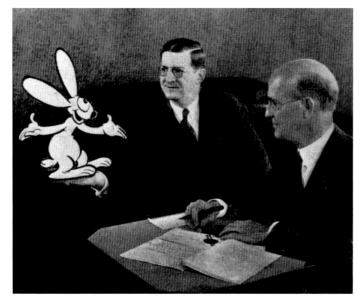

Publicity photo of Charles Mintz with the original concept of Oswald the Lucky Rabbit prior to Disney redesigning him. Top: Charles Muntz, the aged villain from Up, *is based on Charles Mintz.*

would be losing $450 per film. This was just the tip of the iceberg, however. Anticipating Walt's response, Mintz went on to reveal that he had signed away all of Walt's animators, save the ever-loyal Ub Iwerks, and now he and Universal contractually controlled the series and the character. Oswald the Lucky rabbit no longer even belonged to Walt Disney.

To Mintz none of this was personal. He was just taking advantage of an opportunity. It was the price of doing business, nothing more. Not wanting to keep Oswald's creator out of the picture entirely, he offered Walt the same deal the other animators had already agreed to. He assumed that after Walt's initial protests he would inevitably have no choice but to sign on the bottom line. After all, it was Mintz who now held all the cards: Oswald was his, the animators were his, and contractually Walt still had to finish the series. Walt had a new bride to consider and with times being how they were, this was not the moment to make a stand.

It was here that Charles Mintz made a crucial mistake, the same mistake that many others would make in the future; he underestimated Walt Disney's resolve. It was now Mintz's turn to get a chilly dose of reality as Walt reacted with sheer revulsion. He had no intention of signing on with Mintz for what he called "an act of flagrant betrayal." By contract, he would finish the series but would sever all connections with Mintz, Universal, and the animators who betrayed him. He walked out of Mintz's office leaving Oswald the Lucky Rabbit, his most successful character to date, behind. Furious, Walt paced back and forth along Fifth Avenue swearing to Lilly that he would "never, never work for anyone again."

The return trip to Chicago on the *Limited* was a quiet one. Walt was seething; he was frustrated and angry, but most of all he was hurt. Everything he had worked so hard to gain was now quickly

SO WHAT EVER BECAME OF POOR OSWALD?

For over eight decades, the character of Oswald the Lucky Rabbit remained a Disney orphan, sequestered indefinitely in some long-forgotten folder of the Universal Studios archives.

Fast-forward to 2006 when the newly appointed CEO of the Disney Company, Bob Iger, initiated a trade with NBC Universal for the rights to Oswald and his collection of film titles. In exchange NBC Universal would receive sportscaster Al Michaels from Disney's ABC and ESPN networks.

Upon hearing the news of the agreement Walt's daughter, Diane Disney Miller commented:

> When Bob was named CEO, he told me
> he wanted to bring Oswald back to Disney,
> and I appreciate that he is a man of his word.
> Having Oswald around again is going to be a lot of fun.

After eightly years, Oswald made a triumphant return to Disney and became a costar in Disney's popular video game *Epic Mickey*. Oswald rules an area called the Wasteland, an alternate Disneyland, inhabited by forgotten animated characters. He is also showing up at the Disney stores and theme parks where "Oswald Ears" hats are gaining in popularity.

As for Al Michaels, he accepted the trade in good humor. Commenting at the time on a recent trade between the Kansas City Chiefs and New York Jets, he was heard to say:

> Oswald is definitely worth more than a
> fourth-round draft choice. I'm going to be
> a trivia answer someday.

slipping through his fingers. He stared out the window at the passing images of the industrial Northeast. As he continued west on *The Chief* after the exchange in Chicago, most likely enjoying one of his favorite railroad fares—macaroni & cheese or chili if it was available, Walt decided it was time for action. He needed a new animation staff, he needed a new idea and he needed a new character.

Perhaps inspiration came while crossing the Missouri River or while watching the sun come up over the shimmering alfalfa fields of Kansas. Or perhaps it was while traveling past the snow capped peaks of the Colorado Rockies, or the Joshua trees of the Mohave Deser. One would

like to think it occurred while passing the small but neatly appointed passenger depot in Marceline, Missouri. His wife, Lilly, would later recollect that it was somewhere between Toluca, Illinois, and La Junta, Colorado.

Somewhere along that long train trip home, slouched in a Pullman coach, his worn sketch pad on his lap, Walt Disney started to doodle a mouse. Originally, it looked a bit like Oswald, but shorten the ears, perhaps round them out a bit, make the body slightly shorter, and the arms and legs a bit thinner, and lose the to cottontail in favor of a slender line.

As he worked on his new creation, his pencil strokes became more determined, and his lines

In 1935 Carl Laemmle, founder of Universal Studios, sent Walt Disney a blank piece of paper asking for his former employee's autograph. Walt signed the paper but added a bit of artistic license as well.

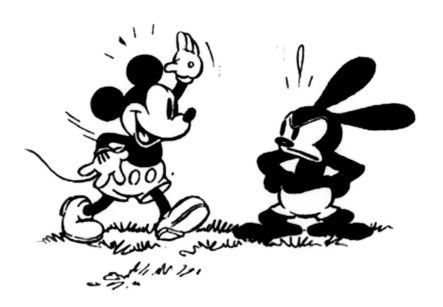

more defined. Now he worked even faster as the train sped through the heartland. Finally, the animator stopped and regarded his new creation, the small figure on his pad happily staring back at him. Walt probably recalled the leaner days of his career working out of an old rented barn in Kansas City, when his only friend was a small field mouse that would climb up onto his desk and gingerly accept the few crumbs he had to offer.

Walt turned to Lilly. "I've got it, I'll do a series about a mouse." He showed Lilly his rendering. "I'm going to call him Mortimer Mouse."

Lilly took the well-worn pad and studied the small face. Walt was hurting and needed support, but he also needed an honest critique from her. "I think that Mortimer sounds a bit too dignified for a mouse," she offered. She studied the image on the page for a moment. Finally it came to her: "Mickey . . . he, looks like a Mickey."

Walt contemplated the moniker for a moment, with the rhythmic clickity-clacking of the rails the only audible sound. "I like it," came his reply. "We'll call him Mickey—Mickey Mouse. Mickey has a good, friendly sound." Walt rested the pad on his lap and took Lilly's hand.

And so, somewhere along the high rail of the Atchison, Topeka and Santa Fe railroad, an American icon was born to the gentle swaying of a steam train headed into the western sunset.

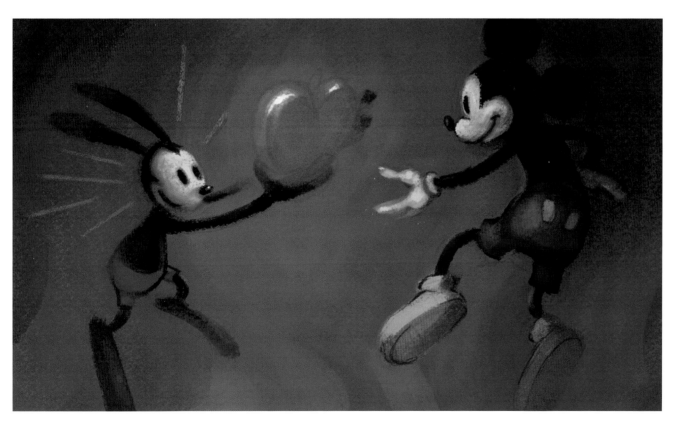

In 2010 Mickey and Oswald made peace in the platform video game Epic Mickey.

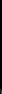

3　Trains in Disney Films

From Paper to Pixels

Casey Jr. concept art

I N 2006, Walt Disney Pictures updated the introductory logo for its films. The blue and white Sleeping Beauty castle logo previously rendered in two dimensions, although one of the most recognizable movie logos in the world, seemed a bit dated. The new opening would still feature the castle but would be enhanced by computer generated imagery and include other familiar visuals.

The new introduction tells a story that would undoubtedly please Walt very much. The opening sequence begins with a delicate balance of piano and French horn as a bright shining star twinkles above. As the camera slowly pans earthward through the rosy twilight, we see a moonlit river guiding a full-rigged sailboat toward the horizon. Suddenly the stillness is pierced by the headlamp of a steam train crossing a trestle and cutting through the darkness. The music swells and we are rewarded with the familiar strains of "When You Wish Upon a Star" as the castle comes into view.

Walt always believed that the journey was just as exciting as the destination, and what better way to arrive at your destination than by train?

It is only fitting for a man who loved trains so dearly that a steam locomotive should be featured so prominently to introduce his company's films. Yet Walt's love affair with trains goes far beyond this title sequence. Trains have appeared and continue to appear in a wide variety of the Studio's films.

The following is an account of the many Disney films that have featured trains or a train sequence. It also includes several behind-the-scenes secrets, images, and tall tales that have never been shared before.

All Aboard!

*Walt wearing a Confederate
Kepi at the throttle of* The
Yonah *during the filming of*
The Great Locomotive Chase.

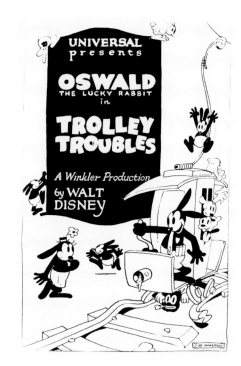

Trolley Troubles (*right and below*) *was produced by Margaret Winkler, who would later go on to marry Charles Mintz, the Universal nemesis of Disney's.*

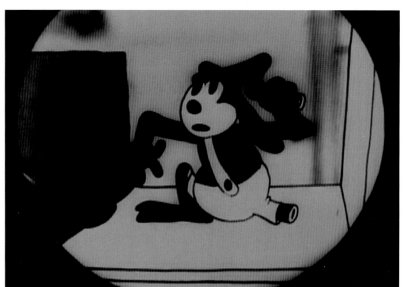

TROLLEY TROUBLES
1927

In this classic short, we find Oswald the Lucky Rabbit working as the conductor of a whimsical trolley, reminiscent of the Toonerville Trolley—made famous in the very popular comic strip that ran from 1908–1955—trying his best to stay on schedule. Of course nothing goes right for Oswald: he's soon besieged by pesky kids trying to hitch a free ride, a stubborn cow causing all sorts of trouble on the tracks, and finally even battles to gain control of his runaway trolley as it merrily cavorts up and down rolling hills. At one point during the madcap ride, Walt actually depicts Oswald removing his own foot and feverishly rubbing it for good luck.

This last bit of business was given to the talented Friz Freleng to animate, causing the perplexed animator to ask Walt, "What do I show when his foot is taken off? Do I show a bone in there or what?" This led to much debate with Walt insisting that as an animator Freleng should instinctively know what to do. Aware that Walt had never really thought out the aspect of Oswald's foot being detached, Freleng, who would later go on to fame as the creator of Bugs Bunny, continued to push Walt. "So Walt, what do I do . . . do I show the bone?" At this point laughter filled the small studio as none of the animators had a clue about how to handle this artistic dilemma.

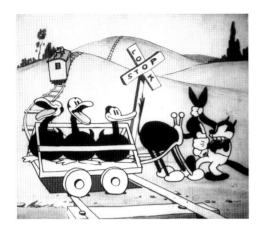

Original captures from Mickey's Choo-Choo. *Note Mickey and Minnie riding atop the boxcar.*

MICKEY'S CHOO-CHOO

1929

When you think about it, it's only fitting that Walt would have his beloved Mickey climb behind the throttle of a diminutive locomotive in *Mickey's Choo-Choo* so soon into his career. After all Mickey was born on a train trip his creator was taking from New York City back to Los Angeles.

In this "sound cartoon," as it was originally billed, Mickey finds himself working as an engineer on a quaint short line railroad. His fun-loving engine merrily chuffs and puffs in perfect accompaniment with the cheery music while Walt himself warbles, *"I've been working on the railroad"* in Mickey's own high-pitched squeak. It was a "chore" Walt no doubt found most agreeable on several levels. Engineer Mickey thoroughly oils his beloved little steamer, taking great care to hit all the right spots before serving up a heaping plate of coal *du jour* for lunch, which the train readily devours.

Walt's sheer joy for his subject matter is certainly apparent in this early short as virtually every component of the little puffer belly comes to life from the loco's toothy cowcatcher to an accommodating brake wheel. As Mickey takes his best girl Minnie for a jaunty romp in the countryside perched high atop a boxcar, all elements work in perfect simpatico like a well-oiled machine. This early short, while not discussed to the same degree as say *Steamboat Willie* or *Plane Crazy*, is still significant, as it is the first time that Mickey and Minnie have an actual conversation with each other. Prior to this, their character dialogue was limited to songs, short punch lines, and squeaks!

INSIDE TRACK:

In October 2009, Disney Channel aired a primetime special for the popular Mickey Mouse Clubhouse *series entitled "Mickey's Choo-Choo Express." The special was a tip of the mouse ears to Disney's love of trains and to this original short. It was accompanied by the release of a new Fisher-Price toy train and was promoted via a virtual train trip that went from Kansas City to Los Angeles in which children could track Mickey's progress as he rode along many of the same rails Walt would have traversed eighty years earlier.*

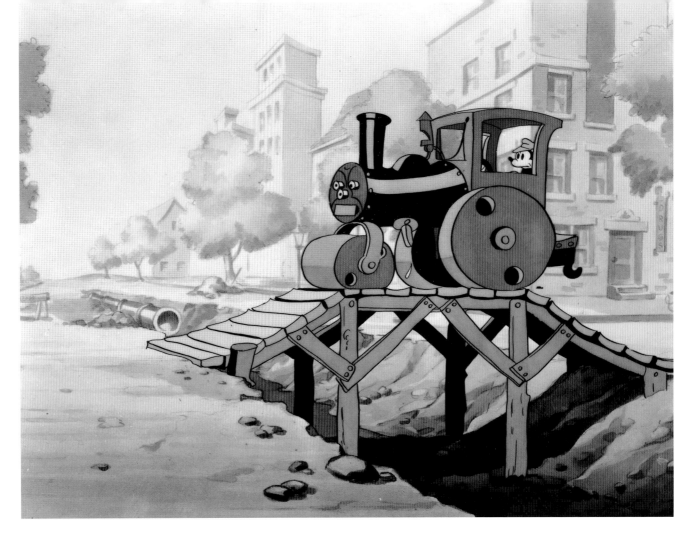

Mickey in the cab of his steamroller.

MICKEY'S STEAMROLLER
1934

Although technically not a steam train, Mickey's steamroller certainly possesses all of the characteristics of a steam locomotive. It huffs and puffs, smokes and whistles, and is very reminiscent of *Mickey's Choo-Choo*. The shorts also feature another glimpse of the Toonerville Trolley harkening back to Oswald's *Trolley Troubles*.

At a running time of 6 mins., 55 secs., the animated short is full of action and comedy. It features Mickey and Minnie but is most notable for the introduction of Mickey's two nephews, Ferdie and Morty Fieldmouse. These two mischievous little mice take over the steamroller their uncle's operating when Mickey lets his guard down in order to woo his beloved Minnie.

It is interesting to note that Minnie introduces Mickey to the boys as their "Uncle Mickey." This led many to question the couple's relationship. Is Minnie married to Mickey or not? In 1935 Walt actually responded to this question by explaining that, "There is no marriage in the land of make-believe. Mickey and Minnie must live happily ever after." In essence Minnie will always be Mickey's leading lady on-screen; what they do in their private life is their own business.

INSIDE TRACK: *Ferdie and Morty would never go on to the same fame as Donald Duck's nephews, Huey, Dewey, and Louie. The pair did have a cameo in the 1938 short* Boat Builders *but didn't appear on film again until 1983, when they made an appearance in* Mickey's Christmas Carol.

DONALD'S OSTRICH

1937

Although not specifically a train film, *Donald's Ostrich*, the third in the Donald Duck series of animated shorts, has the easily irritated duck portraying a baggage clerk at a small railway station in the town of Wahoo. His latest arrival is a bit of live cargo, Hortense the ostrich, who literally eats anything. As is true in most of the Disney animated shorts from the 1930s, the background painting is absolutely stunning and the detail of the small station is a work of art in itself.

INSIDE TRACK: *This is the first and only time that Hortense the ostrich appears on film. She was later seen as a comic book character playing opposite Donald.*

The tuba that Donald uses to startle the ostrich has a tag that reads F.O.B. This is a railway baggage term referring to "freight or free on board," meaning that the shipper has already paid for the parcel's transportation. It's a small railroad detail to say the least, but a wonderful example of Disney's strong attention to detail.

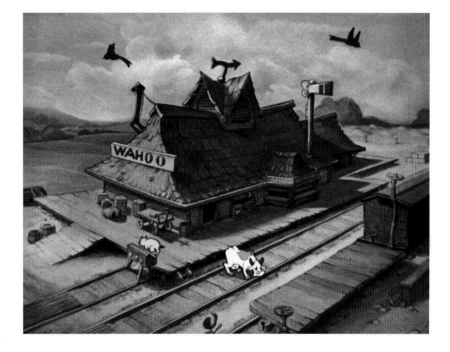

Top right: Detail of Wahoo station. Right: Publicity sketch for the film Donald's Ostrich

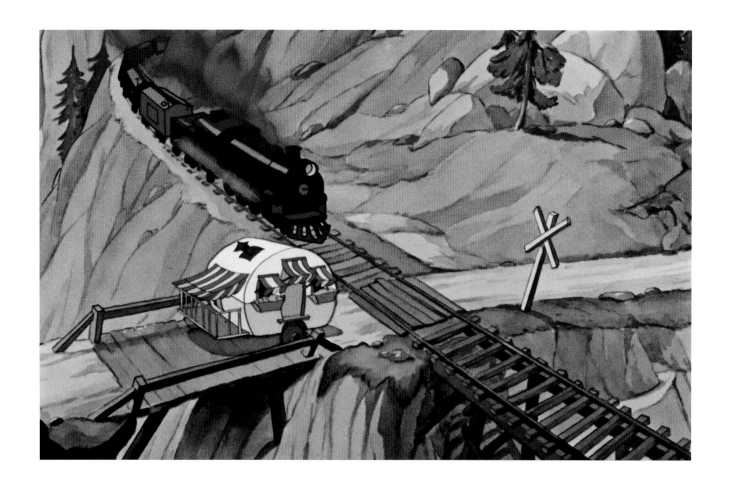

MICKEY'S TRAILER
1938

By far, this is one of the best-loved Disney animated shorts; it's way ahead of its time and regarded by many as an instant classic.

The story line is unique in that it actually departs from the classical depiction of man versus machine so common in the Goofy shorts and instead presents a world where everything associated with technology. . . . goes right. That is at least in the hands of Mickey Mouse.

The short opens in a bucolic mountain setting, with a quaint country cottage nestled by a tranquil lake. In a charmingly whimsical piece of business, Mickey appears on the front porch, breathes in the fresh air, and exclaims, *"Oh boy, whatta day!"* He then proceeds to pull a large lever, which an experienced railroader would instantly recognize as a *Johnson bar* and the cottage begins to shake revealing that it is in fact a mobile home. Simultaneously, the white picket fence surrounding the cottage is automatically retracted into the trailer's body as are the painted flowers and stone walkway. One side of the trailer then opens and out drives Goofy in his sputtering jalopy ready to pull the inhabitants on their merry way. Just before they depart, however, the pastoral background is abruptly folded up to reveal the true location, the city dump.

The animators, taking every advantage to add a steam engine whenever possible, actually sneak one into this scene. If the viewer looks closely at the background, an idling locomotive is clearly visible ready to head out. This same train will play an integral part later in the story.

Then it happens. A lone steam whistle is heard in the distance accompanied by the low rumblings of freight cars. The loose trailer's occupants soon realize that they are headed straight for a railroad crossing. Helpless as the trailer careens toward its inevitable fate, Donald frantically yells for the rushing locomotive to *"get outta the way!"* then drops to his knees in erstwhile prayer.

The bobbing trailer comes within a mouse's whisker of being pulverized by the rushing locomotive, but it manages to cross the tracks just in the nick of time avoiding disaster.

Breathing a collective sigh of relief at their good fortune the boys have just enough time to wipe their foreheads when, almost immediately, another train whistle is heard! Thanks to the curvy mountain road, they soon discover that this is in fact the back end of the same train. A now frazzled Donald falls to his knees once again. With the pair speeding toward certain doom all looks lost, but Mickey's luck holds out and this time the rollicking trailer just misses the caboose!

INSIDE TRACK: *The character of Pete actually makes a brief cameo appearance in this short. If you watch carefully, he's the driver of the truck that just misses the runaway trailer.*

Disney animators were so keen on depicting trains realistically that even the brightly colored refrigerator cars of the Pacific Fruit Express, including their rooftop ice hatches, can be clearly seen as the train rushes past. These orange and yellow "reefers" would have been a familiar sight back in the 1930s; they are especially associated with California, so the animators took great care to depict them correctly.

Once everything is stowed safely in his trailer, Mickey reaches above his head and pulls on a trolley cord, signaling Goofy that it's time to leave. Soon enough the boys, now joined by a sleepy Donald Duck, are off and rolling—quite literally. After a hearty breakfast they come to realize that Goofy, who now is seated between them, is no longer at the wheel. Goofy gingerly leaps back into the driver's seat, but by that time the damage has been done. The trailer, now detached, begins to bob and weave down a closed mountain pass all unbeknownst to Goofy. Meanwhile Mickey and Donald are being tossed about inside the runaway trailer as it begins to cavort and tumble down the mountain at breakneck speed. They manage to defy hairpin turns, sheer cliffside drops, and even a slow-moving truck on a one-way road until all seems to be under control.

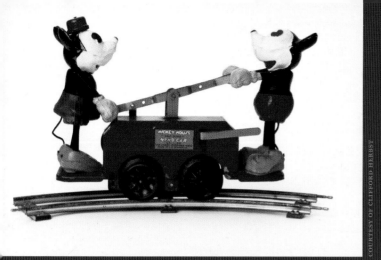

THE LITTLE MOUSE THAT SAVED LIONEL TRAINS

MICKEY MOUSE SAVES JERSEY TOY CONCERN;
CARRIES IT BACK TO SOLVENCY ON HIS RAILWAY

So read *The New York Times* on Tuesday, January 22, 1935.

Joshua Lionel Cowen founded the Lionel Company in 1900 and had a moderate degree of success against established European competitors.

But the Great Depression took its toll and by 1934, the Lionel Company was poised to join scores of failed businesses and shutter its doors forever. Then on July 19, 1934, Lionel reached a licensing agreement with Disney to manufacture a small mechanical toy: the Mickey Mouse Handcar.

Reasonably priced at one dollar, the set included a small whimsical red clockwork handcar, which Mickey and Minnie would happily pump along a circle of track. The Mickey Mouse Handcar was an immediate success, with 254,000 sold in just four months. The Lionel factory worked overtime to keep up with the demand and within three years, handcar sales

exceeded 1.2 million with Mickey and Minnie pumping the company out of bankruptcy.

During the Depression, Lionel would go on to manufacture several other Mickey Mouse railroad items, including a Santa and Mickey handcar, a Donald Duck handcar, and two detailed train sets: the Mickey Mouse Passenger Train and the Mickey Mouse Freight Train. Both sets were beautifully rendered, complete with Mickey shoveling coal into the firebox, but at $1.50 a set they never matched the popularity of the Mickey Mouse Handcar and were discontinued. They remain rare collector's items today.

INSIDE TRACK: *Lionel trains are consistently selected as one of the top ten toys of the twentieth century. For a short time in the early 1950s, Lionel was the largest toy manufacturer in the world. So it comes as no surprise that Lionel was indebted to Mickey and made sure to take care of his creator by supplying Walt with a steady stream of model railroad equipment for the rest of his life.*

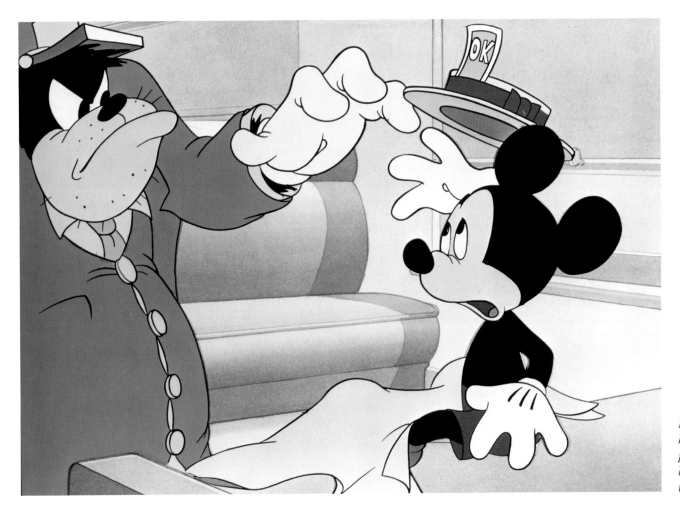

Pete hands Mickey his tickets back after punching (actually biting) "OK" through them.

MR. MOUSE TAKES A TRIP
1940

In this classic animated short, Mickey and his faithful dog, Pluto, are planning to take a train trip in California from Burbank to Pomona, which in 1940 was considered to be out in "the country." Everything is going fine until they encounter Pete the conductor, who upon spotting Mickey's beloved pooch, promptly hurls the pair unceremoniously off the train bellowing his signature line, *"Hey you! . . . No dogs allowed."*

It's up to Mickey to sneak his loyal companion back onto the train past the watchful eye of Pete. The popularity of this short is in keeping with the era's zany comedies set on trains, complete with mistaken identities, car-to-car chase scenes, and characters donning makeshift disguises using any material at hand. In one memorable encounter, Mickey disguises himself as a Native American chief by wrapping himself in a red blanket and propping a feather duster on his head while Pluto hides "papoose style" in a golf bag on his back.

The villainous Pete is actually the oldest continuous Disney character. Tracing his birth all the way back to 1925, when he first appeared in Disney's Alice Comedies, Pete was also a recurring character in Oswald the Lucky Rabbit movies, eventually teaming up with Mickey in *Steamboat Willie*, which was released in 1928. So Mickey's chief nemesis actually predates him by three years!

INSIDE TRACK: *When Mickey and Pluto first board the train, the name on the side of the passenger car is only partially revealed as* GERONIM, *leading one to speculate whether it was a misspelled nod to the famous Apache chief. The naming of railroad coaches was a standard practice of the day, so why did the animators leave off the final "O"? Could it be they just forgot? With the Studio's legendary attention to detail, this is highly doubtful. More likely it's a hidden reference to the director of the short, Clyde Geronimi.*

This animated short also helped to propagate the urban myth that Pomona was in fact Walt Disney's original planned location for Disneyland. As the legend goes, Pomona's city council declined the offer, as they felt the concept of a themed amusement park would not be successful and that the city would fall into debt. Although

Pomona may have been one of several Southern California locations considered, there remains no record of any serious discussions ever taking place. More than likely, Pomona was ruled out early on due to climate concerns. Still the legend endures and was most recently resurrected in James Ellroy's 1990 novel L.A. Confidential, *where Pomona is used as the setting for a fictional theme park named Dream-a-Dreamland created by an animation magnate named Ray Dieterling, a character reminiscent of Walt Disney.*

Although Mickey, Pete, and Pluto appear to be the only credited characters appearing in the film, it has been suggested that Clarabelle Cow makes a cameo during the sleeping car scene. That is her gloved hand and frilly hat do, as she beats a cringing Pete for mistakenly entering her berth.

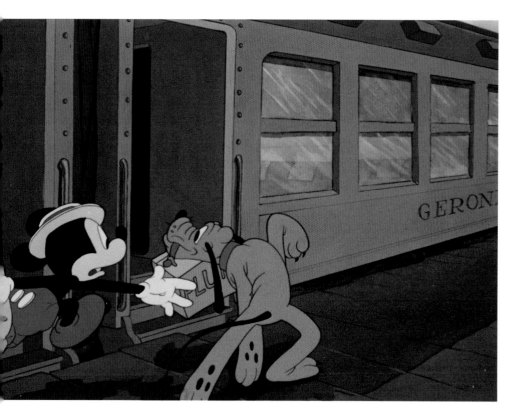

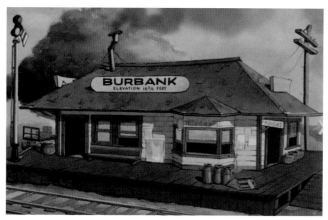

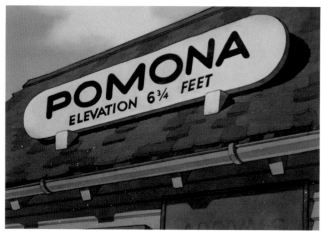

The name on the side of the passenger coach could be either "Geronimo" or a partial name in honor of Clyde Geronimi, the film's director. Renderings of real stations (right) were also done for this film, including the Burbank station (Burbank is the home of Walt Disney Studios) and the one in Pomona, Mickey's final destination in the movie.

BAGGAGE BUSTER

1941

In this, his third animated short, Goofy appears as a station agent at a rural railroad depot. His "simple" task is to load a magician's trunk onto the 5:15 p.m. train. Of course everything goes wrong as animals, birds, and even a palm tree begin to magically appear and sprout all around him. Goofy finally gets everything (and everyone) back into the trunk just in time to throw it into the train's baggage car. Once the train departs, however, the viewer discovers that the opposite car door was opened and the trunk has been left behind—meaning Goofy will have to start the entire process again.

INSIDE TRACK: *In this short, Goofy is depicted with five fingers on each hand as opposed to the usual four. Over the years animators discovered that four fingers are actually easier to work and appear more natural and uncluttered on the character's hand.*

The magician's rabbit depicted in the short appears to be an early rendering of Thumper from the animated film Bambi, *released in 1942. Perhaps a work in progress, he thumps his foot repeatedly, and although he does not speak, he does exhibit the same childlike giggle that Thumper displays.*

Two other Disney animals make an appearance in the theatrical short: Ferdinand the Bull makes a not so subtle cameo, and we get a very a brief glimpse of Pluto when the magician's silk handkerchief empties its entire contents onto the train platform.

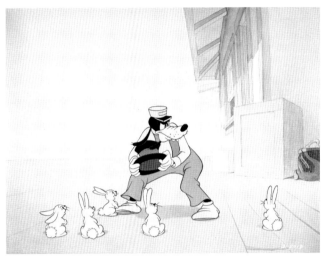

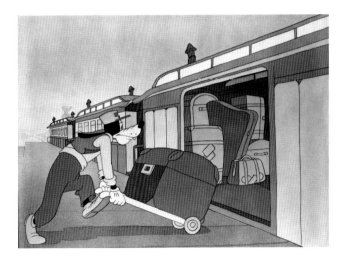

Goofy hard at work at his railroad depot. Notice the attention to detail when it comes to the railroad items.

Film captures and concept art from Timber.

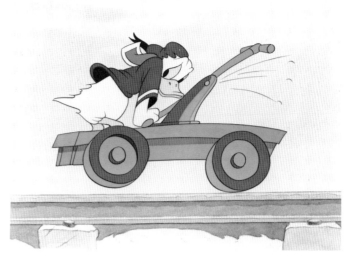

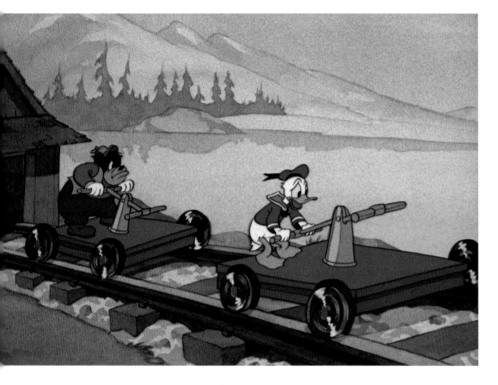

TIMBER
1941

In this clever little short Donald finds himself walking the rails hobo style complete with his bindle on his back. As is his want, he tries to take Pete's dinner from an open window. Pete, who portrays a lumberjack, quickly realizes what is going on and puts Donald to work as a lumberjack, helping him cut down trees. Donald of course tries to get out of work whenever he can and a hilarious race on handcarts soon has the two zipping across the forest primeval. Both handcarts soon begin to disassemble resulting

in both Donald and Pete racing along on a single set of wheels. In the end, Pete crashes into a row of boxcars and Donald goes on his merry way.

INSIDE TRACK: *This is one of those rare moments that Pete finds Donald as his nemesis; usually Pete directs all of his anger towards Mickey or Goofy. It's actually the Beagle Boys, who trace their lineage back to Pete, who continue to go after Donald and his uncle, Scrooge McDuck.*

DUMBO
1941

The Academy Award-winning animated feature *Dumbo* is a sentimental favorite of many a Disney fan. Elegant in its simplicity and story line, it is considered to be one of Disney's most charming films. It certainly was one of his favorites. Although released just a few weeks prior to the United States' entrance into World War II, it was the most financially successful Disney film of the 1940s.

Dumbo speaks to all of us on a variety of levels both artistically and emotionally. It would be difficult for even the most cynical critic not to get a bit misty eyed during the tender rendition of "Baby Mine." Everyone remembers the adorable baby elephant with the large ears that enable him to fly, but for many a railroad enthusiast the little circus train pulled by Casey Jr. is the real star of the show.

The task of animating Casey Jr. fell to one of Walt's "Nine Old Men," Ward Kimball, who was unquestionably the best man for the job. After all, it was Ward who encouraged Walt to first try model railroading, a hobby that eventually would lead to small-scale backyard railroading. Unlike Walt, instead of a miniature train running in his backyard, Ward had a full-scale three-foot, gauge-operating railroad on his property. Named the Grizzly Flats Railroad, it included several working steam locomotives, passenger coaches, rolling stock, and handcars. It also had a Engine House, water tank, and railroad depot that later became

the inspiration for many a Disney animated feature. This was pretty impressive stuff, especially when you consider that Ward's property consisted of only about three acres.

Ward animated Casey Jr. with a distinct personality, and his "face" can express a wide range of emotions. Using his steam cylinders and side rods for limbs he also could emulate a large variety of movement. Casey Jr. even has his own song in the movie.

Casey Jr. departs from his winter-circus quarters. Note the WDP (Walt Disney Productions) Circus sign.

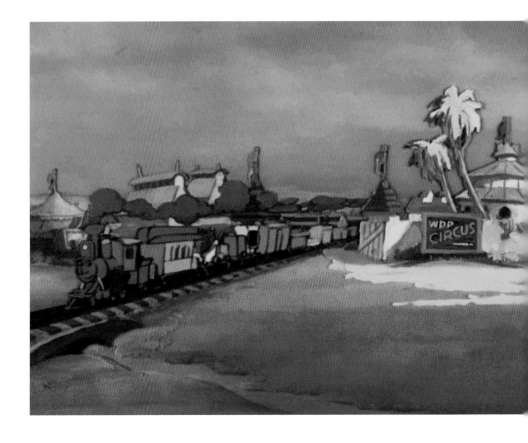

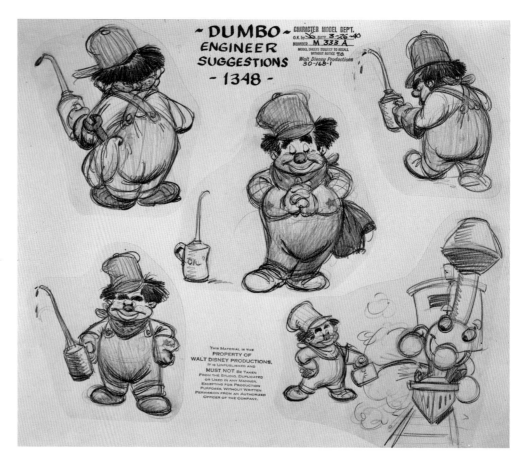

Ward Kimball with a maquette of Casey Jr., and (right) the Original Casey Jr. engineer concepts bearing a striking resemblance to Kimball.

INSIDE TRACK: *Casey Jr. is named after the legendary railroad engineer Casey Jones who died in a head-on collision with another train. Staying at the locomotive's throttle until the very end, Casey was able to reduce the speed of his steam engine long enough to avoid any other fatalities on either train. As a ship's captain goes down with his ship, so to did this brave railroad engineer who went down with his train, so to speak.*

When Casey Jr. departs from Florida, the winter headquarters of the circus in Dumbo, *if you look closely there is a small sign to the right of the train that reads* WDP Circus. *WDP are the initials for Walt Disney Productions.*

The Casey Jr. Circus Train ride is one of the original attractions still in operation at Disneyland; there is also an updated version of the ride in Disneyland Paris.

In a bug's life, *the circus wagons that make up P. T. Flea's Circus caravan are actually empty boxes of Casey Jr. Cookies.*

Three months before Dumbo *was released, Walt Disney Productions premiered another film,* The Reluctant Dragon. *Part live action, part animation, the film centers on humorist Robert Benchley visiting the Walt Disney Studios in search of Walt Disney to pitch his new idea for an animated film. His travels take the audience through the animation process. It is at the sound effects department, known then as the Foley studio, that we first encounter an early version of Casey Jr. We see how Casey's distinctive chuffs and puffs are created along with sounds for a thunderstorm and a bridge collapse. The real fun, however, is learning how Casey Jr. gets his distinctive voice courtesy of a "sonovox" machine.*

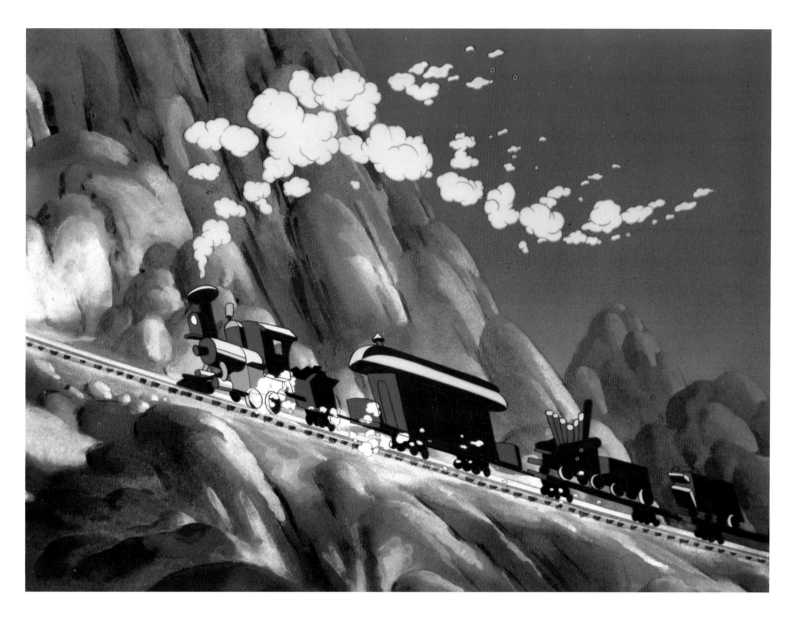

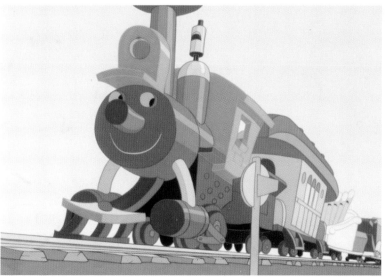

Above: Casey Jr. strains
"I think I can, I think I can."
Left: Close-up of Casey Jr.
using the headlamp as an
engineer's cap is classic
Ward Kimball design.

The sonovox device consisted of two loudspeakers placed on either side of the throat. An actor simply needed to whisper the words and the speakers would emulate the voice box adjusted either high or low to create a kind of mechanical sound. When used with a musical instrument, it sounds like the instrument is forming words and singing. The recording artist Peter Frampton would use an advanced example of the sonovox machine to emulate the sound of his guitar singing in "Do You Feel Like We Do" off his Frampton Comes Alive! album (1976).

In 2012 Walt Disney World added a whimsical water-play area in the Magic Kingdom called Casey Jr. Splash 'N' Soak Station. The play area has a turntable for locomotives where Casey Jr.

and his boxcars soak and spray guests. The numbers on the colorful train cars correspond to the year that each Walt Disney World park opened: 71 (The Magic Kingdom), 82 (Epcot), 89 (Disney's Hollywood Studios), and 98 (Animal Kingdom).

One of the steam locomotives on the Disneyland Railroad is named after Ward Kimball. It is Engine 5, and if you look carefully at the locomotive's headlamp, you will see a small silhouette of Jiminy Cricket, arguably one of Ward's most recognizable creations. Interestingly the number 5 also refers to Ward's love of Jazz. A competent jazz trombonist in his own right, Ward was a founding member of the Disneyland favorite, the Firehouse Five Plus Two. This hidden reference to 5 can also be seen in the Casey Jr. Splash 'N' Soak Station at Walt Disney World. If you look carefully at the clowns painted onto the side of car No. 82, you will see that they are wearing fire helmets emblazed with the number "5"; the center clown also bears a striking resemblance to Ward Kimball.

In 1954 Ward appeared as a contestant on the TV show You Bet Your Life, hosted by Groucho Marx. When Groucho innocently asked if Ward had any hobbies, the subject of the backyard railroad immediately came up and the two began to banter back and forth as if they had known each other for years. When Groucho finally got back to the game, one of the random questions asked was about a Disney film that included such characters as Figaro, Stromboli, and Ward's own creation, Jiminy Cricket. Once Groucho realized the absurdity of the situation, he smiled at Ward and said, "Oh you dirty crook."

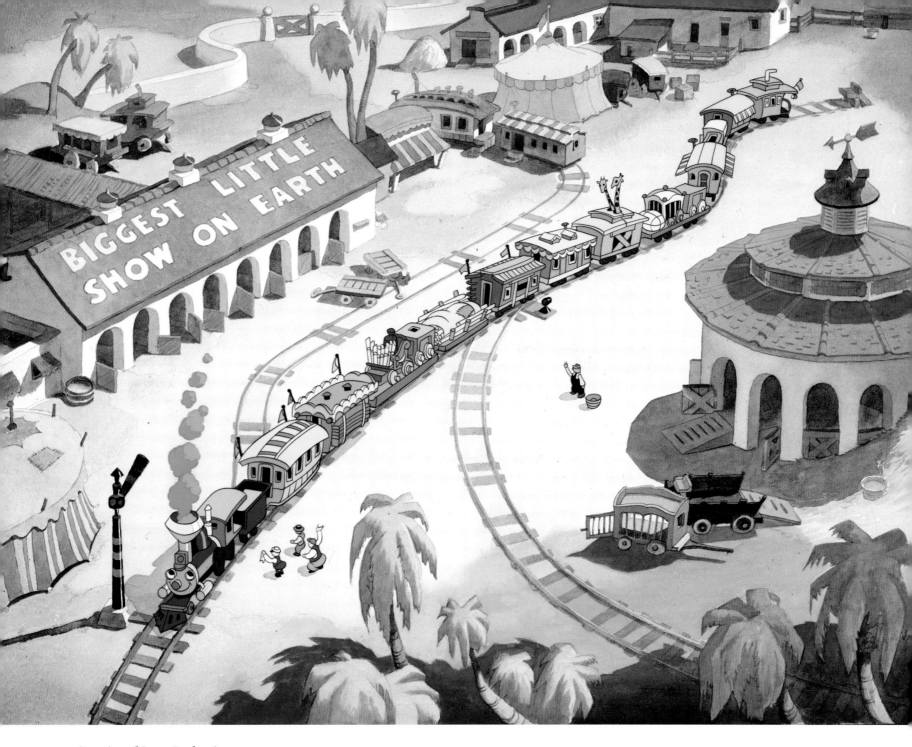

Overview of Casey Jr. showing Ward Kimball's clear love for his subject matter. Opposite: Detail from Casey Jr. Splash 'N' Soak Station with Ward Kimball featured on the side of car No. 82.

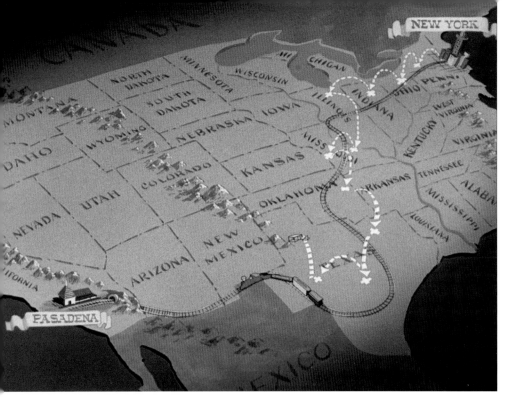

Left and below: Film captures from Victory Through Air Power.

VICTORY THROUGH AIR POWER

1943

This feature, which heralded the birth of Disney's full foray into educational films, was actually the brainchild of Walt's himself.

The year was 1942 and Hitler's Third Reich was at the height of its power; it was a dark time for the world. America had just entered the war and

Walt Disney was engrossed in a new book, *Victory Through Air Power* by Major Alexander P. de Seversky. The book, which emphasized the importance of aircraft in warfare, so impressed Disney that he actually financed the film himself. A compilation of live action and animation, the feature artfully combines visual storytelling with de Seversky's theories to deliver a deadly serious message.

Of course Walt being Walt, the temptation to get a train into a film about airpower must have been too great to resist. So in a particularly light sequence dealing with the first transcontinental flight, Disney reminds the viewer that a steam train carrying spare parts accompanied the aircraft. In a series of sixty-nine short hops (and fifteen crashes), we see the flimsy airplane bang, crack, bump, and thud its way across the country as the little steam loco smoothly and faithfully leads the way.

INSIDE TRACK: *The film not only impressed the public, but military and world leaders as well. One of the biggest supporters was none other than British prime minister Winston Churchill himself. Churchill was so moved by the film that he arranged a private viewing for President Roosevelt during their 1943 Quebec Conference. FDR was so influenced by the film's message that he made a commitment to long-range bombing, a decision that helped turn the tide and perhaps end the war sooner than expected.*

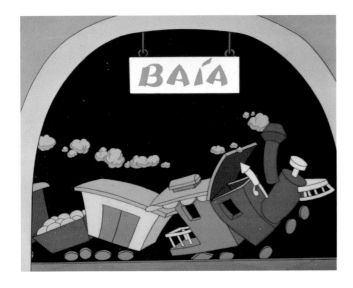

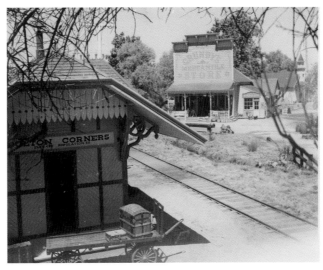

THE THREE CABALLEROS
1944

In the segment entitled "Baia," a colorful little South American train literally steams off the pages of a child's pop-up book to take Donald and his friend (a Brazilian cigar-chomping parrot named a José Carioca) on a whimsical flight of fancy through the Brazilian countryside.

This wonderful segment really allowed the animators to flex their creative muscles with colors and movement bouncing by in perfect samba rhythm of the syncopated guitar and flute beat. For many it is the highlight of the film and hints of more daring animations to come.

INSIDE TRACK: *The Three Caballeros can still be seen performing at the Grand Fiesta Tour Starring The Three Caballeros at the Mexico Pavilion at Walt Disney World's Epcot.*

SO DEAR TO MY HEART
1948

So Dear to My Heart is a heartwarming film about a farm boy growing up in rural Indiana. He adopts an outcast black lamb and learns a valuable lesson about life and love. This was the Disney Studio's first foray into a full-length, non-animated feature film, and Walt took great interest in the project. *So Dear to My Heart* eventually became a personal favorite of Walt's, and the connections between the fictional town of Fulton Corners, Indiana, and Marceline, Missouri, are hard to miss.

When asked about the project, Walt reminisced, "*So Dear* was especially close to me. Why, that's the life my brother and I grew up with as kids out in Missouri."

The opening scene depicts a steam train chugging into town to deliver a prize-winning racehorse, though it's not the story of the locomotive that is so relevant to this movie, but the little train station. One of the more charming back lot stories, known to only a few people, centers on the depot. It was common knowledge that whenever Walt needed anything railroad related, be it designs, information, memorabilia, or even music, he would always turn to one of his most reliable animators and trusted friends, Ward Kimball.

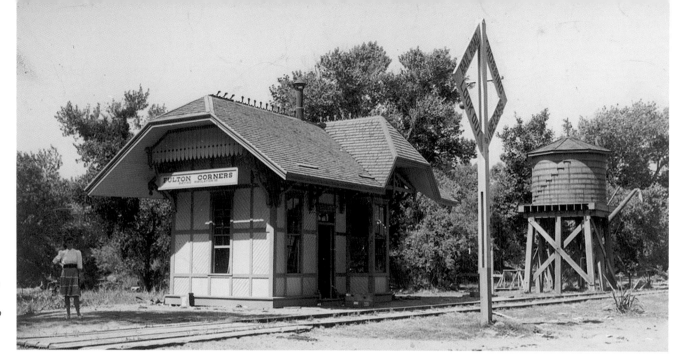

Although highly detailed, the Fulton Corners station was purely a prop and had practically no screen time.

It was Ward, along with Ollie Johnston, who really reignited Walt's passion for railroading.

Ward's job was to find a suitable railway station for the little town of Fulton Corners. He reached for an old volume of *Buildings and Structures of American Railroads* by Walter G. Berg. The book was printed in 1893 and was a trove of detailed illustrations of every train station, freight house, engine shed, signal tower, and yard office. After some review he presented Walt with a stylish illustration of a little flag depot built along the Pottsville branch of the Lehigh Valley Railroad in Pennsylvania.

The design was perfect; a flag depot signified a station supporting a very small community or industry located so far off the beaten path that it was not on a regular train schedule. In those days the station clerk would literally hang a flag off the station to signal the train to stop. This was the look Walt was after, and the set designers began to construct a replica of the little depot on location.

While the Fulton Corners station was quaint, it certainly wasn't functional. It was a movie prop, destined to be torn down after filming was complete. The only image of the station that even made it into the movie is a split-second glimpse through an open door. In reality, it wasn't even a complete structure; though detailed on the three sides, the fourth wall was simply left off.

One day toward the end of filming, Walt turned to Ward and said, "You need a train station for Grizzly Flats." All Ward had constructed was a small watchman's shanty. Walt continued, "Why don't you take the Fulton Corners station when we are finished here?" That was all Ward needed to hear and immediately set to work staking out a location and pouring concrete for the depot in his backyard.

True to his word, the day after filming wrapped, Walt had the tiny station taken apart piece by piece and a Studio truck delivered the entire structure to Ward's home. For the next six months, as Ward would later put it, "we beat, sweated, and swore the pieces into place."

Several years later, when Disneyland was under construction, Walt thought it would be a nice touch to have the former Fulton Corners station, now the Grizzly Flats station, reside in Frontierland. Anticipating the type of reception he might receive if he asked Ward for the station back, Walt opted to send the head of the Studio's machine shop and fellow railroad enthusiast Roger Broggie over to Ward's house to do the dirty work. "You can tell Walt to get his own damn train station . . .

Indian giver," the feisty Ward adamantly replied. He had simply invested too much time, money, and energy to simply hand the depot over, even when the request came from his boss.

In the end, Walt had his Imagineers go back to the original 1893 plans for the Pottsville Depot, but opted to mirror the front and back so that a bay window could be added to both sides. He also had the main doors made double-wide to accommodate wheelchairs. This second version of Ward's station, originally called the Frontierland station, still exists across the tracks as the New Orleans Square station.

Publicity photo of the Fulton Corners station crew.

INSIDE TRACK: *In addition to the lure of railroading,* So Dear to My Heart *also inspired another passion of Walt's—the design, construction, and furnishing of miniature rooms. He first encountered the hobby in 1939 while at the Golden Gate International Exposition. There he was able to observe firsthand the miniature rooms of Mrs. James Ward Thorne and became an avid fan of hers. (Sixty-eight of Mrs. Thorne's miniature rooms depicting interiors from the seventeenth century to the 1930s can still be seen today at the Art Institute of Chicago.) As with many of his hobbies, Walt threw himself into the work and was soon scouring all of Europe for miniature items. What he couldn't find, he constructed. The first scene he completed was inspired by an actual location from* So Dear to My Heart, *Granny Kincaid's cabin, complete with a hand-braided rug, a guitar with strings no larger than a mouse's whisker, and an ornate stone fireplace with pebbles Walt hand-collected while on vacation in Palm Springs, California.*

In reference to his new hobby, Walt would later write, "My hobby is a lifesaver. When I work with these small objects, I become so absorbed that the cares of the studio fade away . . . at least for a time . . ."

Walt continued building miniature dioramas and eventually decided that his collection should go on a national tour. He conceived a moving exhibit transported by a twenty-one-car train that traveled the country, allowing children and families to enjoy his exhibition without having to pay for a costly vacation. The project's name was coined by Walt himself: Disneylandia.

The idea of the exhibit was eventually scrapped due to conflicting railroad schedules and time constraints. This was in addition to Walt's very real concerns regarding the safety of small children crossing dangerous railroad yards to access his traveling exhibit. So Disneylandia in its original form never happened. What Walt couldn't imagine at the time was that the concept he initially envisioned would not fade away, but instead grow into something else entirely. Something magical.

While Walt intended So Dear to My Heart *to be his first all live-action feature, the film's distributer, RKO Pictures, thought that the public would be confused and might be hesitant to purchase tickets to a Disney film without animation. So at the last minute they convinced Walt to add an animated narration. Walt explains it best: "I saw the cartoon characters as figments of a small boy's imagination, and I think they were justified."*

THE ADVENTURES OF ICHABOD AND MR. TOAD
1949

Disney trains make a brief, but albeit memorable, appearance in "The Wind in the Willows," the first segment of this two-feature film.

The master of Toad Hall, J. Thaddeus Toad, better known as "Mr. Toad," has an absolute mania for all things mechanical that will carry him to exciting adventures in far-off locales. Most recently he's been taken with a newfangled motor car that will eventually cause him to lose the deed to Toad Hall and end up in jail on Christmas Eve.

But fear not; disguised as a washerwoman and aided by his faithful horse, Cyril, Mr. Toad breaks out of prison and makes his way onto an idling steam train. The sheer joy that comes over Mr. Toad the moment he first sneaks on board the small English locomotive and speeds off down the tracks is apparent. He fiddles with every lever and gauge, pulls the whistle cord, peeks into the glowing firebox, flings handfuls of coal into the fire, and takes a deep, heady breath of steam. All this is actually happening while Mr. Toad is ambivalently dodging the ricocheting bullets from the pursuing constables virtually clinging to every available surface of their own steam engine in what is a tip of the hat to the Keystone Kops comedies.

Toad eventually makes it to safety, gets the deed to Toad Hall back, and learns his lesson . . . well almost, as we do see him flying off in a newfangled airplane at the end of the film.

INSIDE TRACK: *Toad's wild abandon and childlike exuberance should not be lost on the insightful viewer. This is Walt, Ward Kimball (who actually animated the tiny locomotives for the film), Ollie Johnston, and all of the other "foamers" that shared Walt's passion for railroading.*

The term foamer *is actually a railroad expression for a die-hard steam train fan—someone who literally will foam at the mouth when encountering a steam locomotive.*

THE BRAVE ENGINEER

1950

On April 29, 1900, engineer John Luther "Casey" Jones, along with his fireman, Simeon "Sim" Webb, fired up Illinois Central Engine No. 382 ("The Cannonball Express"), which was on route from Memphis, Tennessee, to Canton, Mississippi. Due to a late start and nasty weather, they were more than an hour off schedule and had to make up time. Running fast through a moonless night which was accompanied by heavy rain, Casey failed to notice a flagman by the tracks sent to warn him of a stalled freight train ahead. When his locomotive's headlamp finally caught the running lights of the stalled freight's caboose, Casey slammed on the air brakes, applied sand to the rails, and threw the Johnson bar into reverse.

Sim, realizing the situation was hopeless, begged Casey to jump, but Casey refused telling Sim to "join the birds." As Sim leaped from the cab, Casey remained at the throttle, slowing the train down from about seventy-five to thirty-five miles an hour.

Casey was the only one killed when the "Cannonball" slammed into the freight. His friend Wallace Saunders, an African American engine wiper, penned a ballad describing Casey's heroics soon after the incident, and Casey Jones became the stuff of American folklore overnight and the most famous train engineer of all time.

As a youth in Marceline, Missouri, Walt had often heard his Uncle Mike repeat the tale of Casey Jones, so he knew the story well. The passion that Walt felt for all things railroad is brought to life throughout the short. Having just constructed his own backyard railroad, the Carolwood Pacific, at his home in the Holmby Hills section of Los Angeles, Walt would have been even more attentive to detail than normal. The animators were keenly aware of this and their skillful compositions are meticulous. From the levers in the switch tower to the realistic locomotive interior, everyone associated with the short realized that Walt was paying close attention.

This attention to detail is not only shared by Walt and the short's creative team but by the animated character of Casey himself. As the engine steams along, for example, we see Casey comfortably sitting in his rocking chair, feet up on his firebox grill, as he slowly and meticulously selects, dusts, and inspects each individual piece

Concept art from The Brave Engineer.

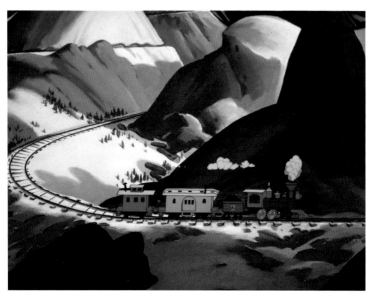

Film and production concepts for The Brave Engineer. *Note the detail of the classification yard (upper left).*

of coal before tossing it into the fire, or discarding one subpar piece because it is "too ripe."

This bit of business is not too far off the mark when discussing the level of detail Walt Disney insisted upon. During the construction of the Disneyland Railroad, entire sections of ballast were removed and replaced because the crushed stones were not the proper scale for the narrow-gauge locomotives.

INSIDE TRACK: *On the switch master's call-board below Casey's name are two others:* SHAW, *for Dick Shaw, who was one of the story's writers, and famed Disney train aficionado* W. KIMBALL, *who animated Casey Jr. for* Dumbo.

In one scene Casey is shown emerging from a tunnel at breakneck speed passing a switch stand. This exact same scene is copied frame by frame in two other Disney shorts involving steam trains:

Concept art for The Brave Engineer.

A Cowboy Needs a Horse *and* Out of Scale.

There's also a scene when Casey rescues the damsel in distress, who's tied to the railroad tracks. He then deposits her in the stationmaster's arms with the comment, "What do you know, sh-email!"—an obvious play on a word for "female" in 1950; with the advent of the Internet, it takes on a whole new meaning today.

Jerry Colonna, the narrator for the story, uses the word egad *no fewer than ten different times. Colonna's skill for stretching out every syllable to its maximum potential is best exemplified in the short and truly ties the piece together.*

Half a century later, the legend of Casey Jones keeps popping up at Disney; most recently it was conjured up in the TV series Aladdin, *where the Genie shape-shifts into the brave engineer.*

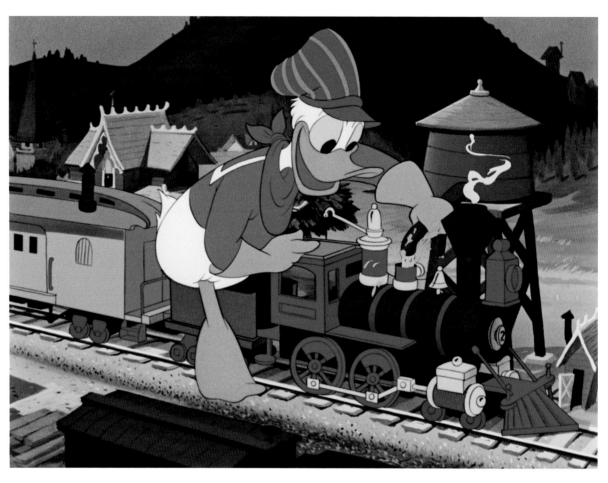

Donald aboard his backyard railroad, from Out of Scale.

OUT OF SCALE
1951

In this engaging short, we find Donald Duck as an avid backyard railroad fan obsessed with keeping everything "in scale" on his train layout. When he initially tries to uproot the tree where Chip and Dale have been storing their walnuts, trouble begins.

The film was inspired by Walt's own adventures in backyard railroading, leading him to comment, "With so many of us interested in model trains, it wasn't too much of a surprise when our story department came up with a cartoon idea about the hobby."

Storyboard concept of Donald's backyard railroad; note the wooden trestle.

INSIDE TRACK: *Donald's miniature locomotive is an exact replica of the engine used in 1950's animated short* The Brave Engineer. *The engine's number is 2, the cab is red, and the coal tender green. In addition, the wheel arrangement, smokestack, and domes are all the same as is the yellow combine car and red caboose. All are scaled-down versions of Casey Jones's train. Even the opening shot of* Out of Scale *is an homage to* The Brave Engineer *with Donald's diminutive locomotive roaring out of a tunnel in an exact frame-by-frame replication of the preceding year's film. Only the numeral on the switch stand is different.*

The layout of Donald's backyard railroad features several iconic features of Disney's own backyard railway, including a tunnel, a forty-six-foot-long trestle, and his red barn.

The short is one of the only times that Donald reaches a compromise with Chip and Dale, allowing their large tree to remain on the railroad. This is reminiscent of Walt's own compromise with his wife, Lillian. While Lillian supported her husband's backyard hobby, the intended destruction of her prized flower beds to make room for Walt's proposed railroad route behind the house was where she drew the line. Walt's compromise was to dig a ninety-foot-long s-shaped tunnel beneath her azaleas.

PIGS IS PIGS
1954

This popular Disney short is a retelling of a turn-of-the-century children's book of the same name. The story line is a simple one, involving a station agent (Flannery) who gets into a heated debate with a customer over the shipping charge for guinea pigs. If the live shipment is classified as pets, it's 44 cents; as pigs it's 48 cents.

To resolve the debate, Flannery sends a wire to railroad headquarters, where the question is shunted from department to department and debated and analyzed in the every-increasing corporate bureaucracy. While all this is going on, the two guinea pigs begin to procreate and grow in numbers (use your imagination): soon the Westcote railway depot is being overrun by the little critters.

Directed by Jack Kinney, the whimsical feature, whose bright colors and stylized animation is reminiscent of his work on the "Baia" train sequence in *The Three Caballeros*, is perfectly blended with a catchy Irish jig. With a running time of just under ten minutes, the melody, provided by Thurl Ravenscroft's Mello Men, has a lot of information to provide in a small amount of time. Yet, as in their treatment of *The Brave Engineer*, every word is clearly understood as the story keeps moving forward without ever becoming frantic.

INSIDE TRACK: *Ward Kimball's Grizzly Flats Railroad Depot served as the inspiration for the Westcote train station featured in the short. In turn, the animated railway station would go on to serve as the inspiration for the Fantasyland station in Hong Kong Disneyland.*

Toward the end of the flick, when the guinea pigs' procreation tendencies actually begin to engulf corporate headquarters, several railroad executives tender their resignation. The signatures at the bottom of the notice are J. K. and B. B., the initials of the short's director, Jack Kinney, and story man Bill Berg.

Thurl Ravenscroft is best known to current-day readers as the voice of Tony the Tiger, the spokes-character for Kellogg's Frosted Flakes.

Thirteen years after Pigs Is Pigs *was released, screenwriter David Gerrold, working with Gene Roddenberry on the original* Star Trek *series,*

In contrast to the painstakingly realistic depictions of everyday objects featured in earlier Disney shorts, Pigs Is Pigs *is animated in the UPA style of limited detail.*

would be inspired by the Disney short to create one of the best-loved episodes in the TV series. Titled "The Trouble with Tribbles," the episode features Captain James Kirk dealing with an ever-increasing population of soft, fluffy guinea pig-like aliens that, as Dr. Leonard "Bones" McCoy puts it, "Reproduce at will, and brother have they got a lot of will."

ALL ABOARD

LADY AND THE TRAMP
1955

It has been suggested that the fictional rural town where both Lady and Tramp reside was inspired by Walt's hometown of Marceline, Missouri. When we first meet Lady we find her safely ensconced in a quaint, well-appointed Victorian home off Main Street. Tramp, in contrast, lives in the local railroad yard. Complete with water tower, shacks, and sidings, this type of railway composition mirrors Marceline's own railroad yard for the Atchison, Topeka and Santa Fe.

INSIDE TRACK: *The small watchman's shanty seen next to the boxcar may have been influenced by a small railroad structure that Ward Kimball designed for his own Grizzly Flats outdoor railroad. Ward was originally involved with the animation of the Siamese cats for the film, but the task was eventually reassigned to other animators; the reason cited was that Ward's cats were a bit too "zany" for the animation style.*

A COWBOY NEEDS A HORSE
1956

With its distinctive animation and story line, the short *A Cowboy Needs a Horse* runs less than seven minutes, yet still captures the innocence of America in the mid-1950s. Boys at this time were obsessed with Davy Crockett, the wild west, and living the cowboy life.

The whimsical piece focuses on a young boy as he peacefully dreams in his bedroom, which is perched on the top floor of a high-rise apartment. The title song, "A Cowboy Needs a Horse," begins to play at this point. The distinctive clip-clop cadence of this gentle lullaby makes the animated short so memorable for most baby boomers. As our hero begins his journey through a classic Western setting, he encounters every possible situation a real cowboy, or rather what a *real* cowboy in the mind of a five-year-old, would encounter.

He fights off a Native American attack, then makes peace with the chief. He next captures a bandit who has just robbed a stagecoach but, true to the cowboy way, won't accept the reward money. Then he rescues a damsel in distress from the villain but will not accept a kiss from her, opting instead to accept one from his horse, and finally he saves a steam train from careening off a trestle.

INSIDE TRACK: *The clip of the steam train exiting the tunnel and rushing around the bend is a frame-by-frame tribute to the same scene in* The Brave Engineer. *The only difference is that the locomotive's number has been changed. It will not be the last time this image will be re-created as a hidden tribute to Walt's love of trains.*

The damaged trestle threatening to collapse as the speeding locomotive approaches and begins crossing is a constant theme running through many Disney films. From Dumbo *to* The Lone Ranger, *the lesson learned here is that if you are traveling by a train in a Disney film, avoid trestles.*

At the height of the Davy Crockett craze, still running strong when this short ran, approximately five thousand coonskin caps were being sold each day.

Above and left: Comparison study between Out of Scale *and* A Cowboy Needs a Horse; *the same iconic image is repeated in* The Brave Engineer *as well.*

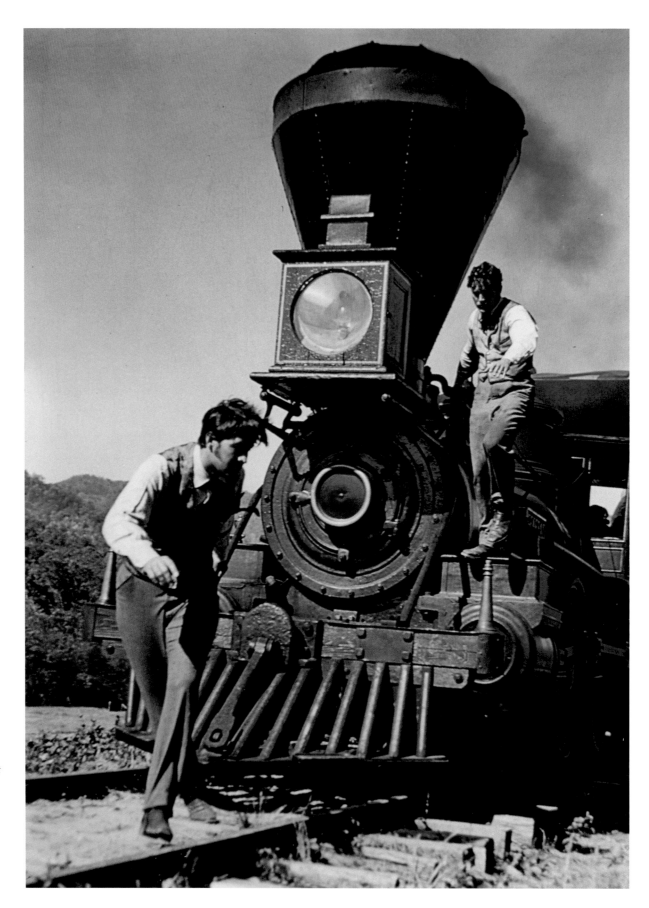

Fess Parker leaps in front of The General, *actually the Baltimore and Ohio's No. 25*, The William Mason. *The same locomotive would be featured in the 1999 film* The Wild, Wild West.

All of the steam engines featured in The Great Locomotive Chase *were functional. They required only minor modifications to replicate the engines of the Civil War era.*

THE GREAT LOCOMOTIVE CHASE
1956

Disney's *The Great Locomotive Chase* is actually based on the real-life exploits of James J. Andrews, a Union spy who, along with twenty Union soldiers in disguise, infiltrated Confederate territory and hijacked a locomotive called the *General*. Andrews and his raiders were able to initially steal the *General* out from under the engineer's nose as he and his crew where having breakfast in the train depot. Andrews's plan was simple—he would make a run for Chattanooga, Tennessee, away from Confederate territory, all the while burning bridges, tearing up track, cutting telegraph lines, and sabotaging the rebel war effort as best he could.

The *General*'s engineer, William A. Fuller, along with his train crew, doggedly gave chase, first on foot, then on a push car, a small switch engine, and eventually in a large locomotive named the *Texas*, which had to be run in reverse! After an eight-hour chase, Fuller caught up with his beloved locomotive, which had been abandoned when it ran out of fuel.

Walt was very familiar with the tale, first told to him by his Uncle Mike back in Marceline, Missouri, and had wanted to bring this exciting story to film. Walt insisted that every aspect of the film be as historically accurate as possible, and the designers took great pains to ensure that the engines

and rolling stock accurately reflected the technology and surroundings of the Civil War era.

Disney also made sure that there was some real star power cast for the film. Fess Parker, direct from Disney's highly successful "Davy Crockett" television series (which had been airing on his ABC *Disneyland* show), would portray James Andrews and Jeffrey Hunter, fresh from his breakout role costarring opposite John Wayne in *The Searchers*, portrayed William A. Fuller.

INSIDE TRACK: *Although Disney used a retired Baltimore and Ohio locomotive to portray the* General, *the original hijacked steam engine is still in existence today. Lovingly restored, the* General *is housed in a museum in Kennesaw, Georgia, along with a collection of vintage posters and memorabilia from the film. The original* Texas *locomotive survives as well and is on display in the Atlanta Cyclorama.*

The Walt Disney Company was not the first motion picture company to bring the story of The Great Locomotive Chase *to life. Thirty years earlier, in 1926, Buster Keaton produced, directed, and starred in the silent film classic* The General. *Considered by many to be the greatest film of the silent era, Walt was just twenty-six when the film*

ALL ABOARD

Engineer (Slim Pickens) and his apprentice (played by Douglas Blecky). Blecky, a native of Clayton, Georgia, was discovered by the director in a lunchroom where the cast and crew ate. Opposite: Moveable smokestack prop on the set of The Great Locomotive Chase.

was released. One can only speculate if the young animator/producer took a break from filming Trolley Troubles *to check out Keaton's masterpiece, allowing himself to revel in two of his lifelong passions: motion pictures and trains.*

The American Civil War was the first military conflict in which railroads played a significant role. Trains could simply move men and material faster than ships or horses.

The actor playing the role of the engineer of the Texas *is none other than Slim Pickens, best known for his roles as the bomb-riding Air Force major in* Dr. Strangelove *and as Taggart in* Blazing Saddles. *This versatile actor appeared in several Disney films, including,* Tonka, *and* The Apple Dumpling Gang, *as well as provided the voice of the robot "B.O.B." in* The Black Hole. *In addition to these roles, Pickens made multiple appearances on* Walt Disney's Wonderful World of Color *in an array of programs. If you look closely, you'll see Slim's character frying bacon on his locomotive's firebox door in* The Great Locomotive Chase.

WALT AND THE TOYS FOR TOTS CAMPAIGN

The Walt Disney Company was one of the original sponsors of the Toys for Tots Campaign. Walt felt so strongly about the concept that in 1948, he personally designed the Toys for Tots red train logo, which is still in use today. In 1956, he also designed the first poster for the campaign: Donald Duck, dressed as Santa, riding Casey Jr.

Walt was a huge supporter of the Toys for Tots campaign and designed their first poster.

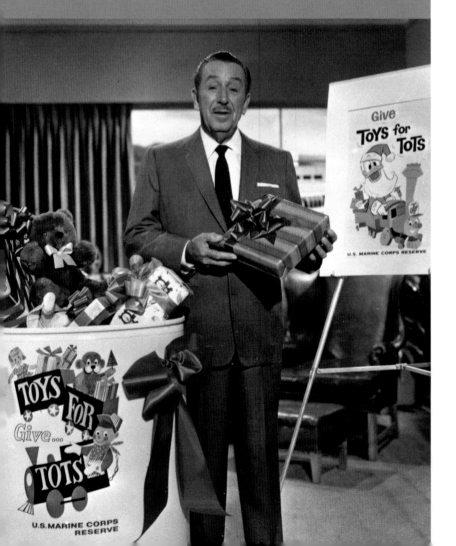

Film capture from Our Friend the Atom *showing a steam locomotive that's reminiscent of the Lilly Belle.*

OUR FRIEND THE ATOM
1957

This film, created for Walt's *Disneyland* television program, tells the story of atomic power in a simple, engaging way and provides a short history on various forms of power. The strength of the atoms found in uranium is compared to the power of a genie in the lamp from "The Fisherman and the Genie" fairy tale.

Toward the middle of the film, steam power is explained. Animation covers how an early steam flywheel functioned; then a paddle wheeler, and, of course, a steam train are shown in action. This steam locomotive looks very much like the *Lilly Belle*, the one-eighth-scale model locomotive that Walt built for use on his own Carolwood Pacific backyard railway.

INSIDE TRACK: *The* Disneyland *program was a prime-time television show that was later renamed* The Wonderful World of Disney, *(as well as several other names during its run). Its opening sequence features the Main Street station with Disneyland aglow behind it.*

PAUL BUNYAN

1958

Cast as the villain in this animated short, a steam train plays an important role in the story line. The scene is a competition between man and machine. Paul Bunyan and his blue ox, Babe, are pitted against city slicker Joe Muffaw and his steam-powered saw and newfangled locomotive. While Paul competes against the saw, Babe competes against the steam engine in a timber-pulling contest. In the end, machine triumphs and Paul and Babe head north into American folk legend.

INSIDE TRACK: *The type of steam locomotive shown competing against Babe is called a Forney. Lumber companies favored the small Forneys because of their compact design and ability to navigate the tight curves of a railroad built among the tall timber.*

Disneyland Railroad's engines No. 3 Fred Gurley and No. 5 Ward Kimball are both Forney locomotives, the only ones of their kind in any of the Disney theme parks.

Babe, the Blue Ox stands off against encroaching modern technology.

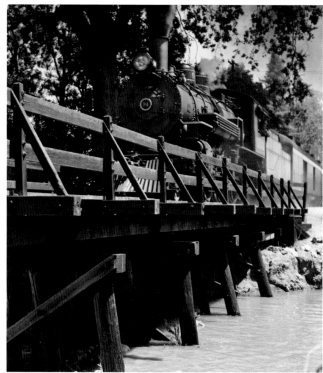

POLLYANNA

1960

Above and opposite page: Film captures from Pollyanna.

Pollyanna is one of those films produced by the Disney Studio that would truly touch Walt's heart. Set in the fictional town of Harrington, Vermont, it's fairly simple to make the connection to Disney's hometown of Marceline, Missouri. The film had such an emotional effect on Walt that the film's director, David Swift, actually witnessed Walt "cry unashamedly when he viewed the rough cut version of the film."

Keeping with the small-town feel of the movie, a steam train would be required. The train chosen was a small commuter train harkening back to Walt's original job on the Missouri Pacific. It consisted of an elegant observation car, a few passenger coaches, and, of course, a combine.

INSIDE TRACK: *The steam locomotive featured in the film, the No. 94, is still in existence today.*

Built in 1909 for the Western Pacific Railroad, it served as the first official locomotive to open the line. And it is currently housed at the Western Pacific Railroad Museum in Portola, California.

The observation car is also still in existence today, but it is housed at the California State Railroad Museum in Sacramento. This car has a unique history of its own, having once served as the private car of historian and bon vivant Lucius Beebe and his partner, Charles Clegg.

The Harrington, Vermont, railway train station depicted in the film was actually the St. Helena train station in Napa County, California. Served by the Southern Pacific's Calistoga branch, the rail route used in the film is still in service today as part of the Napa Valley Wine Train. The small station, though now abandoned, is still in its original locale.

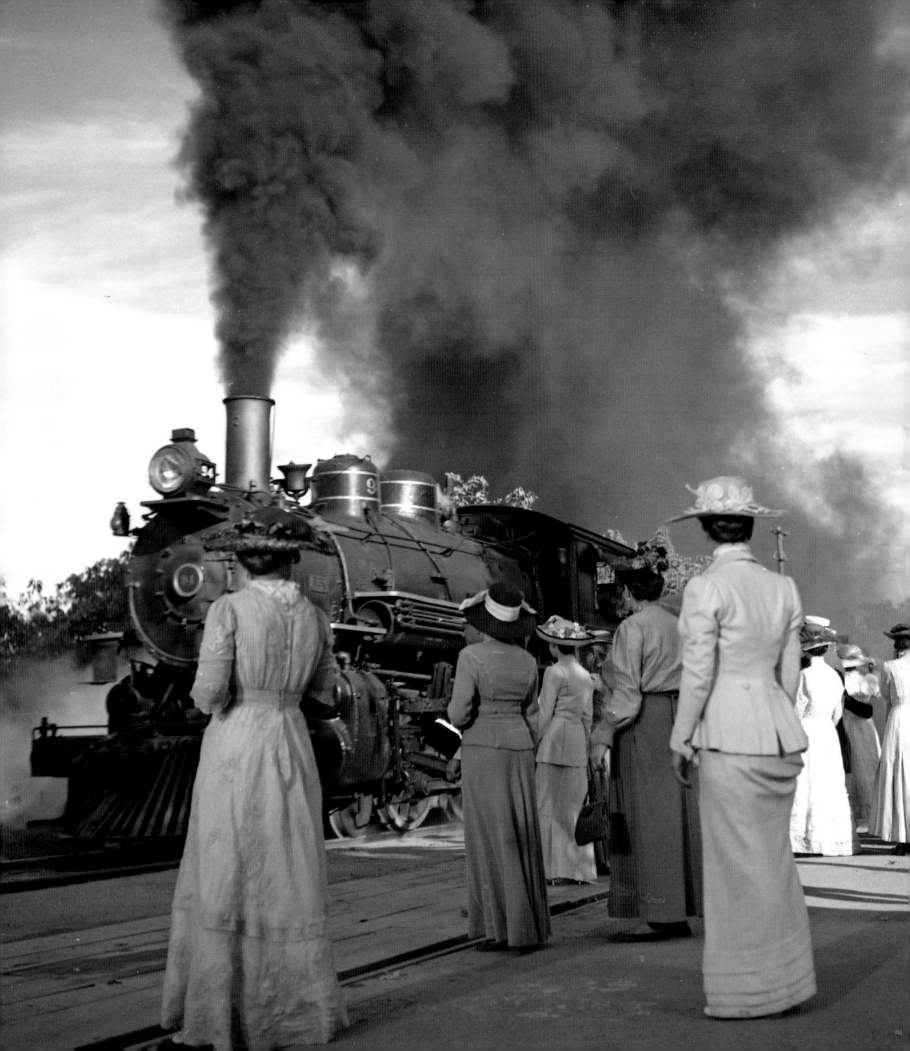

DONALD AND THE WHEEL
1961

In this educational short, the spirits of progress, voiced by Thurl Ravenscroft and Max Smith try to coax a reluctant Donald Duck into inventing the wheel. Starting with early man, we are taken on a journey explaining how wheels advanced technology at a rapid pace. The highlight of the film for rail buffs is when the steam engine is introduced. Quite a bit of screen time is spent on the development of steam trains, with two locomotives featured: *Stephenson's Rocket* and the *Virginia & Truckee* American type—each of which is drawn with particular attention to detail.

INSIDE TRACK: *The* Virginia & Truckee *steam locomotive has the same wheel configuration and paint scheme as Walt Disney's one-eighth-scale working steam locomotive the* Lilly Belle, *which was named after his wife, Lillian. That train ran on his backyard railroad, the Carolwood Pacific.*

If you look carefully at the railroad cars that are pulled by Donald's locomotive, you will find

Donald engineering Robert Stephenson's Rocket.

a combine car. This is the same type of railroad car that Walt Disney spent most of his time in while working as a news butcher. The fact that it is painted yellow also suggests that it is the property of the Santa Fe railroad. Besides being Walt's favorite railroad line, it was also the only railway company to sponsor the Disneyland Railroad.

Robert Stephenson built his steam engine Rocket *in 1829. While it was not the first steam locomotive ever built, its design was the basis of all locomotives for the next 150 years. Stephenson's* Rocket *was depicted on the posters promoting the 1948 Chicago Railroad Fair. Attended by Walt and animator Ward Kimball, the fair served as inspiration for Walt to create Disneyland.*

Stephenson is also the name of the high-speed spy train in Cars 2.

In addition to his role as the spirit of progress, Thurl Ravenscroft was a regular in the Disney Studios, lending his vocal talents to a wide spectrum of films and other projects. Beginning in 1941 with Dumbo, *where he sang "Pink Elephants on Parade," to 1997, when he re-created his role as Kirby in* The Brave Little Toaster to the Rescue, *Ravenscroft's voice has been featured in more than twenty films. His distinctive bass voice is also heard throughout Disneyland in a wide variety of attractions, including Pirates of the Caribbean and the Haunted Mansion, where his is the voice of one of the singing busts. Until recently he was also the narrator on the Disneyland Railroad.*

In addition to his Disney work, Ravenscroft also sang "You're a Mean One, Mr. Grinch." He was uncredited in the film, leading to the myth that Boris Karloff, who was the narrator, sang the song.

Left: Close-up of the Virginia and Truckee locomotive, looking very similar to the Lilly Belle.
Below: Photo of the Empire State Express, which was featured at the Chicago Railroad Fair. The locomotive was the first to break the one-hundred miles-per-hour barrier on May 10, 1893.

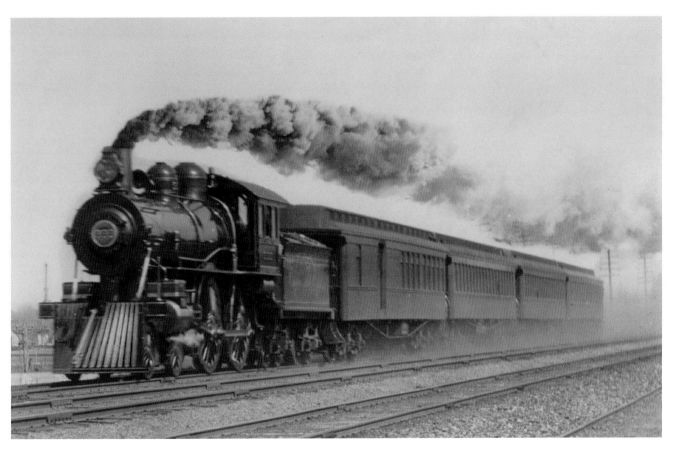

Film capture from The Aristocats.

ALL ABOARD

THE ARISTOCATS

1970

The story line follows the life of a glamorous feline named Duchess (voiced by Eva Gabor) along with her three adorable kittens Berlioz, Toulouse, and Marie. All live a pampered Parisian existence with their eccentric owner, Madame Bonfamille, who has recently decided to leave her entire estate to her beloved cats.

This does not sit well with her conniving butler Edgar, who doesn't particularly relish the thought of his golden years being dedicated to the care and feeding of felines. Edgar decides to rid himself of Duchess and her kittens once and for all and cat-naps the lot. But his dastardly plan goes astray and the furry family finds itself alone in the French countryside. Befriended by a stray cat named Thomas O'Malley (voiced by Phil Harris), the group sets off for home.

While following the railroad tracks back to Paris, the group must cross a river on a very high trestle. The kittens, enjoying this adventure, line up one behind the other and begin to mimic the movements of a train. Marie, much to her chagrin, serves as the caboose. As they are chuff-chuffing along, their tiny voices are overpowered by the sound of a very real French-style locomotive steaming toward them. But have no fear, Duchess and the kittens are able to escape with Thomas's help and inevitably make their way back home.

INSIDE TRACK *When Edgar, the villainous butler, rides his antiquated motorcycle with a sidecar, the distinctive "putt-putt, bang-bang" sound effect that emanates from his engine comes not from the automotive world but from the world of Disney trains.*

The banging, belching, stuttering engine noise is provided by a one-cylinder, two-cycle motor Fairmont rail speeder that was used to help build and inspect the rails at Disneyland. A kind of mechanical open-air jalopy, the speeder would ride along the rails with a small train crew. Walt gave the speeder to animator Ollie Johnston for his own backyard railroad, and it inevitably made its way to John Lasseter's backyard railway, where it is still in operation today.

Below left: Edgar the butler defies gravity.
Below: The kittens play train.

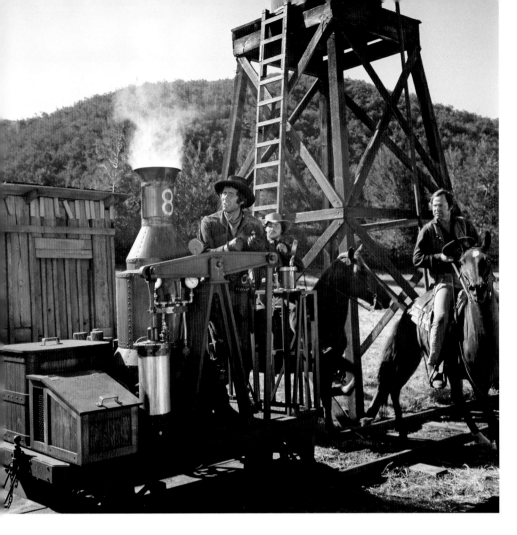

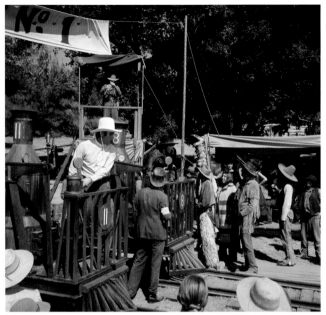

Left: Film captures from Hot Lead and Cold Feet.
The locomotives used in the film are reminiscent of the
Tom Thumb, *the first American-built steam locomotive.*

HOT LEAD AND COLD FEET
1978

This classic Western farce pitches two twin brothers against each other for control of the fictitious town of Bloodshy. One twin, "Wild Billy" Bloodshy, is a gunfighter, while the other, Eli Bloodshy, is a meek missionary; actor Jim Dale plays both twins. One of the highlights of the film is a frantic race between the brothers on four-wheeled steam-powered locomotives, referred to as "walking beam engines." These early steam engines differed from the classic images of steam locomotives as both their boilers and cylinders were mounted vertically as opposed to horizontally.

INSIDE TRACK: *The actual steam walking beam engines that Eli and "Wild Billy" used to* race against each other are still in existence. Both reside at the Big Thunder Mountain Railroad attraction at Disneyland. Eli's Steam walking beam engine is located along the queue to the attraction, while Wild Billy's resides along the Big Thunder Trail leading to Fantasyland.

The walking beam engines created for the film are actually based on a real locomotive called the Tom Thumb. *The engine was the brainchild of inventor Peter Cooper who, in 1830, proposed a race between his locomotive and a horse-drawn car to convince the owners of the newly formed Baltimore and Ohio Railroad to embrace the concept of steam travel. Due to technical difficulties, the horse ended up winning, Cooper, however, made his point and the* Tom Thumb *became the first locomotive built in America.*

When Walt Disney and Ward Kimball traveled to the Chicago Railroad Fair in 1948, they were able to view a working replica of the Tom Thumb. *Today this replica can still be seen at the B & O Railroad Museum.*

THE FOX AND THE HOUND
1981

The Fox and the Hound was the final film in which the initial character development was done by Disney's original animators, better known as the "Nine Old Men." Halfway through production, a new set of young animators was brought on to complete the movie. This freshman class was comprised of some of the best-known animators, directors, and producers in films today. Glen Keane, John Musker, Brad Bird, Tim Burton, and John Lasseter all first cut their Disney teeth on *The Fox and the Hound.*

The story line, loosely adapted from the 1967 novel of the same name, follows the friendship of Tod, a red fox, and Copper, a hound dog. As they grow older, the prejudices of the world begin to pull them apart, culminating in a chase scene across a railroad trestle where an oncoming locomotive injures Copper's mentor, Chief. Not to worry, however; the story does have a happy ending with the friends reunited.

INSIDE TRACK: *In an earlier version of the film, Chief actually dies when hit by the train. It was thought that this would justify Copper's revenge against Tod. But just as Trusty lives in* Lady and the Tramp *and Baloo survives in* The Jungle Book, *the scene was rewritten because it was deemed too intense for children.*

The Fox and the Hound *was the last film that animators Frank Thomas and Ollie Johnston worked on together.*

The Fox and the Hound *was the last film that animators Frank Thomas and Ollie Johnston worked on together. It would also be John Lasseter's first film as a Disney animator.*

THE JOURNEY OF
NATTY GANN

1985

In this movie set during the Depression, a tomboy named Natty escapes from her uncaring guardian and goes in search of her father, who is two thousand miles away searching for work. During her trek, she befriends a wolf that has been abused in dogfights. Together they travel the rails, hopping freight trains and eventually meeting up with Natty's father in a heartwarming conclusion.

Natty's K-9 costar was played by Jed, who was actually a cross between a wolf and Alaskan malamute. Jed also starred in Disney's White Fang.

INSIDE TRACK: *Although Natty is seen hopping a variety of steam trains as she crosses the country, only two locomotives were actually used: Canadian Pacific No. 3716 and No. 1077. Both steam engines had their numbers changed several times to reflect different trains. This was not the first time the locomotives shared screen time together however. They also appeared in the 1982 film* The Grey Fox *starring Richard Farnsworth as gentleman train robber Bill Miner.*

TOUGH GUYS

1986

Burt Lancaster and Kirk Douglas are considered by many to be two of Hollywood's most dynamic stars. They appeared in a total of seven films together; *Tough Guys* would be their final collaboration. The two Academy Award winners portray a pair of seniors in this Touchstone picture who have recently been released from prison after having each served thirty-year sentences for a train robbery.

After a vain attempt at adjusting to a society that has pretty much forgotten them and "progressed" far beyond what they recall, the two decide to team up one last time and do what they do best. They conceive a plan to rob the same train they held up back in the 1950s as it prepares for its final run.

The train used in this movie was the Southern Pacific *Daylight* SP 4449, a famous luxury train serving a mainline route between Los Angeles and San Francisco. With a distinctive black, silver, and orange paint livery, the SP 4449 is the only surviv-

ing example of the GS-4 class of steam locomotives still in operation.

In the movie, it appears that the *Daylight* is wrecked as the aging desperados crash the locomotive that's heading south (not toward the intended destination, San Francisco) past the border into Mexico. Although the train did travel toward Mexico on a long-abandoned railroad spur,

Above: The distinct colors of the Southern Pacific's Daylight. Left: Doyle L. McCormack, an actual engineer and chief mechanic of the locomotive.

A life-size model of the locomotive was created to simulate the aftermath of the crash at the climax of Tough Guys.

it never crashed. Models were used for the scene. When asked what their favorite scene in the film was, both actors quickly responded, "The train crashes of course!"

INSIDE TRACK: *As the police open fire on the steam locomotive, the officer in charge, played by veteran actor Charles Durning, says, "What is this, the gunfight at the O.K. Corral?" This is an inside joke, as the 1957 classic film* Gunfight at the O.K. Corral *was the first film that Burt Lancaster and Kirk Douglas starred in together, playing Wyatt Earp and Doc Holliday, respectively.*

During the scenes set in the steam engine's cab, Lancaster seems quite at ease behind the throttle of the locomotive. This would make sense, as twenty years earlier he starred in the black-and-white film classic The Train. *In this film, Burt did the majority of his own stunts and actually operated several steam trains.*

The locomotive used in the film, the SP 4449, also pulled the American Freedom Train *while it was touring the initial continental forty-eight states during America's Bicentennial celebration in 1975–76.*

The gentleman who portrayed the engineer of the flyer in Tough Guys *was not an actor but Doyle L. McCormack, the actual engineer and chief mechanic of the Southern Pacific 4449.*

The locomotive still survives along with ten of its coaches and can be viewed at the Oregon Rail Heritage Center in the city of Portland.

WHO FRAMED ROGER RABBIT
1988

This landmark film, which artfully combines animation with live action, was the first of its kind to receive four Academy Awards. It also combined animated characters not only from the Disney Studio, but also those from Warner Bros., Fleischer Studios, Universal Pictures, and Walter Lantz Productions.

One of the subplots in the film revolves around the dismantlement of Los Angeles's public streetcar system, referred to in the movie as the Red Car system. At the film's climax, we discover that the protagonist, Judge Doom, played by Christopher Lloyd, is actually behind a plot to rid the city of its distinctive streetcars in favor of a new system of freeways. This is actually a not-so-subtle reference to a historically based event referred to as the Great American Streetcar Scandal. The scandal, also known as the General Motors Streetcar Conspiracy, claimed that the oil, tire, trucking, and automotive industries conspired together to purchase and subsequently destroy electrically powered streetcar systems in all major cities across America.

When Eddie Valiant (Bob Hoskins) learns that Judge Doom, who we find is also the president of Cloverleaf Industries, is actually a toon himself with a plan to eradicate Toontown to make room for an on/off ramp, his reply speaks volumes: "That hare brained freeway idea could only be cooked up by a Toon."

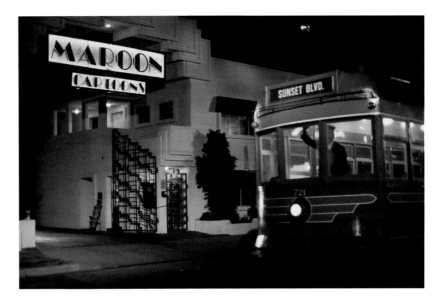

Right: Screen capture from Who Framed Roger Rabbit. Middle: Pacific Electric streetcar at Disney California Adventure Park. Bottom: Iconic image of Pacific Electric trolley cars stacked and awaiting demolition.

INSIDE TRACK: *As Judge Doom's Dipmobile makes its way into Toontown in order to dissolve the local inhabitants, a fast-moving cartoon express train slams into the contraption and destroys it. If you look closely at the passenger cars, various murder scenes are played out in each window.*

At the turn of the last century, the original Pacific Electric streetcar system, also known as the Red Car system, covered 1,100 miles of track. That's almost 25 percent more than New York City's current mass transit system.

Disney California Adventure Park has now returned the familiar red and yellow Pacific Electric streetcars to the streets of California.

One trolley is numbered 623. The 23 is in reference to 1923, the year that a young Walt Disney, with only $40 in his pocket, arrived in Hollywood. The 6 refers to the 600 series of streetcars that came out in the early 1920s.

Another trolley has the yellow wing design and is numbered 717, which represents the date that Disneyland first opened: July 17, 1955. The 7 also represents the 700 series constructed in 1955. Only a handful of American cities still have surviving streetcar systems, including Boston, Philadelphia, Pittsburgh, and San Francisco.

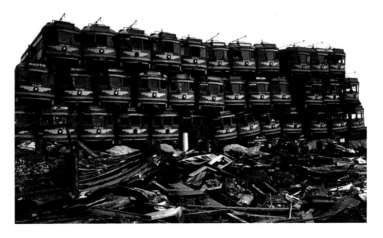

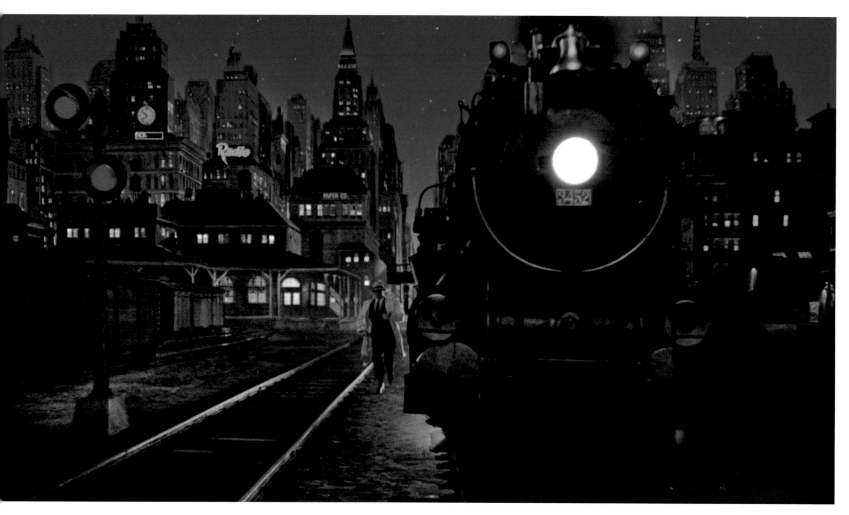

The heart-pumping railroad scene involving Kid from Dick Tracy.

DICK TRACY
1990

Dick Tracy is a live-action creation of the popular Chester Gould comic strip with Warren Beatty directing and starring in the leading role. With emphasis on primary and secondary colors—the film is almost entirely composed of red, blue, yellow, orange, green, purple, black, and white images—*Dick Tracy* takes the viewer to a completely new and original world where live-action footage blends seamlessly with meticulously painted matte backdrops of grand cityscapes.

Nowhere is this more exemplified than when Dick Tracy is chasing a young street urchin simply named Kid into the busy railroad yards of the city. In his determined effort to escape, Kid races a fast-moving steam locomotive, eventually cutting across its path. When the train finally passes, Kid is momentarily nowhere to be found.

This impressive scene was created almost entirely on a soundstage using only 150 feet of scale track along with a fifteen-inch gauge locomotive and passenger cars. The live actors were filmed separately and added into the scene later.

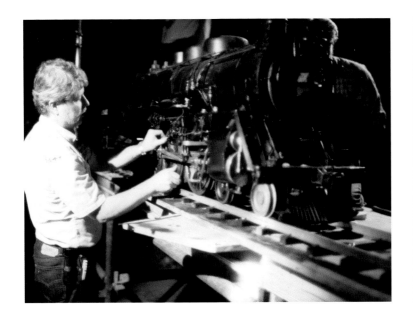

Special effects teams prepare the model locomotive for filming, which one sees in action (above) passing a Hidden Mickey that's revealed in the signal light to the left.

INSIDE TRACK: *During the chase scene cited in the summary, once the locomotive begins to travel away from the viewer, if you look closely toward the left of the screen you will see an image of Mickey Mouse illuminated among the railroad signals.*

As visual effects producer for Dick Tracy, Harrison Ellenshaw was responsible for the sumptuous look and feel of the movie's detailed matte

backdrops. Ellenshaw, son of Disney Studio legend Peter Ellenshaw (20,000 Leagues Under the Sea, Mary Poppins) also produced matte backgrounds for Star Wars, The Black Hole, Star Wars: The Empire Strikes Back, and Tron. The title "Visual Effects Supervisor" was used for the first time on Tron.

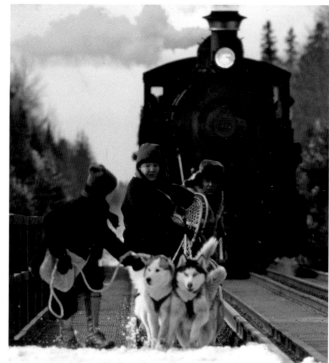

*Above and right:
In the opening scene
of* Iron Will, *the
character of Will
Stoneman and his dog
team race against a
Great Northern steam
locomotive.*

IRON WILL
1994

During the opening credits of *Iron Will*, the viewer is treated to a brisk winter race between a steam train and a dogsled team. This exciting scene is beautifully photographed and once again pits man and animal against machine, but in a good-natured way. It is a perennial favorite for steam train buffs.

The movie is actually based on a historical event, the 1917 Winnipeg, Canada, to St. Paul, Minnesota, dogsled race, sponsored by the Great Northern Railway. The main character in the film, Will Stoneman (Mackenzie Astin), is a fictional combination of two of the actual drivers. One was Albert Campbell, a Cree trapper from Canada's Manitoba province, who would go on to win the race. The other was Fred Hartman, the sole American participant who would become a media darling. Both men had their challenges.

Campbell, being of mixed blood, endured countless racist comments from the other drivers. Hartman's lead dog was killed, forcing him to drive his dog team through waist-high snow while the other participants were able to ride most of the race on their sleds.

INSIDE TRACK: *The actual race was covered extensively, with the Great Northern providing a special train with a converted flatcar for the press, so they could shoot film of the drivers and their teams whenever they came to a clearing near the tracks.*

All of the locomotives and train cars used in the film were on loan from the Lake Superior Railroad Museum in Duluth, Minnesota. Because of the complexity of many of the steam train scenes, the Disney Studios thought it best to utilize the actual train crews from the museum as opposed to extras.

JOHN HENRY
2000

This stylized animated short tells the legend of John Henry, one of the earliest African American role models. Made famous by the *Ballad of John Henry*, history does tend to support that John Henry was most likely a real man. He was a steel driver working for the Chesapeake and Ohio (C&O) railroad and swinging a nine-pound hammer (though folklore suggests it was forty pounds). John Henry helped lay the tracks and bore the tunnels for the C&O. Although history is a bit sketchy on the exact location of the race between John and the steam drill, many believe it occurred at Big Bend Tunnel in Talcott, West Virginia, where a statue of John, hammer in hand, still guards the entrance.

INSIDE TRACK: *Director Mark Henn is best known for animating a host of iconic Disney leading ladies including Ariel, Belle, Jasmine, Mulan, and Tiana. Mark, an avid historian with a passion for American history, used the sound from his own Civil War pistol to start the race between John Henry and the steam drill in the movie.*

In 1996, the U.S. Postal Service issued a 32-cent stamp commemorating the legend of John Henry.

Film captures from John Henry.

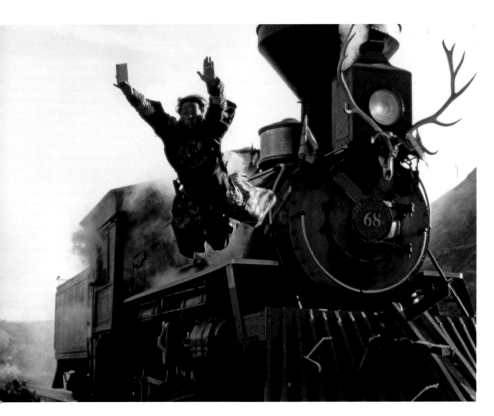

Jackie Chan hurdles from a runaway steam locomotive in a scene that would eventually be cut from the film.

SHANGHAI NOON
2000

Shanghai Noon opens with a wonderful chase scene aboard a fast-moving steam train. In the scene, which is also the first time that Chon Wang (Jackie Chan) and Roy O'Bannon (Owen Wilson) encounter each other, Chon uses every grab bar, catwalk, and end ladder to his full advantage. He leaps effortlessly from car to car, making every inanimate object suddenly come to life in his hands. The chase culminates with both Chon and Roy performing a quick step on top of a rapidly discharging flatcar loaded with logs.

Later in the scene, Chon tries to stop the abandoned locomotive but fails miserably. As the train comes to the end of the line, Chon hurls himself off the runaway locomotive just before it crashes and explodes in a huge fireball. When the debris from the explosion begins to fall back to earth, the engine's brass bell narrowly misses his head. Then the detached cowcatcher hurtles to the ground, implanting itself like an arrow just inches from Chon. It would have been an exciting scene for rail buffs, but unfortunately it was cut from the final film.

INSIDE TRACK: *The steam engine featured in* Shanghai Noon *was actually the same locomotive that appeared in the 1985 movie* The Journey of Natty Gann. *Although the locomotive was built in 1923, it had to look like it was from the 1880s for the movie. A false smokestack was added (as were brass-banded steam domes), a wooden cowcatcher replaced the iron one, a new wooden roof was built over the existing steel one, and the entire engine was dressed up in period colors.*

Mr. Incredible works out with a box and tank car.

THE INCREDIBLES

2004

Trains in *The Incredibles*?

That's right. What better place for a man possessing superhuman strength to go and work out than the local railroad classification yard? Throughout his inspired training montage, we see Mr. Incredible weight training by pulling loaded freight cars, work out with a boxcar and tank car, and bench-press a FA-1 diesel locomotive.

It's no secret that John Lasseter, Chief Creative Officer at Pixar, Disney Animation Studios, and Disney Toon Studios, loves trains; so why wouldn't he hide a few in several famous Pixar films?

INSIDE TRACK: *At the end of the film, the two older gentlemen that remark, "Now that's old school; yep there's no school like the old school,"* *are actually characterizations of Ollie Johnston and Frank Thomas, two of Walt Disney's famous "Nine Old Men" group of animators. It was these two gentlemen, as noted earlier in the book, who actually got Walt into backyard railroading. The film's director, Brad Bird, asked the two animators, both then in their nineties, to provide voices for their own characters. It wasn't the first time Bird included these two railroad buffs in his films. They also appeared in Bird's 1999 film* The Iron Giant *as, what else, locomotive engineers.*

The paint scheme of the Metroville Union diesel locomotive is the same shape and style of the since-defunct Green Bay and Western Railroad. Perhaps this is a hint of where the fictional city of Metroville is located?

HOME ON THE RANGE
2004

So far we have covered locomotives being operated by mice, ducks, chipmunks, and frogs, so it seems only fitting that the humble bovine takes her place behind the throttle.

Home on the Range is a 2004 animated film about three cows, voiced by Rosanne Barr, Judi Dench, and Jennifer Tilly, who set out on a quest to save their farm. Historically speaking, cows and steam trains don't mix very well together—a sentiment best illustrated by the triangular metal grille projecting outwards at the front of the locomotive, better known as the cowcatcher. Yet our heroic trio of heifers not only steal a locomotive, they uncouple it, fire it up, switch tracks, thwart a head-on collision, and jump the rails, all to arrive just in time to provide this tale with a happy ending.

CARS
2006

It's true; a train does make an appearance in the original Cars animated film. The train, or rather the locomotive, is called Trev Diesel of the Pacific Flyer Railroad. Trev is an EMD E–series diesel locomotive who Lightning McQueen almost runs into once he tumbles out of his trailer and off the interstate. Trev's loud air horns startle Lightning and set him off speeding in the direction of Radiator Springs.

INSIDE TRACK: *Trev's illuminated call numbers, located on either side of his headlamp, read A113. This is an inside reference used by many animators who, along with John Lasseter, are fellow alumni of the California Institute of the Arts. Classroom A113 houses the first-year graphic design studio. Similar to the Broadway caricaturist Al Hirschfield hiding his daughter's name "Nina" in his artworks, "A113" has appeared in almost every Pixar film from* Toy Story *to* Brave, *and* a bug's life *to* Ratatouille. *The number is also hidden in the movies of fellow animation alumni Brad Bird, Andrew Stanton, Pete Docter, and Tim Burton. It has appeared from time to time in animated series like* The Simpsons *and* American Dad, *as well as mainstream movies, including* Mission: Impossible, Terminator Salvation, *and* The Avengers.

Trev's diesel 's illuminated call-boards reflect a hidden Pixar reference.

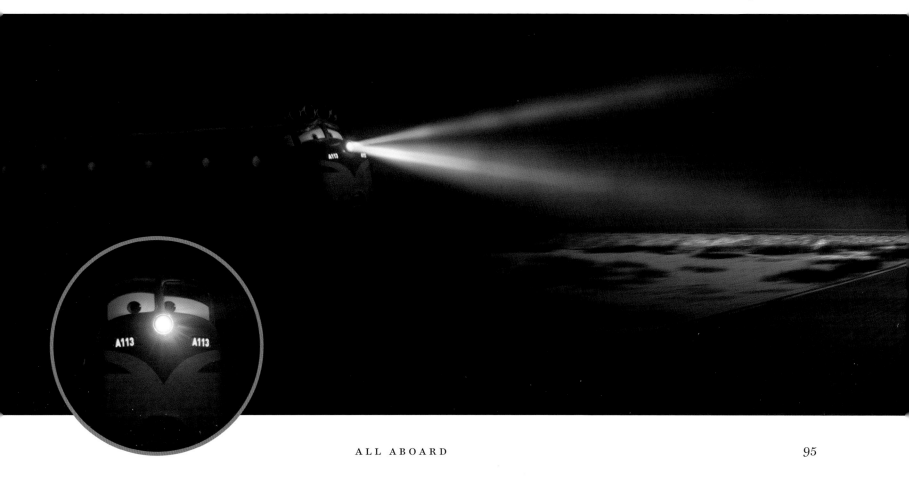

Rhino, Bolt, and Mittens hop a freight.

BOLT
2008

Bolt is the story of an American white shepherd pup who stars in a popular TV show. Growing up on the studio set, Bolt (voiced by John Travolta) truly believes that he possesses superpowers. But when he accidentally is shipped from Hollywood to New York, Bolt must find his way home through the real world. With the help of a stray cat named Mittens and a hamster with a major TV obsession named Rhino, Bolt realizes that he doesn't need superpowers to be a hero.

In an attempt to find fast transport back home, Rhino leads Bolt and Mittens to a railroad overpass. Soon enough a fast-moving freight train appears, pulled by a pair of EMD SD70M diesel locomotives from the CSX Corporation. Bolt, still thinking he possesses superpowers, grabs onto a homecoming banner and attempts to swing onto the speeding train. The trio makes it, but barely, with Mittens and then Bolt dangling off a damaged boxcar ladder that has come loose and is hanging precariously over the side of the train.

As the train rounds a sharp curve, a railroad signal comes directly into the path of the overhanging ladder. At the last minute Bolt is able to escape just as the ladder is smashed to bits against the signal. Five years later in 2013, the film *The Lone Ranger* repeated this image. During the climatic railroad chase scene, Tonto is using a ladder to move himself from one train onto another. But just as he lands on the roof of the opposite train this ladder is smashed to bits against a tree along the tracks.

INSIDE TRACK: *The number on the back of Bolt's dog tag is 2100 Riverside Drive, which happens to be the address of the Feature Animation Building at the Disney Studios in Burbank, California.*

While planning his journey home, Bolt reviews a Waffle World map of the USA. When he looks up to Minnesota there is an image of Paul Bunyan and Babe, the Blue Ox from the 1958 film.

Top: A CSX diesel emerges from an overpass, while Bolt (middle), and Tonto— in a scene from The Lone Ranger *(below)—speed along the rails perched precariously upon their respective ladders narrowly escaping disaster in two separate movies. Coincidence perhaps?*

Woody attempts to stop the runaway train.

TOY STORY 3
2010

Toy Story 3 opens with an exciting steam train chase as Woody, Jessie, Bullseye, and Buzz try to rescue orphans from a runaway train headed toward a wrecked trestle courtesy of One-Eyed Bart (Mr. Potato Head). The scene has all the action and adventure of the classic Western genre, complete with stirring music, breathtaking scenery, and clear heroes and villains.

It also has a great steam train.

Pulling the train in question is a 4-4-0 American type locomotive. Historically accurate for the Old West, it is also reminiscent of two other Disney trains. The locomotive closely resembles both the Disneyland Railroad's Engine No. 1, the *C. K. Holliday,* as well as Walt's beloved *Lilly Belle.* All three locomotives share the same wheel arrangement, the same color scheme, and even the same smokestack. There is one noticeable differ-

ence, however. The steam locomotive in *Toy Story 3* sports the No. 95, not only on its brass number plate, but on the side of the cab as well. In this case the number may have two meanings. Ninety-five is Lightning McQueen's number from *Cars,* but it also signifies the year of the original *Toy Story*'s release, 1995.

INSIDE TRACK: *This is not the first time Sheriff Woody daringly jumped from train car to train car. In* Toy Story 2, *he leaped along a string of airport baggage carts. Although not technically a train, the scene was enhanced with a classic Western score and the rumbling clickety-clack of the carts.*

The railroad trestle booby trapped with explosives has oft been repeated in several Disney shorts, including The Brave Engineer *and* A Cowboy Needs a Horse.

Toy Story 3's opening (right and below) was a much-awaited feast for train buffs.

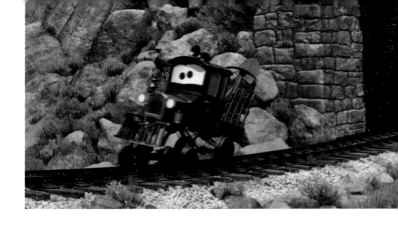

CARS 2
2011

Cars 2 has not one, but two trains making appearances in the film.

The most noticeable is a major player in the spy game named Stephenson. It's a British high-speed spy train that takes Finn McMissle, Holley Shiftwell, and Mater to Porto Corsa. Loaded with high-tech spy gear, Stephenson is not a locomotive to be trifled with.

The second train makes a very brief cameo appearance at the beginning of the film when Mater convinces Lightning to take off his tires and ride the rails into a tunnel. Suddenly they hear a long blast from a diesel locomotive and the pair makes a quick exit, neither of them noticing the diminutive rail truck that shakily rattles out of the tunnel. Named *The Galloping Geargrinder*, this small engine actually consists of a Model T truck body mounted on steel locomotive wheels. A holdover from the declining days of steam railroading, *The Galloping Geargrinder* would have continued to deliver the mail to small railroad towns like Radiator Springs before the creation of interstate highways.

INSIDE TRACK: *Stephenson is actually a Pixar tip of the hat to English mechanical engineer George Stephenson who in 1820 constructed the first successful steam-powered railway in the word.*

The Galloping Geargrinder is actually derived from a railcar named The Galloping Goose. *These railcars were built by the Rio Grande Southern Railroad during the Depression when it was very expensive to run a regular steam train. With just one driver/engineer* The Galloping Geese *railcars were constructed to take over passenger and mail service on rural runs. The front end consisted of an auto or bus chassis, while the back end consisted of a railway passenger coach or boxcar. The combination, while efficient, was a bit unstable even at normal speeds and had a tendency to wobble like a trotting goose, hence the moniker.*

Top: The Galloping Geargrinder *and the high-speed spy train known as* Stephenson *both make Mator's acquaintance in* Cars 2.

ALL ABOARD

PLANES

2013

Dusty Crophopper is a lowly crop-dusting plane with aspirations of becoming more than what he is. He pursues his dream all the way to competing in an international around-the-world air race. While traveling toward the Himalayan Mountains, Dusty, who will only fly at low altitudes because of his fear of heights, is confronted with a difficult situation to be sure.

Advice comes from Ishani, a fellow-racing plane from India, who recommends that Dusty follow "the iron compass," a reference to the railroad route through the Himalayas. Taking Ishani's advice, he follows the tracks only to come upon a tunnel. With the option of either turning back or ascending over the mountain range Dusty decides to fly straight through the tunnel. As he gingerly flies through the portal and into the tunnel, we see a steam locomotive approaching from the opposite side!

INSIDE TRACK: *The unknown steam locomotive appears to be of British origin, most likely a reference to the Darjeeling Himalayan Railway. Nicknamed "the Toy train" by locals, this tiny railway, in existence since 1881, is still operating and is the only way to travel the Himalayan route via the rails.*

Himalayan saddle tank steam locomotive almost collides with Dusty Crophopper (inset) coming through the tunnel in Planes.

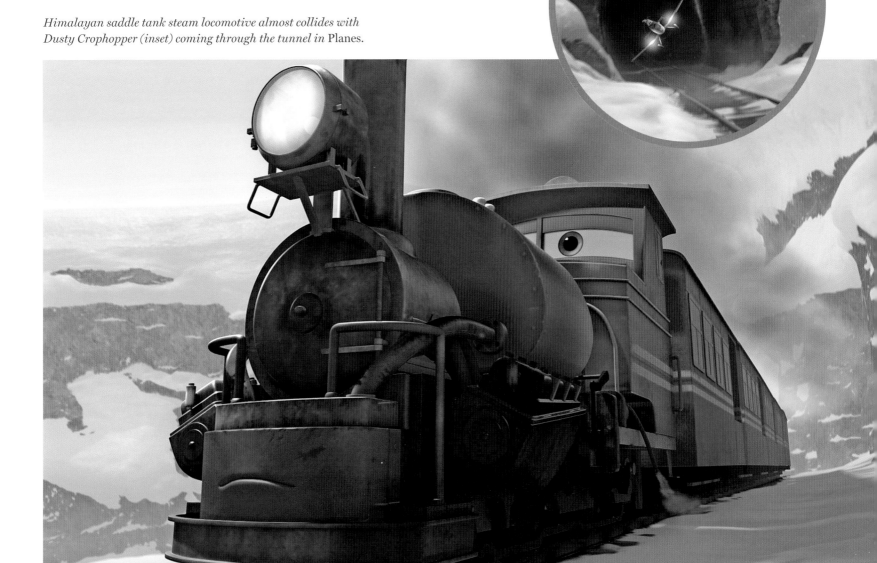

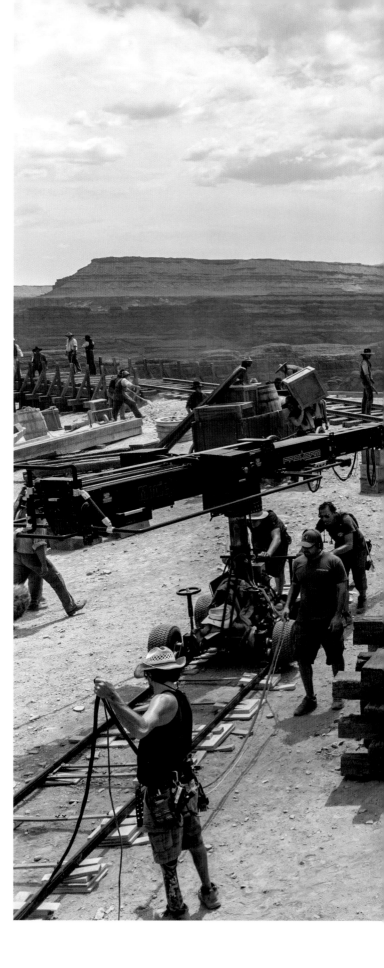

THE LONE RANGER
2013

Not since *The Great Locomotive Chase* has a Disney feature film emphasized trains on such a grand scale as *The Lone Ranger.* Director Gore Verbinski made it clear very early on that the plot would be driven by the westward expansion of the railroad. "It became apparent that the train was going to be a significant character in the movie, symbolizing progress and the inevitability of change," he said. "And once you have that train in there . . . it just couldn't sit in the background."

The filmmakers originally decided to film on an existing railroad in southern New Mexico but soon decided that in order to have complete control of the schedule and placement of cameras, an entirely new railroad line should be constructed. Utilizing more than 4.3 million pounds of steel rail, wooden ties, bolts, washers, and other necessary track parts, a fully functioning railroad line began to appear in the middle of the Rio Puerco desert. When completed, the movie railroad consisted of a five-mile loop composed of single and double track. Meanwhile, 330 miles north, another mile of track and a full-scale trestle over a rocky creek were constructed in Creede, Colorado, where the silver mining portions of the film took place.

But this full-scale ultimate train set didn't end there. Eight-hundred miles away in Sun Valley, California, a machine shop was busy construct-ing two full-size 250-ton vintage locomotives complete with a full cast of train cars. Although considered large functioning props as opposed to

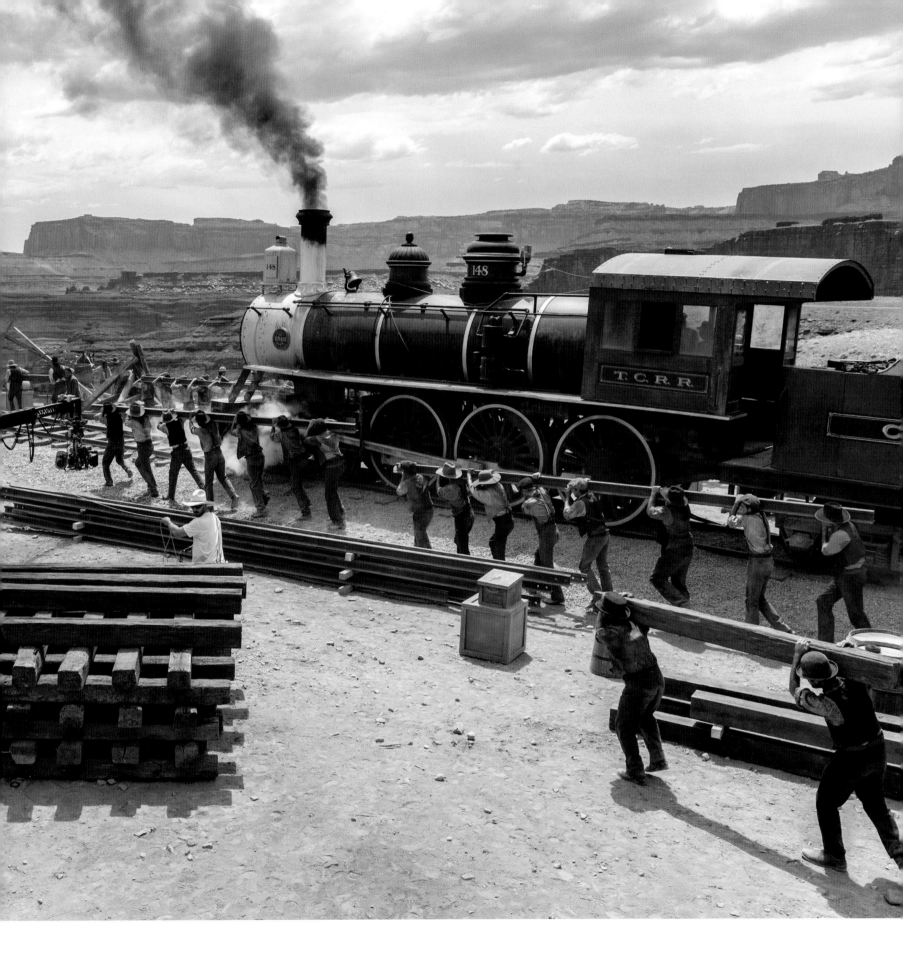

actual steam locomotives, their wheel alignment and running gear were quite real. One of the engines was based on the *Jupiter* of Golden Spike fame, while the other was dubbed *The Constitution*. Both were able to create smoke and steam for dramatic effect, but were actually non-powered and pushed by diesel engines.

While the locomotives and cars utilized the five-mile loop for wide-angle and panoramic shots, some of the close-ups were handled in a different way. The action-packed final fight scene atop the moving passenger coaches was actually filmed by having a string of train cars mounted onto flatbed tractor-trailer trucks. "That will go to the absolute top of my list of most terrifying things I've ever shot," commented William Fichtner, who portrays the villain Butch Cavendish in the film. "They're filming us moving at a good speed, on top of train cars. Sometimes on top of flatbeds being pulled through canyons by trucks. There were so many things involved in that.

"Think about the height!" Fichtner continues. "It's a sloped roof. I've got a gun in one hand, Ruth Wilson in the other, looking around for the Lone Ranger, going around bends at thirty-five miles an hour with a little tether that holds on to you."

The film is an adrenaline rush on steel wheels. Not so much historically accurate (the film depicts so many derailments, explosions, crashes, bridge collapses, and careening locomotives plummeting into rivers that the Transcontinental Railroad would never have been finished), the film is a pure escape for all of us with a secret desire to gallop along the top of a moving train headed for a tunnel.

INSIDE TRACK: *The specially constructed five-mile railroad loop did not connect with any other modern line and was completely dismantled when filming ended.*

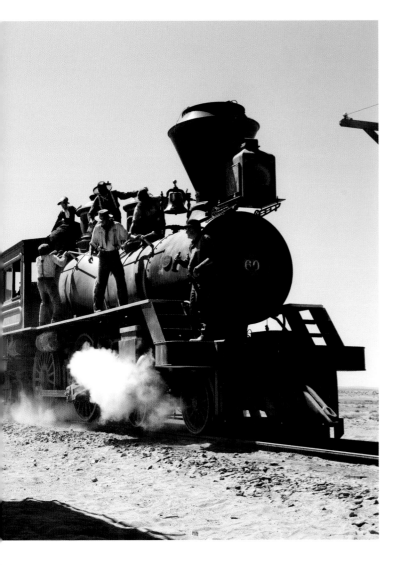

The plunging train crash off a sabotaged wooden trestle in The Lone Ranger *bears a striking resemblance to another train crash off a sabotaged wooden trestle in* Toy Story 3.

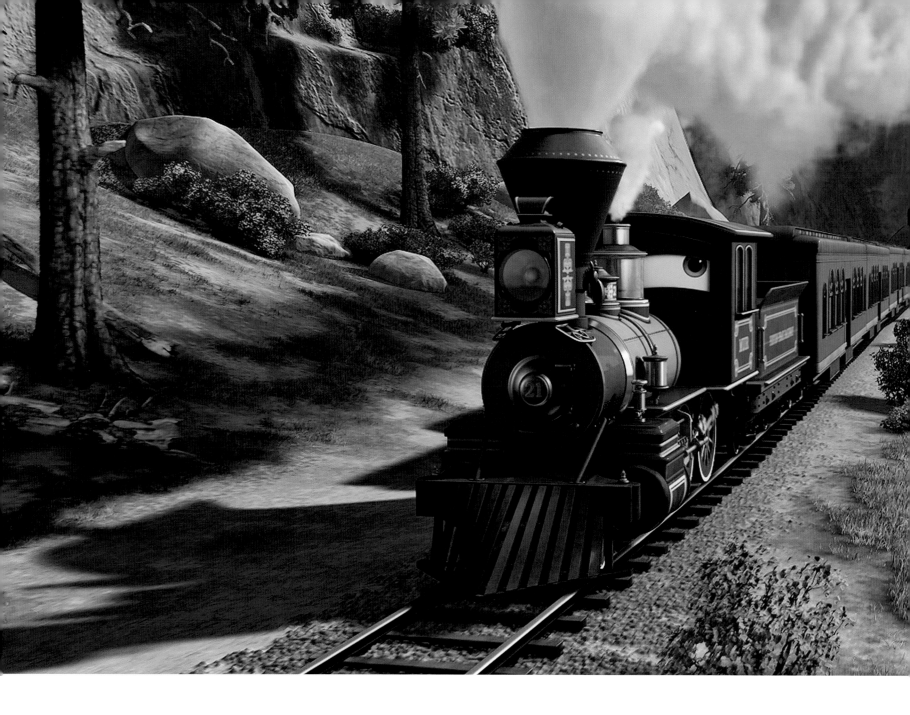

PLANES: FIRE & RESCUE
2014

Muir is a hardworking 2-6-9 steam locomotive, No. 21. He carries visitors along the Piston Peak Scenic Railway.

He is named in honor of John Muir the famous American naturalist, conservationist and botanist, considered the father of the National Park Service. Through letters, books and published writings John Muir was able to convince the U.S. Government to protect as national parks Yosemite Valley, Sequoia and the Grand Canyon.

The character of "Muir" is the first American steam locomotive to be animated by Pixar. Unlike his European cousins who have a front bumper Muir has a cowcatcher, this required his mouth to be relocated to his smoke box.

Dusty tips his wings to Muir the locomotive. Muir's animated face has his eyes located in his cab while his mouth is just below his number plate. This is a welcomed change from the all too common animated depiction of locomotives with their faces on the smoke box door.

INSIDE TRACK: *The railroad station built into the lobby of the Grand Fusel Lodge in Piston Peak National Park was based on a real station in Yellowstone National Park. It was designed by Robert Reamer, who also designed the Old Faithful Inn.*

If you look closely at one of the cliff faces

Dusty passes while en route to Piston Peak, an image of the front of a steam train is clearly visible. Perhaps a hint into the future?

4 Four Men, Four Trains

A Shared Passion for the Rails

Walt riding on handcar given to him by railroad historian Jerry Best. The handcar now resides at Walt Disney World in front of Main Street station on a siding.

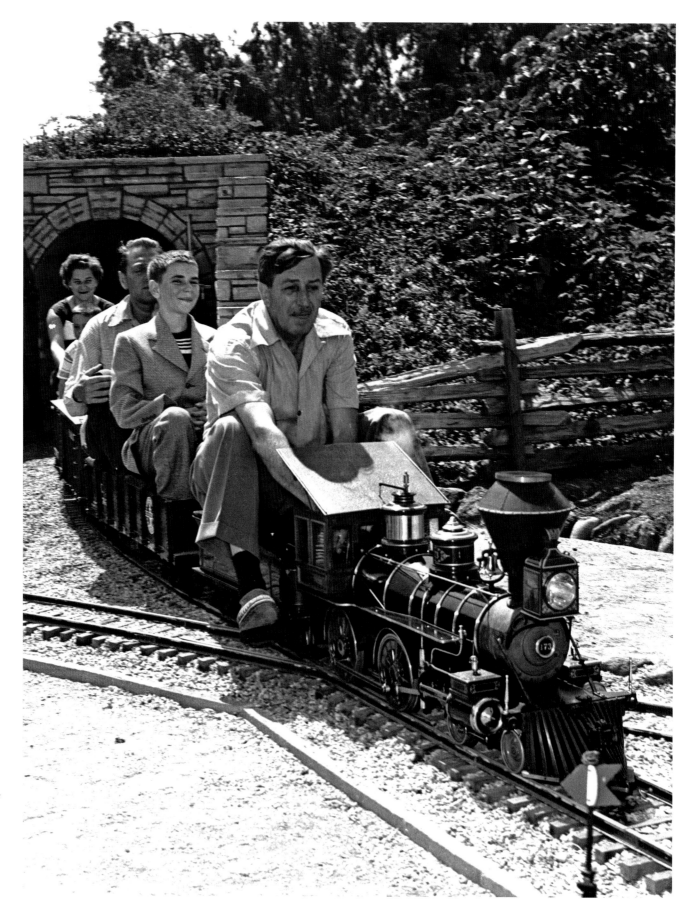

Walt emerges from his S-curve tunnel traversing a diamond crossing. Note the small-scale switch signal in the lower right corner.

BACKYARD EMPIRES

THE STORY of Disney trains involves many people, including Walt's Uncle Mike, who worked on the Santa Fe Railroad; original Imagineer Roger Broggie, who was Walt's technical guru as he built his backyard railroad; Billy Jones, whose eighteen-inch-gauge train was *almost* the prototype for the Disneyland Railroad; and Hazel George, the studio nurse who suggested a trip that would change Walt's life forever.

For me, however, it all boils down to four men and their trains—the past, present, and future of Disney trains. The first, of course, is Walt himself. But it was two of Walt's trusted animators who were responsible for reigniting his passion for the rails and for steam locomotives in particular.

Ward Kimball—artist, animator, musician, director, visionary, historian, two-time Academy Award recipient, and certified railroad fanatic— was the first person in the United States to privately own an actual railroad, in his own backyard. On his first date with his future wife Betty, he took her to an old railroad yard to look at a vintage steam engine.

Ollie Johnston—animator, artist, National Medal of the Arts award winner, and true gentleman—introduced Walt to small-scale backyard railroading, also known as "midget railroading." In his later years, Ollie would go on to mentor another multi-talented young animator, innovator, and storyteller: John Lasseter. Ollie would advise John not only in the art of animation, but would regale him with stories of steam trains and railroads.

Just as Walt did before him, it would be John who would now take the throttle and guide, inspire, and preserve Disney trains into the next century.

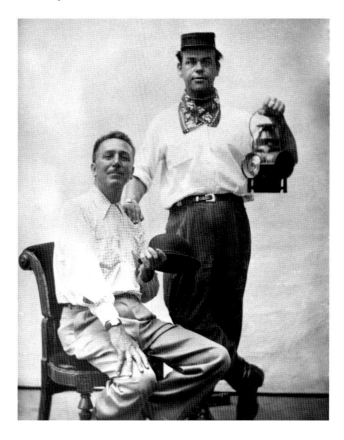

Walt Disney and Ward Kimball ham it up in period costumes while at the Henry Ford Museum.

Walt and the Mickey Mouse Team during a benefit game against the Hollywood Team. In 1936 Disney produced an animated short titled Mickey's Polo Team, *which consisted of Mickey, Goofy, the Big Bad Wolf, and Donald Duck playing against the Hollywood Team of Stan Laurel, Oliver Hardy, Harpo Marx, and Charlie Chaplin.*

WALT DISNEY, THE CAROLWOOD PACIFIC, AND THE *LILLY BELLE*

THE LATE 1930s into the 1940s proved to be a very trying time for Walt Disney. Throughout World War II the Disney Studios performed their patriotic duty with great fervor, creating films and animations for virtually every branch of the armed forces and U.S. government. At the height of the war as many as 90 percent of studio employees were working on the production of training and morale-boosting films.

But WWII also took a toll on the Studio's featured animated films with overseas distribution dropping by 40 percent. All of this, combined with a particularly nasty Studio employee strike made life very difficult for Walt who was already working ten- to twelve-hour days, six days a week. The physical strain was beginning to show and his physician suggested he needed an outside hobby to distract him from Studio concerns.

Walt tried his hand at golf, boxing and even wrestling, but all just led to greater frustration. Eventually he would settle on polo. Walt loved horses since his childhood in Marceline, Missouri, and was an accomplished rider. He actually played on a team and won several trophies, but just as this pursuit was beginning to work, a stray polo ball un-horsed Walt crushing four cervical vertebrae in his neck, resulting in an injury that would hinder him the remainder of his life.

While recovering from his neck injury, Walt decided it might be fun to set up a model train layout in an adjacent room next to his office. As noted earlier, Walt had a strong connection to the Lionel Company and the manufacturer was quite happy to accommodate him with a new model railroad set and accessories. Of course word spread quickly around the Studio lot that "the Boss" had a train set in his office and Ward Kimball found his way over to play with the trains.

Soon after that, Kimball went in search of Ollie Johnston, another railroad fanatic and fellow member of Walt's "Nine Old Men" of animation (Ollie had created the character of Thumper of *Bambi* fame.) Ollie would later recall:

One day in early December 1948, Ward Kimball came into my office and said, "There's something up in Walt's office you've gotta see." We walked in and there was a complete Lionel layout he had built.

Although Ward was well known around the Studio as the "train guy" the soft-spoken Johnston

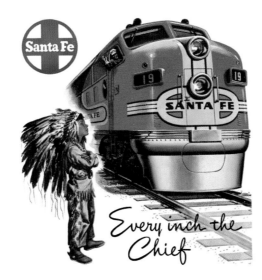

was not. So it must have been a bit of a surprise when Ollie invited Walt to his home in La Cañada, California, to see his one-twelfth-scale live steam railway. In addition to steam trains, Walt always had a passion for miniatures, and it seemed that a hobby that would combine both of his loves might be the right tonic.

Still Walt remained stressed and more frustrated than ever. After his polo injury, he had gone to his chiropractor who had manipulated his back to ease the tremendous pain. (Doctors would later argue that he injury might have healed on its own had a cast been set, but instead a large calcium deposit built up on the back of his neck, which caused a very painful type of arthritis.) It was during one of these flare-ups that Studio nurse and Walt's confidant, Hazel George, told Walt he needed to take a vacation and suggested the Chicago Railroad Fair.

The event, hosted by Chicago's Museum of Science and Industry, would showcase an impressive collection of steam power that covered one hundred years of American railroading. All of the nation's top railroads were represented with several restoring vintage locomotives to full operating condition. The idea intrigued Walt, but he knew that the trip wouldn't appeal to his wife, Lillian, and their

daughters, so he decided to invite Kimball, who always seemed to be stress free, to accompany him.

Walt had visited Ward's own full-size, backyard railroad several times. Kimball had actually allowed him to operate his beloved *Emma Nevada* Baldwin locomotive at a "steam-up." Ward would later recall, "I'm sure that I never saw him smile wider than that evening when he pulled the throttle on the *Emma Nevada* as she steamed out of the enginehouse with her bell ringing and whistle blowing." This was the first time Walt had been back at the throttle of a live steam train since his days as a news butcher and he was sure to have remembered this kindness when it came time to select a travelling companion.

The trip was an eventful one, with Walt and Ward cavorting about the Santa Fe *Super Chief* all the way from Pasadena to Chicago. The president of the Atchison, Topeka and Santa Fe Railroad had arranged for the pair to ride in the diesel locomotive's cab for a time and Walt had great fun pulling the loud twin air horns when approaching level crossings.

The real excitement came at the fair itself when the president of the Museum of Science and Industry, Lenox Lohr, invited the pair to

come "backstage" and see the locomotives up close for the Fair 's centerpiece a staged pageant entitled "Wheels – a – Rolling."

Backstage turned out to be a 450-foot platform with multiple tracks set up along the banks of Lake Michigan, and the pageant a kinetic display of locomotive power from the *DeWitt Clinton* all the way up to the *Burlington Zephyr* and beyond. The pageant also featured a variety of horse-drawn wagons, stagecoaches, and buggies, along with cable cars, vintage fire engines, and early automobiles. Lohr further invited Walt and Ward to "climb aboard" and even offered both the chance to operate some of the locomotives during the performance.

After the fair, Walt and Ward went on to Dearborn, Michigan, to tour the Henry Ford Museum. Ford had designed a museum that featured the growth of American industry. It was also a tribute to his idol Thomas Edison, complete with a re-creation of Edison's Menlo Park, New Jersey, laboratory. Here the pair toured through historic re-creations of buildings from the late eighteenth

and early nineteenth centuries, rode on a steam-powered riverboat and a vintage steam locomotive, and had their photos taken in turn-of-the-century railroad garb.

Both events left a lasting impression on Walt, who was always looking for the next big idea, and by the time he arrived back in California, he was already talking concepts for a "Mickey Mouse Park." His park would include vintage buildings, horse-drawn vehicles, and a steamboat. Walt wanted it "to look like nothing else in the world, and it should be surrounded by a train."

Disney would eventually give his office railroad layout to his nephew, but he was far from done with this new hobby. Later when speaking to the Studio's chief mechanic, Roger Broggie, about the model railroad, Walt casually said, "How 'bout a real one now?"

In 1949 Walt bought a new home seated on five acres in Los Angeles' Holmby Hills neighborhood on 355 N. Carolwood Drive and set about building his own backyard empire. Walt describes it best in an interview for the October 1965 issue of *Railroad Magazine*:

Walt working on a scale locomotive in the Studio's machine shop. Note the film canisters in the background. Right: Walt in front of his beloved Lilly Belle. *The amount of detail on the* Lilly Belle *was so exact that it's hard to believe that this is actually a 1/25th scale model with a photo of Walt miniaturized and placed beside it.*

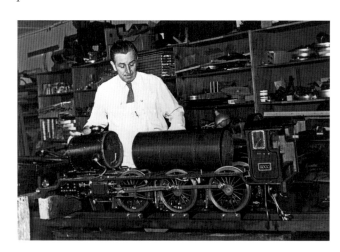

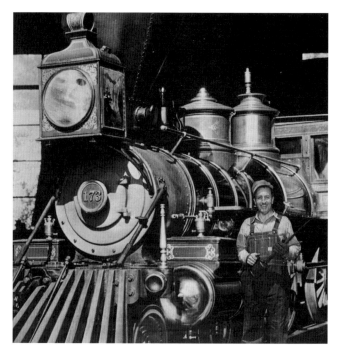

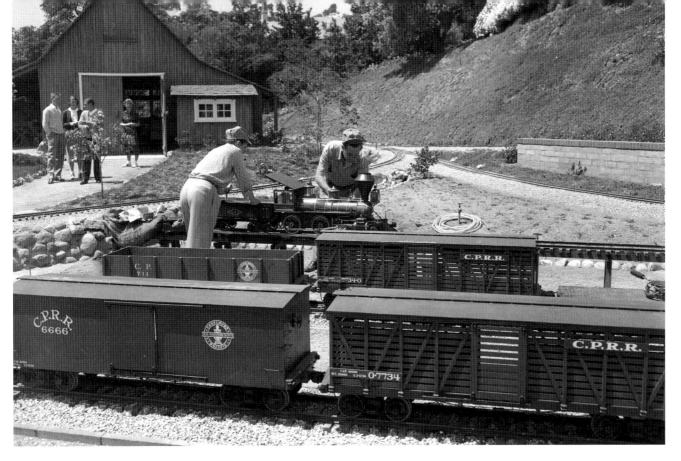

Walt working on the Lilly Belle on his backyard railway. Walt's barn, seen in the background, has been completely restored by the Carolwood Pacific Historical Society and is currently on display at Los Angeles Live Steamers in the city's Griffith Park.

Shortly after the Second World War I was having trouble getting my studio rolling again. I knew another fellow living in Beverley Hills who had built a midget railroad and I was determined to build one of my own to keep my mind busy and off studio problems.

Walt had already sought the talents of Broggie, and they had built an operational steam train to one-eighth scale that they had run around a small track on the Studio lot. It ran on coal and water, "like the ones [he] had known as a new butcher." The design was modeled after a woodburning steam locomotive No. 173 of the old Central Pacific Railroad. In order to retain the locomotive's initials, he named his backyard railway the Carolwood Pacific, incorporating his new street address. The locomotive and tender combined to a length of seventeen feet and was an exact replica of its namesake. He also built boxcars and flatcars that people could ride upon and hand-laid the individual track pieces. He was particularly proud of his caboose. Painstakingly scratch built in miniature the caboose was a work of art, right down to the potbellied stove and coal shovel in the corner. The layout extended 2,615 feet and was so cleverly designed that one could almost travel a mile without going over the same track in the same direction twice. Walt threw himself into his new hobby, but his wife, Lillian, objected to the idea of her new home's backyard being taken over by a railroad line.

"All my planning worked our perfectly except for one factor, my wife. She didn't take kindly to the idea of having a railroad run around our house and told me so in no uncertain terms. "Things came to such a pass that I went to my lawyer and had him draw up a right-of-way agreement giving me permission to operate the railroad on the property. My wife signed it and my daughters witnessed the agreement."

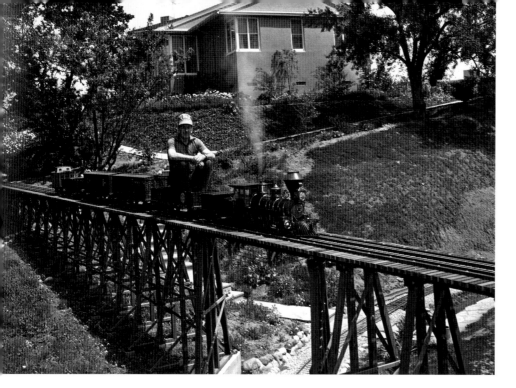

Walt crosses his wooden trestle behind his house in the Holmby Hills section of Los Angeles.

The major concern for Lillian was her prized flower beds; Walt's track design included a six-foot cut that would traverse directly through them. The idea of a greasy, smoky, wet steam locomotive barging through her garden was too much to bear, even for a woman as patient as Lillian Disney, and she put her foot down with a firm "NO." As he did with every major problem that confronted him Walt came up with an alternative.

" I compromised by building a tunnel 90 feet long (below the planned flower beds) and covering it with dirt. I gave my secretary strict instructions not to tell me how much it cost."

The specially designed tunnel was laid out with an interior S curves so that passengers on the *Lilly Belle* couldn't see the other end. Once emerged from the darkness, riders were treated to a spectacular 9-foot high trestle spanning Yensid Valley (Disney spelled *backwards*.) Walt didn't know it at the time, but he was actually designing a distinct theatrical experience that would define several of Disneyland's "dark rides" like the The Grand Canyon Diorama portion of the Disneyland Railroad and the Pirates of the Caribbean.

Walt sought the advice of horticulturalists Jack and Bill Evans to design a beautifully tiered garden above his newly installed tunnel. That did the trick and harmony was restored in the Disney household. Eternally grateful to the Evans' for their part in ensuring marital bliss, Walt would later use the brothers' talents when designing the horticultural elements for the Jungle Cruise.

Walt went on to change the name of the locomotive from the No. 173 to the *Lilly Belle* in honor of his long-suffering wife. Lillian, who more than anyone understood her husband's passion for his railroad, appreciated the tribute.

In the center of the layout, Walt constructed a red barn layout that would function as his switch tower, workshop, and "man cave" to use the current vernacular. The rustic barn, complete with realistically designed sagging roof, was reminiscent of a barn on his property back in Marceline. Here Walt worked on his trains and met with his friends. It was also the spot where, on a workbench, he sketched out a rough idea for an amusement park surrounded by a train.

The Carolwood Pacific soon became a magnet for a variety of celebrities. Mary Pickford, Frank Sinatra, Edgar Bergen (accompanied by his young daughter Candice), Kirk Douglas and even Salvador Dali all rode behind the *Lilly Belle*.

Of all people Dali actually had concerns about the Lilliputian railway and reckoned that . . . "Such perfection does not belong in models" Dali feared that the locomotive would have a real train accident "or even sabotage...from miniature train wreckers."

More and more guest arrived to travel on Walt's railroad. It was filmed and photographed extensively and was a featured story in *Look* magazine. Prior to the Carolwood Walt was not a publicly recognized figure but this was all starting to change.

More and more people were visiting the Carolwood Pacific with more and more strangers hopping on board every weekend. Then in the spring of 1953 a guest engineer took a curve a bit too fast

resulting in a derailment. The *Lilly Belle* came off the tracks and turned on her side tearing off her steam whistle. The escaping steam sprayed onto the legs of a little girl that had run over to see what the commotion was all about. Although the injury was minor and Walt attended to it immediately the incident troubled him so much that he closed down the Carolwood Pacific for good and put the *Lilly Belle* in storage.

Although the Carolwood was no more, Walt had already moved on to bigger things. He wanted a full-scale railroad to surround his Mickey Mouse, now dubbed "Disneyland" Park, and concept. He even had the perfect location, a sixteen-acre lot next to his studio lot in Burbank. The location had the added bonus of being adjacent to Griffith Park and it's rail line so his track plan had the possibility of extending even further.

Walt thought it was an inspired proposal and approached the Burbank City Council to pitch his vision. He had detailed renderings made and models prepared, but in the end Walt's vision was soundly rejected. The city council didn't want a carnival-type atmosphere, along with all the riffraff that accompanied it, within their city limits. As always Walt handled the rejection with his usual aplomb. He simply stood up, turned to his team, and with a brusque, "Let's get out of here," left the meeting.

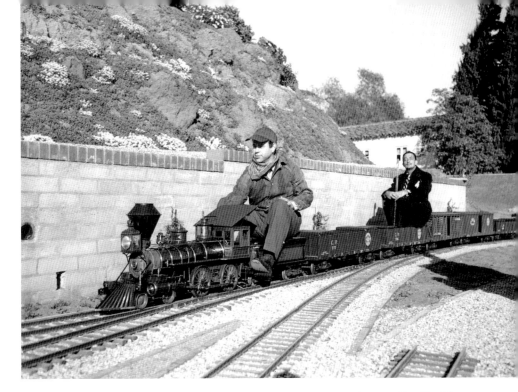

A very refined looking Salvador Dalí hops a ride on the Carolwood Pacific.

Walt then turned to Buzz Price, his urban planning expert, to find a suitable location with lots of space but with a population on the increase.

After doing a thorough investigation Price came back with a recommendation: Anaheim, California. The location was far enough away from Los Angeles to expand but close enough to draw in crowds. Walt and his design team began their work in earnest now and plans for the Disneyland we know today were set in place. True to his word, it would look like nothing else in the world and be surrounded by a train.

Walt's original concept for Disneyland Park. Note the railway station and vintage locomotives surrounding the park.

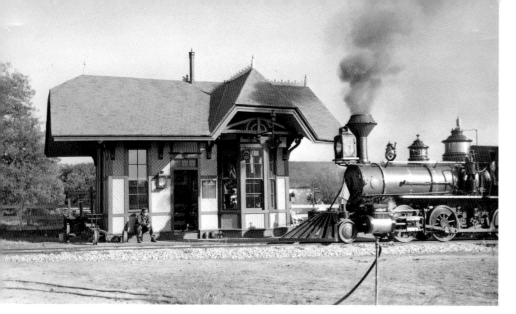

Far left: The Emma Nevada *steams up to the Grizzly Flats depot. Left: Ward Kimball's wife, Betty, walking the iron rail.*

WARD KIMBALL, *EMMA NEVADA,* AND THE GRIZZLY FLATS RAILROAD

WARD KIMBALL was the owner and operator of the Grizzly Flats Railroad in San Gabriel, California. You could say that railroading was always in Ward's blood. Although he never actually worked on a functioning public railroad like Walt had, he always had a close association with all things train. This fascination started very early. At nine months old, Ward was presented with a gift from Santa, a Hafner Clockwork train; it was a simple train that ran in a small loop, but it would be a train he would keep his entire life.

By age five he was drawing extremely detailed and technically accurate renderings of steam locomotives and trolley cars. At age eleven, Ward went into business for himself selling soda pop outside the Union Pacific yards in Glendale, California. The proceeds from his endeavor funded a correspondence drawing course. When he was fourteen, he built a large-scale detailed Toonerville Trolley that he and his friends could play inside. After

graduating from the Santa Barbara School of the Arts in 1932, he answered an ad for animators for the Disney Studio and was hired on the spot.

Ward met his wife, Betty, while she was working in the Studio Ink and Paint Department. It has long been rumored that Betty Ward was one of the inspirations for Tinker Bell.

Ward created the Grizzly Flats Railroad at his home in San Gabriel. It was a three-foot gauge, fully functional railroad which he ran in his private three-acre backyard.

This railroad is credited with inspiring Walt Disney to build the Disneyland Railroad.

The line's origins date back to 1938 when Ward found three old three-foot-gauge passenger coaches from the Carson and Colorado Railroad for sale. Ward purchased one with the intention to house his model train collections inside. Betty actually had another idea. With the wisdom of woman who truly knows the soul of the man she married, Betty

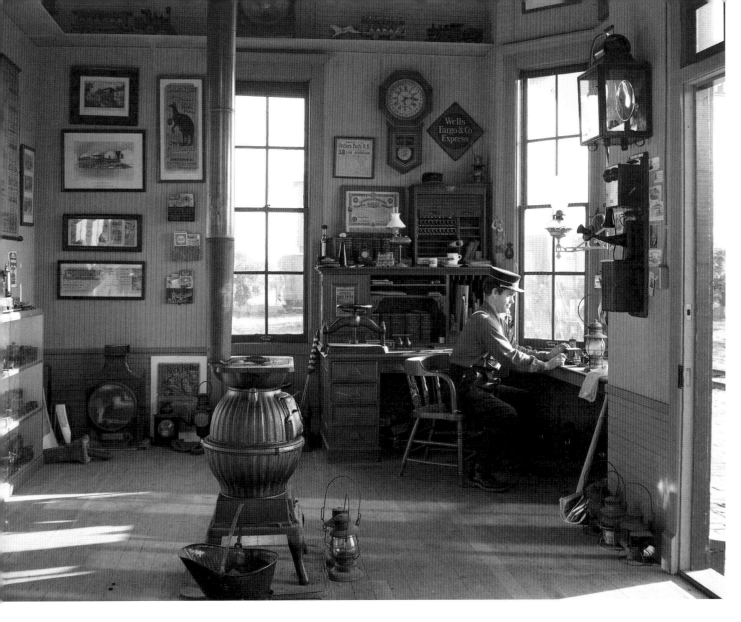

Ward Kimball works the telegraph inside his Grizzly Flats Railroad station. The small depot housed a treasure trove of vintage railroad memorabilia.

suggested to Ward that since he already had a passenger car, he might as well have a locomotive to pull it.

Ward the found an old 2-6-0 Baldwin circa 1881 steam locomotive from the Nevada Central Railroad being sold for scrap. Originally named the Sidney Dillon, he bought it and renamed it the *Emma Nevada* after the famous opera diva of the late 1800s.

Although many of Ward's neighbors were considerate, there were just as many who objected to coal dust and soot dirtying their bedsheets as they hung them out to dry. Even Groucho Marx got in on the debate in 1954, commenting, "I assume by this time your neighbors have a fairly decided opinion about you," when Ward revealed on the television show *You Bet Your Life* that he had a full-scale steam locomotive operating in his backyard. In response to outside pressure, Ward purchased a small Baldwin plantation locomotive that he named *Chloe*, after his daughter. *Chloe* burned clean wood instead of dirty coal and the neighbors were more forgiving to the fragrant aroma of burning mesquite.

Into Ward and Betty's magical backyard universe came a host of artists, entertainers, and celebrities. Of course Walt and Ollie Johnston were regular visitors, but there were other famous

animators from across the globe: Bruno Bozzetto from Italy; Richard Williams from Canada; and from England, Rowland Emett, whose whimsical creations inspired *Chitty Chitty Bang Bang*; Emett actually preferred staying at the Grizzly Flats station to a hotel. Osamu Tezuka, creator of Astro Boy, father of the manga animation style, and regarded by many as the Japanese equivalent of Walt Disney, took his turn at the throttle as did Michael Jackson.

Over the years Ward was also able to accumulate a cattle car, boxcar and caboose.

To say that Ward was a bit eccentric would be an understatement. To have a functioning full-scale railroad in your backyard was unique enough, but when you consider that Ward's backyard was just under 3 acres, it's downright unbelievable. But that's what Ward was all about—he loved dressing up and having fun. In fact, it was quite common to see Ward and his family dressed up in turn-of-the-century outfits as they wandered along Main Street, Disneyland.

Ward retired from Disney at the young age of fifty-eight. As he recalls, one day Betty came into his train room and said, 'What are you going to do with all this stuff? You either need to sell it or donate it. They just can't sit here.' Ward thought for a moment and decided, "Let's play with them." He retired the next day and played with his trains up until the day he died. Ward so loved his trains that when once asked about the frequent earthquakes that occur in California, he gleefully replied, "I hope I can hold out for the big one, the great earthquake. Then when California slips into the Pacific Ocean, then me and all my trains can fall into the great abyss and into oblivion."

When Ward passed away he donated his entire railroad collection to the Orange Empire Railway Museum in Perris, California. The only items that weren't donated were the Grizzly Flats station and water tower. The price to transport and restore those would not be cost-efficient for a nonprofit organization; besides, both were actually movie props as opposed to historic railroad structures.

INSIDE TRACK: *One distinct feature on the Grizzly Flats Railroad was an old wooden windmill from the late 1880s. While the fact that the wooden windmill survived is impressive enough (by the 1900s farm windmills were being constructed of metal), it's the story of how Ward found the item that's most significant. During*

Ward Kimball strikes a pose in front of his depot. A good chunk of the Grizzly Flats railway can be seen in this photo, including the water tower and enginehouse.

ALL ABOARD

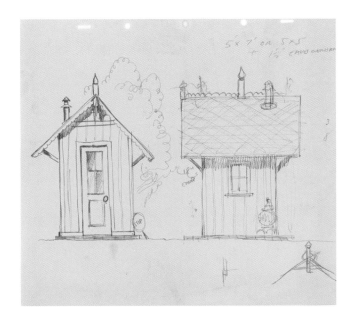

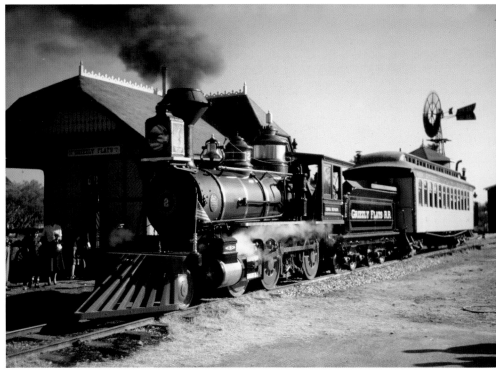

Ward Kimball's design for his watchman's shanty. Originally the only structure on the Grizzly Flats railway. Right: The Emma Nevada *is shown under way. Note the wooden windmill in the background.*

World War II, Ward, along with his fellow musicians from the band the Firehouse Five Plus Two, where driving out of Chino, California, headed back to Los Angeles. They had just finished playing a camp show at the local Army base when it began to storm. With Ward at the wheel, he and the boys in the band were soon hopelessly lost.

Then, as Ward recalls, "the clouds parted and the sun shone upon this old wooden windmill next to a farm." So Ward slammed on the brakes and went running up the front steps to speak to the farmer's wife. While he was still "trying to cook the deal," as he so elegantly put it, the woman suddenly went pale and began to shut the screen door. What Ward didn't realize is that two of his friends from the Firehouse Five had run up behind him. Dressed in long coats and porter hats that they found in Ward's station wagon, the two took on the appearance of stern orderlies from a sanitarium.

Ward sharply turned and reprimanded them: "Beat it guys, I'm trying to buy this windmill!" To which the "orderlies" replied in a soft and reassur-

ing manner, "Yes Ward, you can buy the windmill. It's alright." Suffice it to say Ward did not purchase the windmill that day, and it took quite a few letters and phone calls to convince the lady of the house that Ward was in fact gainfully employed as a Disney animator and not an escapee from a mental institution.

Much has been said about Ward's full-scale railroad, but Ward also had one of the most diverse collections of small-scale trains as well. His collection was so immense that he even owned the very first electrically powered train that Joshua Lionel Cowen, of Lionel Trains fame and founder of American Electric Toy Trains, ever produced. It was a 1901 motorized gondola car, sold to Ward by Cowen himself.

Ward also had a hand in the steam engines the National Parks Service reproduced for the Golden Spike site at Promontory Summit in Utah. He helped identify the historically accurate color scheme and did the artwork on Central Pacific's Jupiter *and Union Pacific's No. 119.*

The Marie E. *as she appeared at Pony Lake Park.*

OLLIE JOHNSTON AND THE *MARIE E.*

THE *MARIE E.* started her adventurous life in 1901 manufactured by the Porter Locomotive Works of Pittsburgh, Pennsylvania, for the Wilkeson Coal and Coke Mines of Wilkeson, Washington, near Tacoma. Simply assigned engine No. 2472 it was not a very glamorous beginning for the small locomotive, but she had an important reputation to live up to. Porter steam locomotives were known to be some of the finest in the world. Manufactured primarily for long repetitive work in industrial areas and coal mines, these tough little powerhouses were reliable and efficient.

She was not a pretty baby. Designed to work underground in low clearances, No. 2472 had a squat low profile and scrunched down cab with just enough headroom for the engineer to cram into. With no tender, cowcatcher, steam whistle, or brass bell she looked more like a thermos bottle on wheels than a functioning steam engine. It was a dark, dirty, and repetitive existence and like the burros that transported the coal and coke before

her, No. 2472 would simply be worked until she was no longer was useful, then her carcass would be dragged out of the mine and sent to the scrap pile. But No. 2472 actually outlived the Wilkeson Coal Company, which ceased operations in 1946.

Having emerged from her subterranean world, No. 2472's next stop was a small amusement park in Puyallup, Washington, called Pony Lake Park. The park consisted of a small pond with an island in its midst—complete with a windmill. There was a scattering of antiquated rides and sad collection of Shetland ponies that methodically carried young riders around the same dreary circle day after day. The little locomotive received a quick garish paint job, a fabricated cowcatcher, and false balloon stack. She also was equipped with a small coal tender and received a shortened name. No. 2472 now would be known as No. 3. It wasn't a glamorous life, but at least it was above ground.

Meanwhile in Southern California in 1961, Ollie Johnston along with his life-long friend and

Impatient to get his new locomotive running, Ollie Johnston has his wife, Marie, along with their sons, Ken and Rick, stand in for the moving parts.

fellow animator Frank Thomas, decided to purchase property together in the town of Julian, an old gold-mining spot about an hour east of San Diego. There they would build summer homes next to each other. Ollie, was no longer satisfied with half-scale railroading after seeing the strides Ward Kimball had made in his backyard operation and decided that he needed a full-scale railway as well. The summer home in Julian was the perfect location for a full-sized narrow-gauge railroad; and with a cooperative neighbor like Frank already there, the track could be extended even farther. There was one thing missing however, a full-scale steam engine.

At first Ollie started looking for small locomotives still operating in South and Central America, but the logistics and shipping costs proved prohibitive, so the search remained closer to home.

In 1965 Ollie got a tip—a family friend, Jerry Best, had located an abandoned small train near a little airport in Puyallup, Washington, that might

fit the bill. Thun Airport was owned by a gentleman by the name of John Thun and the small train that Jerry Best had referred to was in fact our heroine, No. 3. Thun was able to liberate her from Pony Lake Park and set her up at his own attraction The Rock Candy Railroad. The name may sound whimsical but the actual railroad was anything but, with old mismatched rails and an ancient pickle barrel serving as the line's sole water tower. Still it was better than the scrapper's torch and the little engine had yet again lived for another day.

Ollie decided it was worth a look and sent his friend and trusted railroad adviser Laurence Hiney up to investigate. It was there, on a rainy November morning, rusting, rotting, and sunk halfway into the mud that the little Porter locomotive that had waited patiently all these years would finally meet her true destiny. Hiney immediately called Ollie from Thun Airport "Ollie I found your engine and she's worth rebuilding."

Ollie operates one of his three 1/12-scale locomotives.

After seeing her chuffing happily along, Ollie realized that there was still something missing and decided that old No. 3 truly deserved a proper name. It didn't take him long to decide, soon plaques were installed on the sides of the engine cab with the simple words Marie E., the name of the one woman that stuck by him through countless days of soot and smoke, coal and steam: his beloved wife, Marie.

Marie E. spent many happy years in Julian, hauling visiting friends, neighbors, and children along her scenic route. Ollie even constructed a wooden trestle bridge for her to traverse. Everyone in the neighborhood came to love her distinct whistle and familiar sweet smell of burning wood. It was paradise for Ollie and the little steamer.

By 1993 however Ollie's children came to the sad realization that Ollie could no longer maintain the locomotive and made the tough decision to sell the property in Julian. The property, being a prime piece of real estate was soon sold, included in the deal was the small wooden trestle bridge, all of the track, railroad ties, road bed, flat car, caboose and lastly the *Marie E.* It was a bittersweet moment for Ollie as he took his train out one last time along her old familiar route. It appeared that the end had finally arrived for the little locomotive. But as she proved time and time again this little engine was a survivor.

The very next day No. 3 was on a truck headed for sunny California. She arrived in La Cañada and received a complete rebuilding. Her fat rusted saddle tank was removed and her splintered and crumbled excuse for a cab was replaced with a full-sized one that an engineer could actually stand up in. She was converted from coal to wood, received a cowcatcher, a steam whistle, a proper diamond smoke stack, polished brass boiler bands, a beautiful head lamp, and a glistening brass bell. Also included in the sale were two ore cars one of which Ollie quickly converted into a flat car with side stakes the other became a beautiful yellow caboose. The Lilliputian survivor had finally found a good home.

By 1968 Ollie had the No. 3 moved to his new summer home to travel along the half-mile track that made up his newly created Deer Lake Park and Julian Scenic Route.

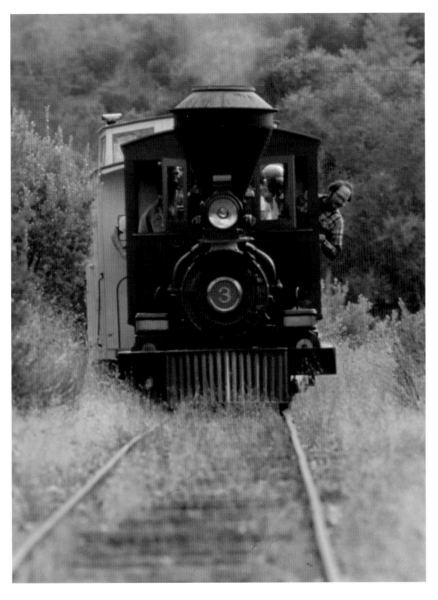

Clockwise from left: The Marie E. *under steam; A quiet moment with Marie and Ollie; Ollie carefully inspects the* Marie E.; *The* Marie E. *undergoes refurbishment.*

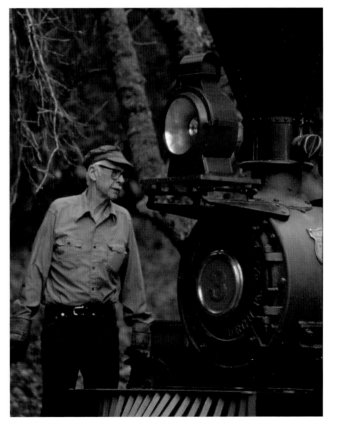

JOHN LASSETER, THE JUSTI CREEK RAILWAY, AND THE RESTORED *MARIE E.*

JOHN LASSETER'S first memory of steam trains is of a small layout he would set up under his family's Christmas tree. While he doesn't recall the actual brand name, he knew it was smaller than his older brother's Lionel. This was just fine by John because "Lionel track never looked right to me; real trains don't run on three

A tender moment with John and his mentor.

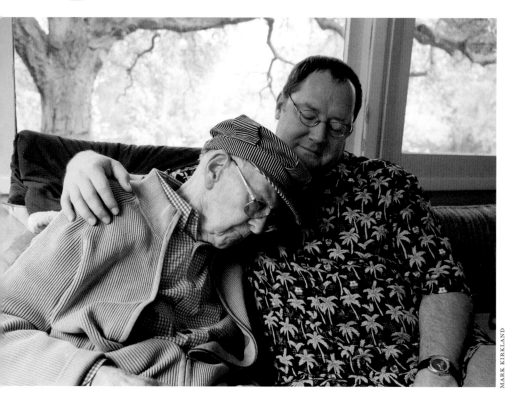

MARK KIRKLAND

rails." Even at a young age, John's eye was trained on details. What was important to him was that his train looked correct, that it looked authentic.

As John got older, the smell of gasoline and perfume lured him away from his train set. He discovered the freedom a car could offer plus how much girls liked guys with cars. It was around that same time that John fell in love with animation. He had found the world of Chuck Jones and vintage animation, but it wasn't until he saw Disney's *The Sword in the Stone* that he decided to make animation his career. John went on to major in character animation at California Institute of the Arts, where he studied under three of Disney's legends—Eric Larson, Frank Thomas, and Ollie Johnston.

John was eventually hired by the Disney Company in 1979 as an animator and would reunite with Ollie Johnston while animating on *The Fox and the Hound*.

Ollie was impressed by the young man's enthusiasm and took the animator under his wing and, in the process, rekindled John's youthful memories and passion for steam trains.

Ollie regaled John with stories of Disney trains past and present, but it wasn't until a fund-

raiser at the Sonoma Country Day School that John officially took the plunge and reengaged with model railroading. A retired gentleman had donated his entire HO-scale layout as part of the event. It was large, it was in good shape, and it was complete. John marveled at the complexity and detail and decided that he "was not going to lose that!" He brought the layout home, set it up, and played with it for hours on end. Lasseter then started to collect more and more HO-scale trains. Eventually his dear friend Marcy Smothers, wife of singer, musician, and comedian Tommy Smothers, told him about her family's love of large-scale LGB trains. She gave John a gorgeous LGB color catalog and he was hooked. John's wife, Nancy, would recall that night after night, he "would fall asleep thumbing through the pages."

In the world of electric model trains, LGB is a very large scale—roughly 1:22—so it's pretty difficult to accommodate anything but a basic circle. John's trains soon outgrew his home. His mom and dad lived nearby, however, and had plenty of space in their living room. Like many other parents of baby boomers, their room was immaculate and reserved for company only. The open floor plan and the fact that it was rarely used made it a perfect location to set up a railroad empire. Even when John's mom Jewell threatened to dismantle the layout from time to time in an attempt to actually use her living room, John's dad Paul always stopped her with an impassioned "You leave Johnnies train set up!"

In 2001, Walt's daughter Diane Disney Miller was working on a film titled *Walt: The Man Behind the Myth* for the one hundredth anniversary of her father's birthday. It is a heartfelt documentary about her dad, reflecting the private side of a man so many knew only as a public figure. Ollie was an integral part of the documentary film, and what made the movie even more special was that Diane selected John to represent the younger generation of Disney animators.

In August of the same year John and his wife

John and Ward in front of the Grizzly Flats switchman's shanty—the next project to be completed on the Justi Creek Railway.

Nancy found themselves seated at the same table as Ollie and Frank Thomas for the premier screening of the film. John started a conversation with his old mentor on the subject he knew was Ollie's favorite, the *Marie E*. "So, how is your train?" Ollie's shoulders slumped as he looked up from his wheelchair. "My sons said I was too old and had to sell the property and the train with it." In actuality, Ollie's sons were moving their father to Washington state to be closer to them, but that didn't matter to Ollie. He was focused on the fact that the train's new owner "never ran the *Marie E*." The small locomotive was only fired up once and then left idle with water still in her boiler. She was separated from the man that loved her and she sat slowly decaying in her old cinderblock train barn.

John hated to see his dear friend in such a sad state. Then he thought about his recently purchased Justi Creek property (he was designing a home for his family) and figured, just as Walt had done before him, that there was more than enough room for a backyard railroad. John slowly turned, and with puppy-dog eyes, looked up at his wife, Nancy. She thought for a moment and nodded with a sigh. John smiled, gently turned back to his friend and said softly, "Ollie, do you think that guy

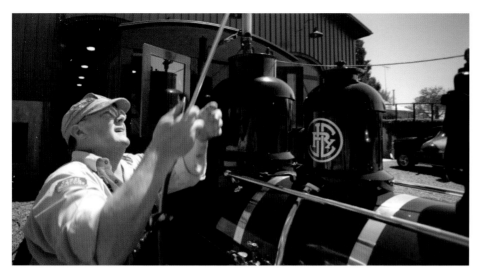

would sell me your train?" Ollie's eyes lit up and he smiled hopefully as he clasped John's hands and asked, "Would you buy my train?" John just smiled and Ollie suddenly looked ten years younger.

As John later recalled, "It would turn out to be the most expensive nod in history."

John purchased the *Marie E.*, along with her flat car and distinctive yellow caboose. A short time later she was being loaded onto another flatbed truck and on her way to the Hillcrest Shops in Reedley, California, for a complete restoration. The locomotive received a proper cowcatcher, a new steam compressor, and all of her worn gauges were restored. A beautifully toned four-pipe steam whistle replaced the single pipe one and her old link-and-pin couplers were updated to knuckles. Lastly, befitting a lady of her stature, she received the high-gloss Disney paint treatment and her electrically powered headlamp was converted to a kerosene lamp, complete with a circular wick. The goal was to have the entire train kerosene lit when operating at night

Ollie was finally at peace. His beloved *Marie E.* had cheated death once again and had found a good home.

Three years later Ollie's best friend Frank Thomas passed away.

As soon as John heard the news he went up to visit his beloved mentor at his home. Ollie was extremely sad. Driving home from the visit John decided that the best way to cheer Ollie up was to let him engineer the *Marie E.* again. But the reality was the trip to John's home in Glen Ellen from Los Angeles where Ollie was now living would just be too difficult for his old friend who had just turned 95. John had to bring the *Marie E.* to Ollie—no easy task.

The problem wasn't so much getting the *Marie E.* down to Ollie, because of her small stature the old girl had ridden on flatbed trailers many times before; but where to put her once she arrived. From her days in the coal mines the *Marie E.* was designed as a narrow-gauge engine. In layman's terms her wheels just weren't wide enough to run on a standard-gauge track. Amtrak couldn't help; neither could LA Metro Rail; even the Travel Town Museum's tracks were just too wide. All of Ward Kimball's old tracks had been taken up and no one felt that taking Ollie and the *Marie E.* back to Julian was a good idea.

Then while driving to Pixar one day John had an epiphany, the one location in the entire Los Angeles area that had a set of rails just the right size for the *Marie E.* was Disneyland.

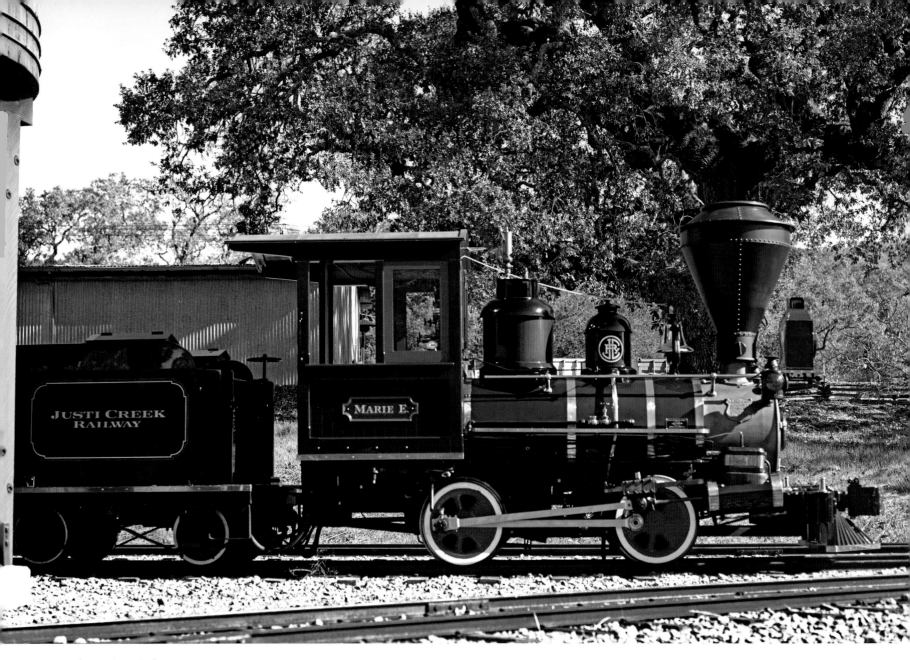

The Marie E. *in her
glorious profile.*

So John approached the executives at Disneyland to see if the *Marie E.* could do a circle around the park, the little engine being the exact same wheel gauge as her bigger cousins. They were open to it, but nothing like this had ever been attempted. The legal red tape made it look doubtful. So up against all odds and with the same determination of a young Walt Disney trying to make his way to the cab of a moving steam engine, John Lasseter set to work to make the impossible, possible. John along his attorney Philip Kalsched, and the Disney legal team, eventually came up

with what can best be described as a loophole in the ironclad Disney insurance rider. Disney allows privately owned construction equipment to work at Disneyland as long as the equipment is operated only by the employees of the company that owns the equipment. For insurance reasons, it is strictly forbidden for Disney employees to operate or ride anywhere on the equipment. So the Marie E. and her caboose became construction equipment for the day. Ollie and his son Ken became employees of John's railroad as well. The problem was that then chairman Michael Eisner and future

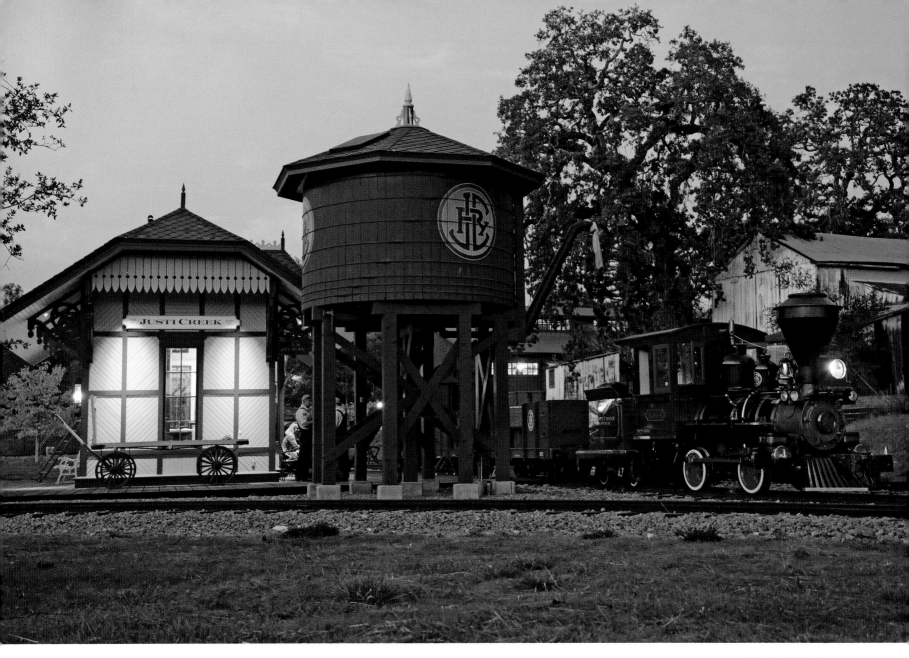

The Justi Creek station, formerly the Grizzly Flats station, formerly the Fulton Corners station.

chairman Bob Iger wanted to have a ride as well.

John proposed a compromise to keep the lawyers and insurance folks happy. So for one day both Michael Eisner and Bob Iger would be hired on as employees of John's railroad at the rate of one dollar each for the day.

On May 6 the *Marie E.* along with her bright-yellow caboose was quietly loaded onto a flatbed truck and driven down to Anaheim where she patiently waited outside the Disneyland roundhouse for her big day. Although she was seen by many of the cast members working around the roundhouse everyone kept the secret.

Finally on May 10, 2005, Ollie was invited to Disneyland. The premise was that in celebration of the park's fiftieth anniversary, he would be honored for helping inspire Walt Disney's love of trains, which had led Walt to build Disneyland.

John would later recall getting the train to Disneyland on that fateful day was like "setting up a military operation." The *Marie E.* was fired up and hidden inside the Adventureland Tunnel just outside the New Orleans Square Station. Ollie in

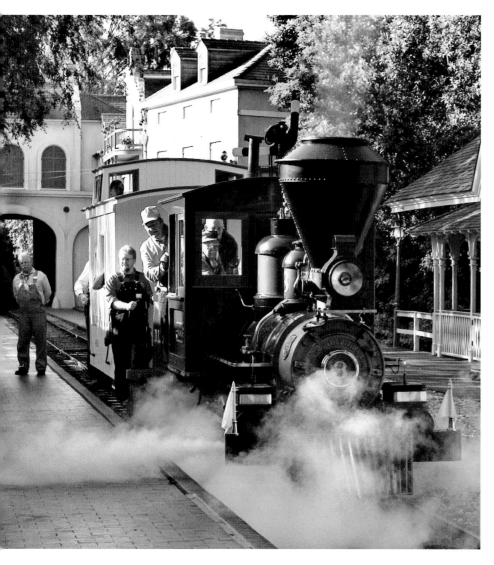

his cap and windbreaker listened to the speeches and graciously accepted a plaque. Then a shrill steam whistle broke the morning silence.

To Ollie's surprise, a gleaming steam engine pulled into the station right behind him. Ollie at first thought it was one of the Disneyland engines. Ollie's son, Ken, then leaned down and whispered in his father's ear, "Dad, it's your train." Ollie immediately broke into tears, as did everyone who was there.

Ollie hadn't seen his little locomotive in years and his face beamed at the sight of her, her brass glistening in the early California sun. Everything had been planned down to the smallest detail and the planets where finally all in alignment.

That's not to say there weren't a few close calls. When Ollie first entered the park it was discovered that there was no seat belt in the *Marie E*'s cab, so a quick-thinking cast member dashed over to the Matterhorn attraction, which was in the midst of renovation, to snag one of the old seat belts. They made it back just in time to secure the purple seat belt from the Matterhorn Bobsled into the cab of the *Marie E.* so Ollie could travel safely.

As that problem was being solved another quickly arose. The transfer ramp that would accommodate Ollie from his wheelchair to the engine cab was a few feet short. A steel plank was soon brought out to accommodate the gap, but it was missing handrails. So an impromptu honor guard of Disneyland engineers that had come to watch the ceremony stood on either side of the ramp and locked arms to help Ollie onto his train.

Ollie calmly sat down on the engineer's seat, took the throttle in his hand, gave two short toots, and was off driving the *Marie E.* as if they had never been apart. Ollie circled the park three times. He probably would have continued well into the day, but it was time for Disneyland to

Above: Ollie skillfully guides the Marie E. *into New Orleans Square station. Right: A clearly delighted Ollie Johnston shares the day with his friend and former student, John Lasseter.*

open and for the *Marie E.* to discharge her passengers and return home.

Ollie's wife Marie passed away less than a week after his final train trip and Ollie passed away later the same year. But as they say his legend lives on. To date the *Marie E.* remains the only piece of outside railroad equipment to have run on the tracks of a Disney property. In memory of this occasion, John Lasseter affixed a bronze plaque on the side of the *Marie E.*'s boiler proclaiming the accomplishment, a tradition heralding back to the golden age of railroading. It simply reads:

MARIE E. DISNEYLAND STEAM UP

A TRIBUTE TO OLLIE JOHNSTON

MAY 10, 2005

THE ONLY PRIVATE TRAIN EVER TO RUN

ON THE RAILS AT DISNEYLAND.

While there were many events to celebrate Disneyland's fiftieth anniversary, most agree that this little moment in May was the most memorable. Perhaps it's because, as John so eloquently puts it, "it wasn't decided in a board room or marketing meeting, but was decided in our hearts."

The *Marie E.* now happily resides on John's Justi Creek Railway, named after the seafaring family which owned the property for four generations. Here the little Porter, along with a few new cars, happily chuffs between the neat rows of grape arbors of the Lasseter Family Vineyards transporting a delighted cadre of family, friends, rail enthusiasts, and school children behind her. John was given Ward's Grizzly Flats station by Ward's family after Ward had passed away. He had the former Fulton Corners station dismantled and shipped along with Ward's old water tower and

watchman's shanty. The station, now reconstructed and christened the Justi Creek station it is now filled with a wide variety of railroad memorabilia. The old Water tank has been reconstructed as well supplying clean water for the *Marie E.* When the *Marie E.* isn't running, John travels the line in a restored rail inspection car. The car, a gift from Walt to Ollie, is also a familiar perch for John's chocolate Labrador, Moose, as it sputters and bangs down the tracks. John houses all of these treasures in a three-track engine house along with his impressive collection of LGB model trains.

John has made a conscious decision to keep the magic of Disney steam trains alive. In a time of cutting-edge, computer-generated imagery, John maintains a strong connection to the past. After all when steam locomotives arrived on the scene, they too were cutting-edge technology. John is a skilled engineer, a dedicated curator, and the future of the *Marie E.* and all Disney trains are truly in safe hands.

Still, this author came away from my visit to the Justi Creek Railway with a different feeling. I realized that it's not the technology so much as the story that John appreciates the most. Every original plank in the water tower and every running board on the *Marie E.*, has a special tale to tell.

During my visit to the *Marie E.*, content and safe in her cozy engine house, I discovered one more cherished item—not so grand as a brass engine plaque but I suspect a very special memory for Ollie's apprentice. When I opened a small jockey box inside the cab, neatly folded in one corner I saw a worn purple seatbelt from the Matterhorn attraction.

I met with John Lasseter to report on a backyard railroad, but what I came back with was a love story.

5 Behind the Roundhouse

*The Not-So-Hidden Secrets
of Disney Trains*

*Concept art for Disneyland.
Notice the locomotive roundhouse.*

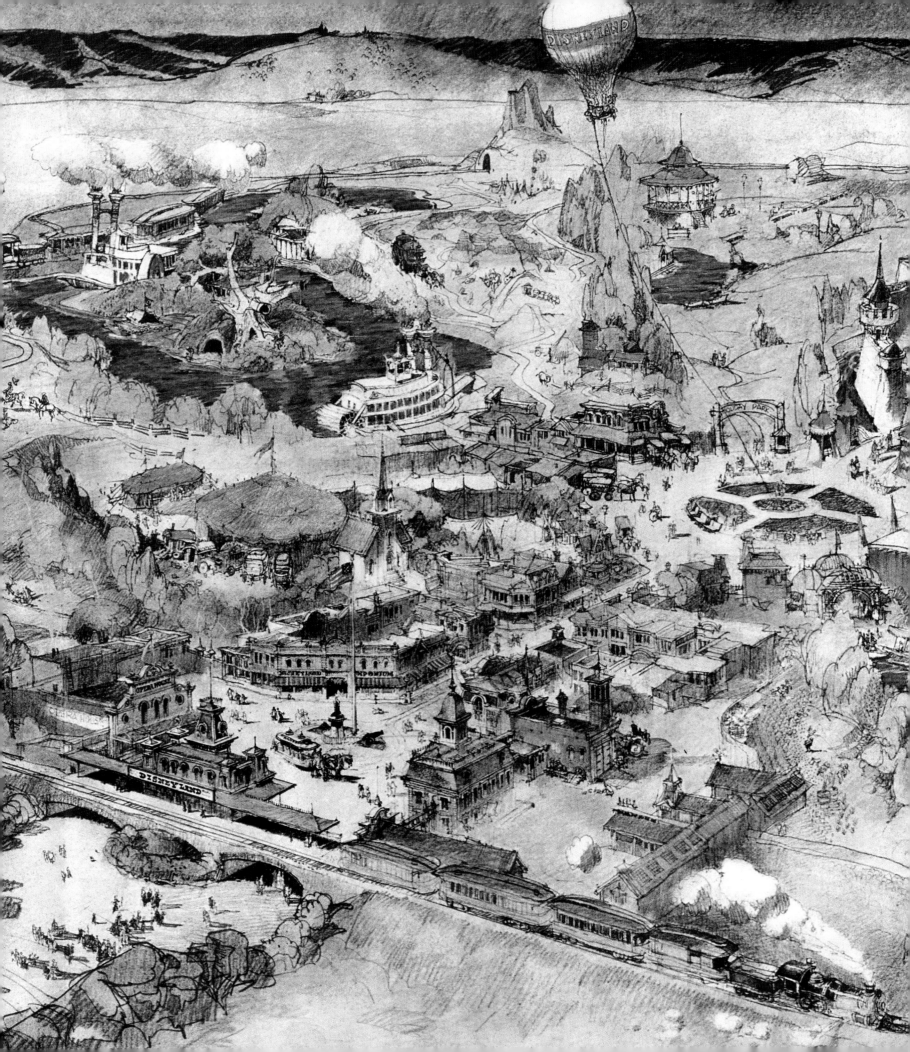

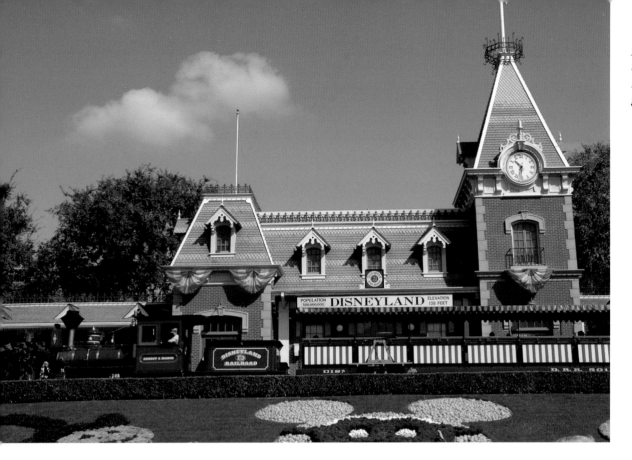

Main Street station, one of the only full-size structures in all of Disneyland, has been welcoming guests since 1955.

DISNEY THEME PARK TRAINS

THE DISNEY CASTLES are among the most iconic images in the world. Seen from a distance, they promise a magical experience. But as you near the entrances of the parks, the castles essentially disappear. At close range, guests must travel through the Main Street Railroad Station.

This is the start of a carefully orchestrated journey, one that Walt himself took many times and one he wanted to take us on as well. During the early 1900s, if someone from Marceline wanted to see the world there were three choices—walk, ride a horse, or take the train. The train, or in this case the train station, represents an escape, a promise leading to an exciting adventure.

The Disney trains offer a treat for the senses. One long and one short blast from a whistle in the distance signal the arrival of a steam engine. It emerges partially enveloped in smoke and steam, which quickly disperse to reveal brightly colored boilers and polished brass fittings gleaming in the sunshine. The engineer will give you a wave, welcoming you to come on board and enjoy the journey. You see the moving wheels; smell the coal smoke; feel the vibration and heat; hear the whistle, the bell, and the chuff-chuff-chuff. This is theatrics at its best, the opening act of a magical experience.

Even when Walt could barely afford a rail ticket, he always still took the journey. This sense of excitement, this promise of adventure, lives on in all the Disney parks around the world. So come aboard and take a journey with the locomotives of the Disney theme parks.

ALL ABOARD!

The DISNEYLAND RAILROAD

at the MAIN ST. FRONTIERLAND or TOMORROWLAND 3 Depots

Colorful Disneyland Railroad posters harken back to the golden days of railroading. Engine No.1, the C. K. Holliday, *is depicted in this one.*

137

THE DISNEYLAND RAILROAD

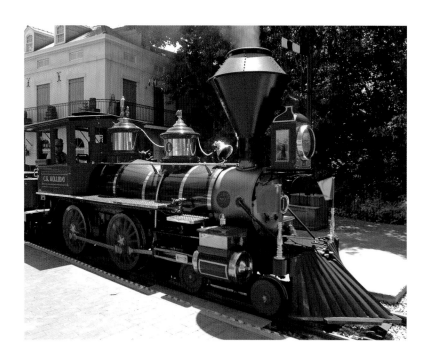

ON JULY 17, 1955, Walt Disney eased down the throttle of No. 2, the *E. P. Ripley*, as he approached Main Street Station. Riding with him in the cab were California governor Goodwin J. Knight; Atchison, Topeka and Santa Fe Railroad president Fred G. Gurley; and a large plush Mickey Mouse. On the platform awaiting his arrival was Art Linkletter, veteran film star Ronald Reagan, and a small army of television camera crews that would document the opening of Disneyland.

Exactly one year earlier, all that was on this 160-acre property in Anaheim were orange groves.

Walt had built his park, and it was surrounded by a train.

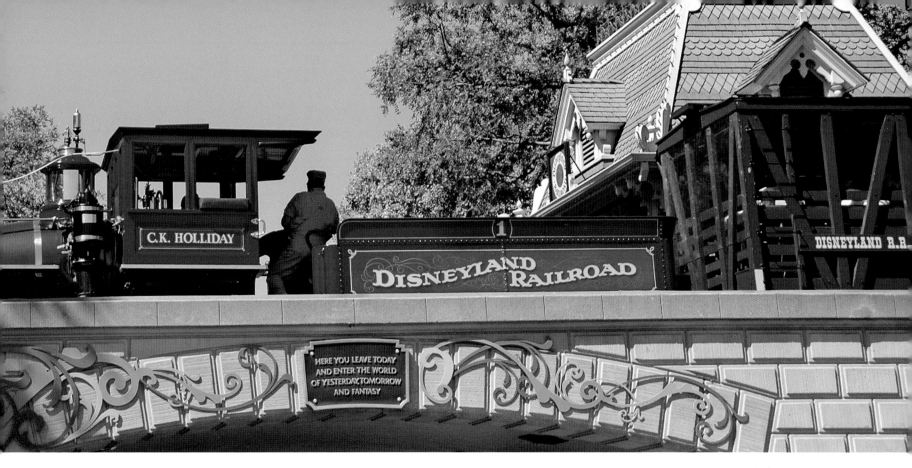

ENGINE NO. 1
C. K. HOLLIDAY

Livery: Red cab, Russian iron blue boiler jacket

Wheel Configuration: 4-4-0

Smoke Stack: Balloon stack (large)

Prototype: Central Pacific 173

Built: 1955 in Burbank, California, at the Disney Studio by WED Enterprises (now known as Walt Disney Imagineering)

Named after Cyrus Kurtz Holliday, founder of the Santa Fe Railroad, the locomotive went into operation on opening day of the park, July 17, 1955.

According to several reputable sources, the design of the *C. K. Holliday* mirrors that of the *Lilly Belle*, the centerpiece of Walt's backyard railroad, the Carolwood Pacific, with the original one-eighth-scale plans simply enlarged to five-eighths. Although not exact, it can be argued that Engine No. 1 is by far the most similar engine to the *Lilly Belle* running in the Disneyland Railroad today.

INSIDE TRACK: *The locomotive sports a balloon smokestack used in the early days of railroading when wood was burned as fuel. The large wide top of the stack, a common sight in the 1870s, housed a device that would prevent sparks from flying out of the smokestack and possibly setting the surrounding area and even the train itself on fire.*

Engine No. 1 was the first engine of the Disneyland Railroad to add a ventilation hatch on its roof. This small hatch, which is now on all the Disneyland locomotives, helps alleviate the Southern California temperatures, sometimes in excess of 130 degrees, that the engine crew has to endure in the cab.

The Holliday *departs Main Street station. Note the fluted steam and sand domes. Opposite: The square headlamp on the* Holliday *represents an oil-fired lamp.*

ENGINE NO. 2
E. P. RIPLEY

Livery: Green cab and tender, green boiler jacket
Wheel Configuration: 4-4-0
Smoke Stack: Straight cap
Prototype: Baltimore & Ohio 774
Built: 1954 in Burbank, California, at the Disney
 Studio by WED Enterprises

Named after Edward Payson Ripley, an early president of the Atchison, Topeka and Santa Fe Railroad, the locomotive entered service on July 17, 1959.

The *E. P. Ripley* would be the last locomotive to be custom built by the Disney shops. At a cost of nearly $50,000, it was decided that to construct another *C. K. Holliday* or *E. P. Ripley* from the ground up simply would not be cost effective. It was Roger Broggie, the machine shop foreman for the Studio, that suggested to Walt to search for existing narrow-gauge locomotives and not only restore them but exceed their former glory.

INSIDE TRACK: *Modeled to resemble engines of the 1890's when coal was the dominant fuel used, the* E. P. Ripley *has a straight smokestack, as the spark-arresting mechanics would now be located in the smokebox. Coal produces far fewer sparks than wood. The top of the smokestack still features a bright brass cap.*

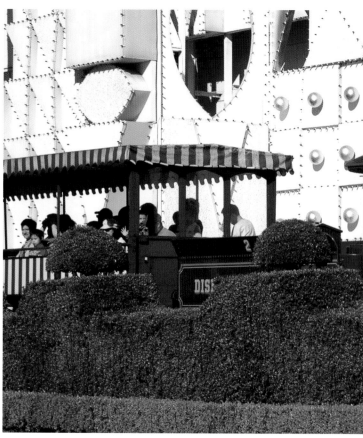

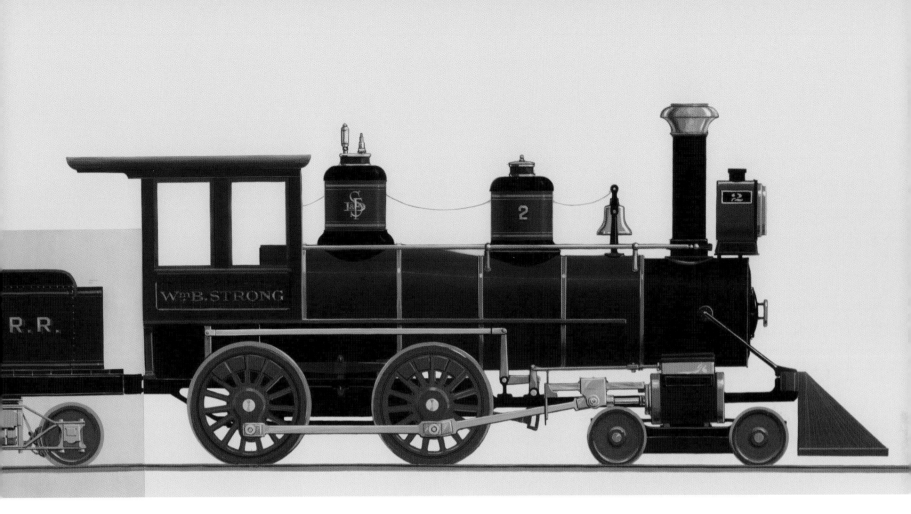

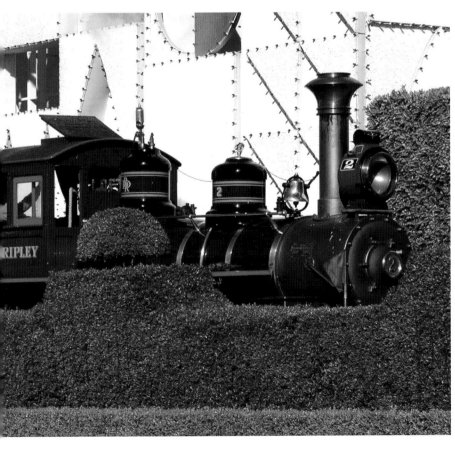

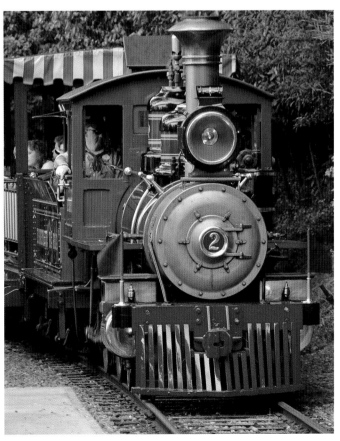

ENGINE NO. 3
FRED GURLEY

Livery: Hunter green cab, Russian iron-blue
 boiler jacket
Wheel Configuration: 2-4-4
Smoke Stack: Straight cap
Prototype: Forney
Built: 1894 by Baldwin Locomotive Works
 in Philadelphia

Named after Fred Gurley, the chairman of the
Atchison, Topeka and Santa Fe Railroad at the time
of Disneyland's opening, it was originally used to
haul sugarcane at a Louisiana plantation, the en-
gine was purchased for the Disneyland Railroad in
1957 for $1,500. Following a $35,000 restoration,
the *Fred Gurley* entered regular service at Disney-
land on March 28, 1958. Now more than 120 years
old, the *Gurley* is the oldest locomotive operating at
any Disney theme park.

The *Fred Gurley* is a Forney locomotive. (The
designation Forney describes an engine with a
single-frame design.) The fuel supply is attached
right to the frame as opposed to being hauled
behind in a tender. It's compact design and ability
to take tight corners made her a favorite for planta-
tions, lumber mills, and elevated city service.

For her opening run on the Disneyland Railroad,
Fred Gurley attended the dedication and rode in
the engine's cab with Walt. It was Fred who had
arranged for Walt and Ward Kimball to travel to
the 1948 Chicago Railroad Fair in style aboard the
Santa Fe *Super Chief*. Fred even let the pair ride in
the diesel locomotive's cab for part of the trip, blow-
ing the massive diesel horn at level crossings.

So it was only fitting that Walt returned the favor
of a cab ride. Before they departed, ninety-six-year-
old Chief Nevangnewa of the Hopi tribe blessed
the train that would take the guests to the newly
opened Grand Canyon exhibit.

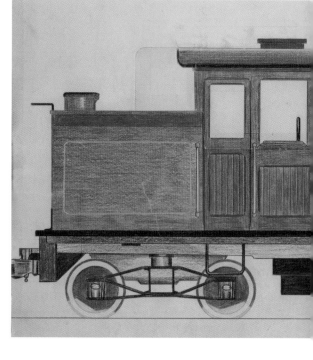

*Top right: Original
concept for the Fred
Gurley. Right: Note the
brass eagle on the dome
directly behind the
smokestack, a detail
present in each of the first
four locomotives on the
Disneyland roster.*

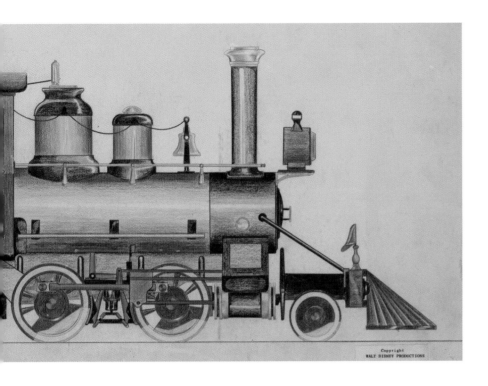

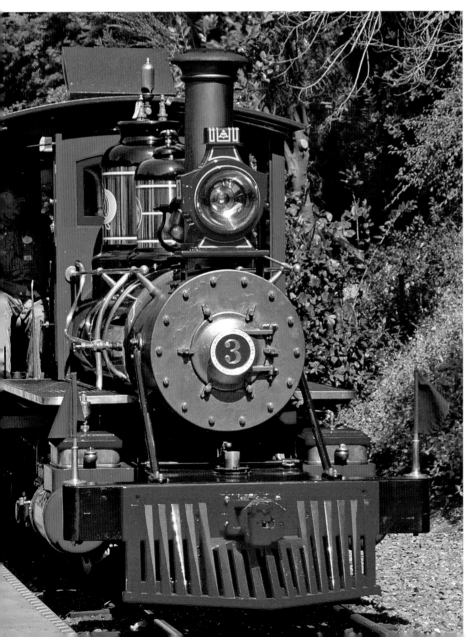

INSIDE TRACK: *Although she's the oldest, No. 3 is regarded by many Disneyland engineers to be the best-running locomotive of the fleet. She is easy to steam up and has great pulling power.*

If you look closely at the top of the Fred Gurley's *tender tank, you will see a hidden Mickey drilled into the steel.*

Harley Ilgen was the Disneyland Railroad's chief engineer when Walt wasn't on the property, and he was operating the Fred Gurley *at the locomotive's dedication. Ilgen had helped restore the engine and had a special fondness for her. On August 4, 1963, while operating the* Fred Gurley *through the Grand Canyon diorama, he suffered a heart attack and died with his hand still on the throttle. Soon after, several train crews started to report an interesting phenomena occurring on the* Fred Gurley. *On still, balmy nights, after departing from Toontown Station, the* Gurley's *bell would begin to sway back and forth, gaining momentum until the clapper actually started to hit the brass. The bell would then begin to ring, faintly at first but much louder when the locomotive passed "it's a small world." All of this happened without the fireman tugging the bell cord.*

While this can be easily explained away as vibration, it is interesting to note that the track is very level along this section and no other locomotive in the Disneyland roster has experienced the phenomena. In addition, the bell has also been reported to ring independently while the locomotive is stopped at a station.

Of course, for those of us who love the traditions and folklore of railroading, this can be explained only one way: Harley Ilgen is still riding in his favorite locomotive and letting the train crews know, with a gentle tug of the bell, that he is watching over them while keeping a watchful eye on his favorite engine.

ENGINE NO. 4
ERNEST S. MARSH

Livery: Red cab and tender, red boiler jacket
Wheel Configuration: 2-4-0
Smoke Stack: Diamond Stack (Small)
Prototype: Denver & Rio Grande Western
Montezuma
Built: 1925 by Baldwin Locomotive Works,
Philadelphia

Named after the president of the Atchison, Topeka and Santa Fe Railroad at the time of Disneyland's opening, this locomotive went into service on July 25, 1959.

Originally designed as a saddle tank locomotive, meaning that her water tank supply was carried around her boiler in saddle fashion, she was not a very pretty sight. This configuration was efficient, however, as the extra weight centered above her driving wheels, giving her more stability.

Similar to the *Fred Gurley*, she also had no separate tender. Coal was stored in a small bunker directly behind the locomotive's cab. She began life hauling sand for the Raritan River Sand

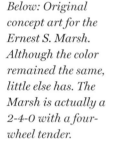

Below: Original concept art for the Ernest S. Marsh. Although the color remained the same, little else has. The Marsh is actually a 2-4-0 with a four-wheel tender.

Company and was purchased in 1958 by Roger Broggie for the Disneyland Railroad for $2,000.

The new configuration of the locomotive was the brainchild of Ward Kimball. Ward had the saddle tank removed and modeled the now stripped locomotive to resemble the Denver & Rio Grande Western Railroad's very first steam engine, the *Montezuma*. Ward also added a four-wheeled tender, the same configuration as on the *Montezuma*, and a diamond-shaped balloon stack, and retained a close-to-original paint scheme.

INSIDE TRACK: *During the locomotive's journey to Disneyland from New Jersey (where it was discovered), it was accidentally misrouted to a railroad yard outside Pittsburgh, where it languished on a siding. It was only after Walt called his good friend and the engine's namesake, Ernest Marsh, that the locomotive was rerouted. With Ernest now personally handling the operation, all tracks were cleared and the locomotive made it to Disneyland in record time.*

Since her heavy saddle tank has been removed, the Ernest S. Marsh *tends to ride a little rougher than her sister engines of the Disneyland fleet.*

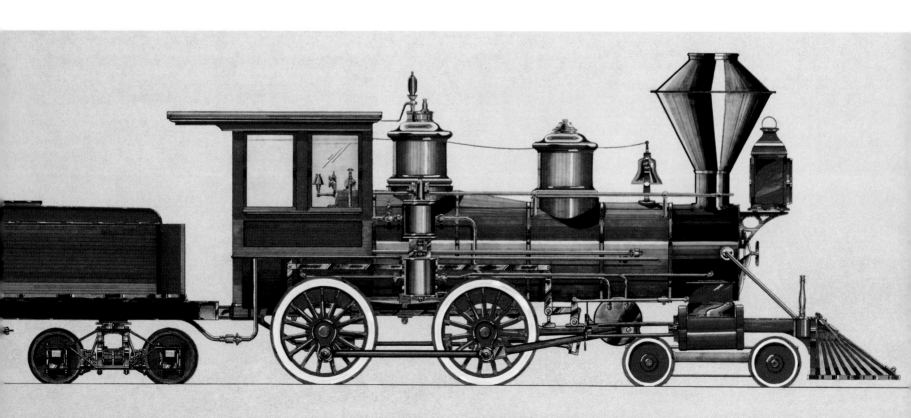

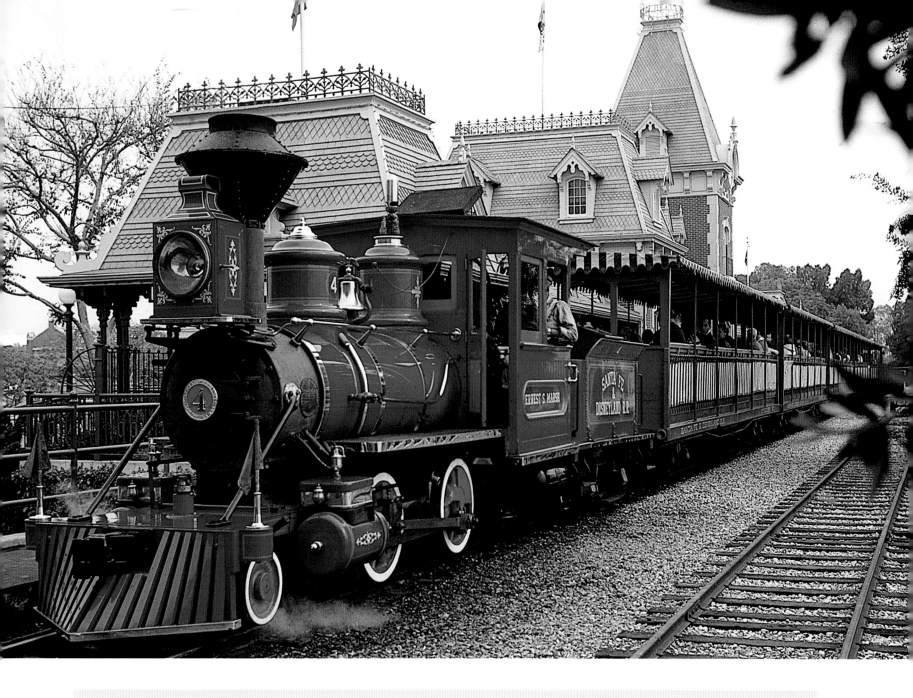

WHO IS RETLAW?

Although the Atchison, Topeka and Santa Fe Railway sponsored the Disneyland Railroad, the rail line and all of the trains were actually owned by Walt under his private company, Retlaw (Walter spelled backwards) Enterprises. Walt was the president, CEO, and sole proprietor of the corporation, and Retlaw's holdings also included the *Mark Twain* Riverboat and later the Monorail. All of the train crews worked directly for Walt, and he would personally sign their paychecks. From time to time, Walt himself would climb into one of the train cabs and operate the locomotives, the guests riding behind in the cars blissfully unaware.

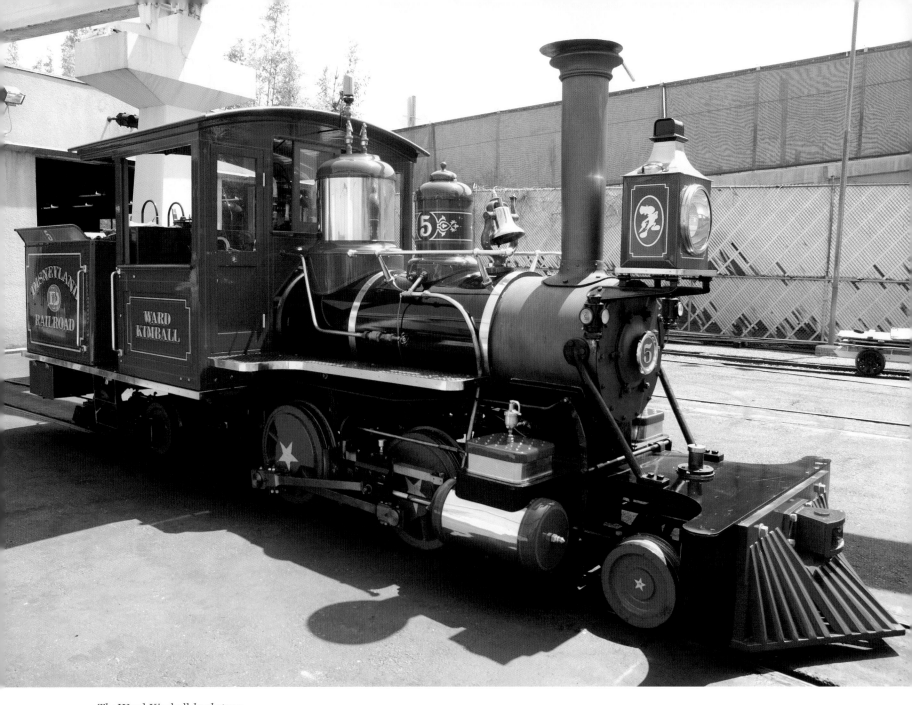

The Ward Kimball *backstage by her enginehouse. Note the Jiminy Cricket silhouette on the headlamp and the Monorail pillar behind her.*

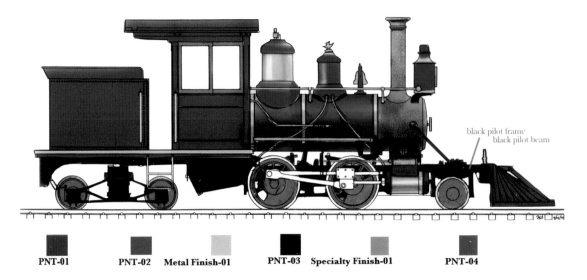

black pilot frame
black pilot beam

| PNT-01 | PNT-02 | Metal Finish-01 | PNT-03 | Specialty Finish-01 | PNT-04 |

The detailed pinstriping on the Kimball was based on its namesake's small plantation locomotive, the Chloe.

ENGINE NO. 5
WARD KIMBALL

Livery: Red cab, midnight black boiler

Wheel Configuration: 2-4-4

Smoke Stack: Straight cap

Prototype: Forney

Built: 1902 by Baldwin Locomotive Works, Philadelphia

This engine was entered into service on June 25, 2005. Because of Kimball's dedication and passion for all things railroad, it is only fitting that the last locomotive to join the Disneyland Railroad roster of steam engines is named after him. It is the only locomotive on the Disneyland roster not to be named after a Santa Fe executive.

Engine No. 5 began her life on the Barker and Lepine Plantation Railroad hauling sugarcane. Her original name, actually painted on the side of her cab at the Baldwin factory, was *Maud L.* Long-rumored to be the mistress of the plantation owner, the nameplate has since been removed and is currently hanging on the wall of the Disneyland enginehouse.

First manufactured in Philadelphia, the engine started out on a sugarcane plantation in Louisiana; then it was saved from the scrap heap to work in an amusement park in Michigan, finally arriving at Disneyland. The *Ward Kimball* has the distinction of having traveled the longest distance before arriving at the park.

INSIDE TRACK: *Ward had a great deal of influence over the redesign and color scheme of his namesake engine. The pinstriping and filigree pattern mirror the design on Ward's personal locomotive, the* Chloe, *and if you look closely at the tiny steamer's headlamp, you'll see two separate portraits of one of his most beloved characters, Jiminy Cricket.*

DuPont manufactures the metallic midnight blue paint used in the restoration of the Maud L. *It is called Imron and is a polyurethane enamel that is also used in aviation paint. Tough, weather resistant, and with a high sheen, the Disney restorers are especially cautious to use every last drop, seeing that a gallon costs in excess of $900.*

Although Ward did not live long enough to see his namesake locomotive steam around Disneyland, his wife, Betty, and son, John, where both present for the debut. John had the honor of dedicating the engine, christening the tender with a bottle of champagne that shattered in an explosion of pixie dust.

Here comes the No. 4 locomotive, the Roy O. Disney, in all her polished glory.

WALT DISNEY WORLD RAILROAD

ALL THE LOCOMOTIVES currently in use on the Walt Disney World Railroad are actual vintage steam trains. Manufactured by Baldwin Locomotive Works in Philadelphia between 1916 and 1928, the locomotives were built for use in Mexico on the *Ferrocarriles Unidos de Yucatan* (United Railways of the Yucatan). These hardworking little locomotives, nicknamed *toros de fuego* (fire bulls) by the indigenous Mayan population, were used to haul sugarcane, hemp, and passengers through the jungles of eastern Mexico.

In 1969, Disney scouts (under the direction of Roger Broggie) discovered five of these engines nearing the ends of their lives in Merida, Mexico. All five were purchased for $32,750, but only four were actually restored—the fifth was too deteriorated to rescue. Shipped to Tampa, Florida, they went through a massive renovation at a local shipyard. The locomotives were fitted with new diamond smokestacks, steam whistles, boiler jackets, cowcatchers, and headlamps.

Their wheels and side rods are still original. Lastly, new fiberglass cabs and new tenders were manufactured and all received the signature Disney paint job. It was quite a makeover for the little fire bulls. During the restoration, their respective passenger coaches were built from scratch.

When the park first opened on October 1, 1971, locomotives No. 1 *Walter E. Disney*, No. 2 *Lilly Belle*, and No. 3 *Roger E. Broggie* were all present. A fourth engine, No. 4 *Roy O. Disney*, entered service a few months later.

ALL ABOARD

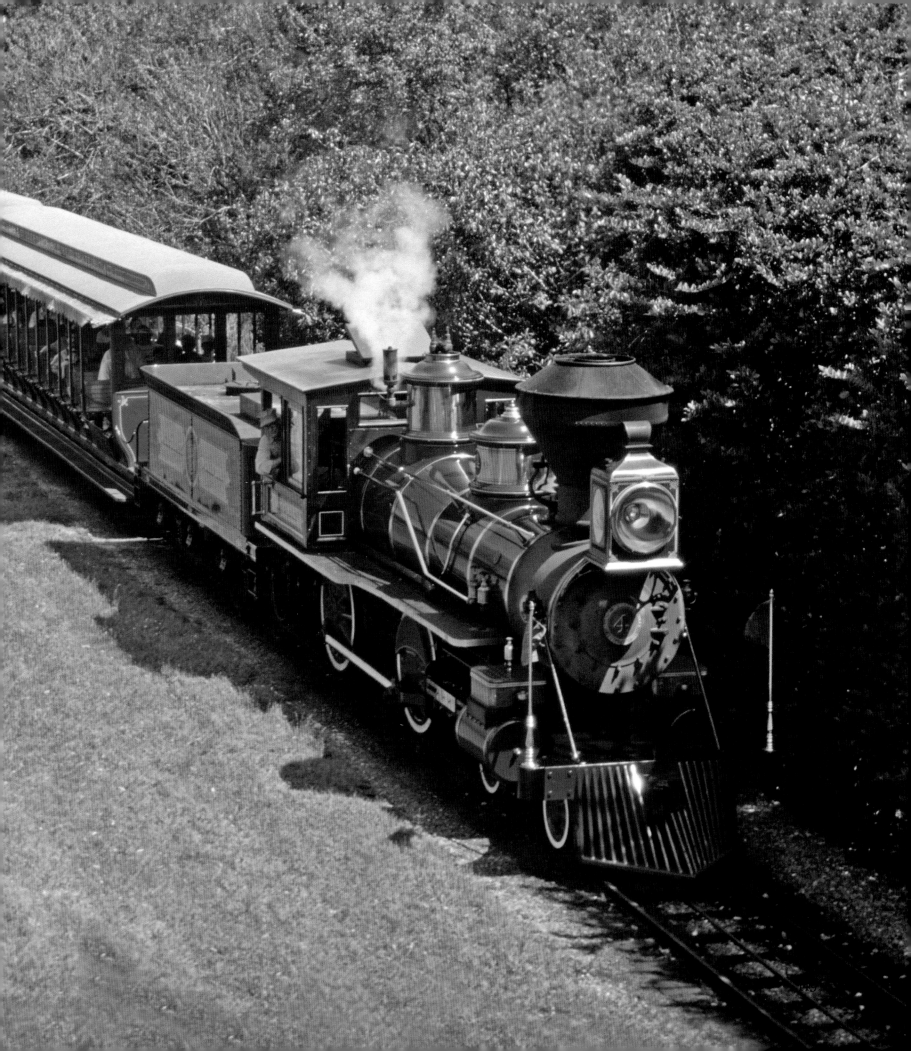

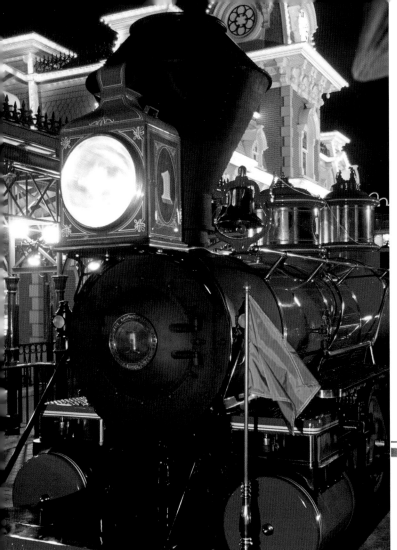

Left and bottom: The green flags on the front of the locomotive harken back to early days of railroading, indicating that another section is following.
Below: Original concept drawing of the Walter E. Disney.

ENGINE NO. 1
WALTER E. DISNEY

Livery: Red cab, red boiler jacket

Wheel Configuration: 4-6-0

Smoke Stack: Diamond stack (large)

Built: 1925 by the Baldwin Locomotive Works in Philadelphia, Pennsylvania.

Named after Walt Disney himself, whose love of railroads helped establish Disneyland and Walt Disney World.

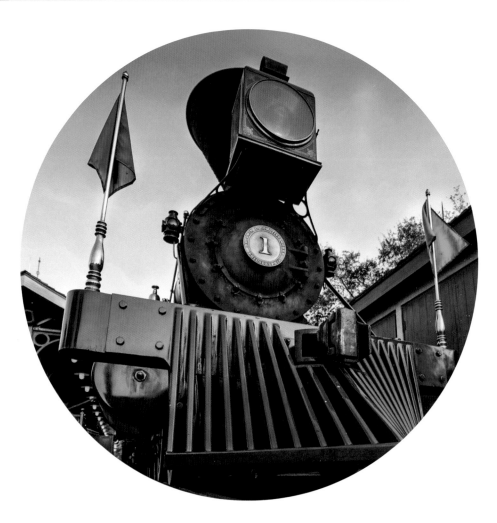

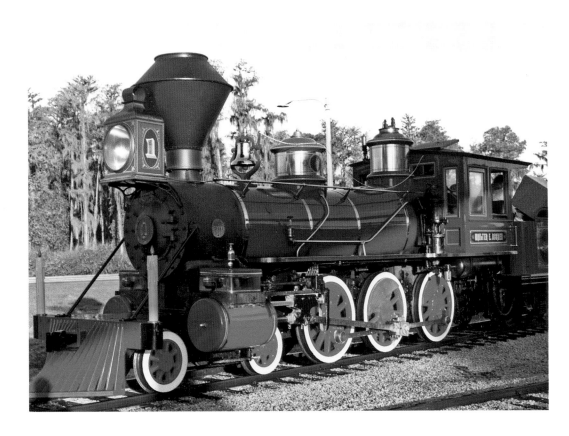

Sand would be released from the No. 1's red-and-gold sand dome and spread onto the tracks to aid in traction. The location of the dome above the boiler was to keep the sand dry, thus making it easier for the substance to flow through the tubes.

Above: Concept art. The design and color scheme for this train was eventually assigned to the No. 2 Lilly Belle. Right: The Lilly Belle *tradition-ally opened the park in the morning, so her passenger coaches have been modified to allow the Disney characters easy-on, easy-off access.*

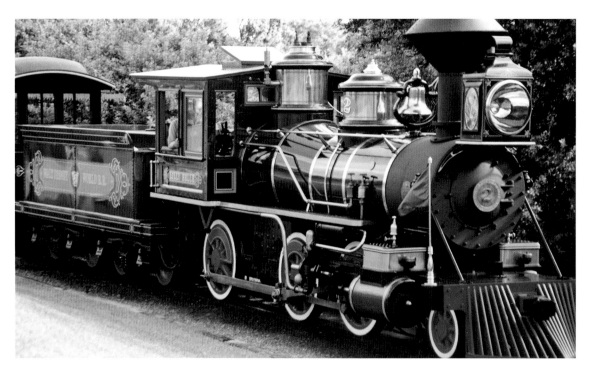

ENGINE NO. 2
LILLY BELLE

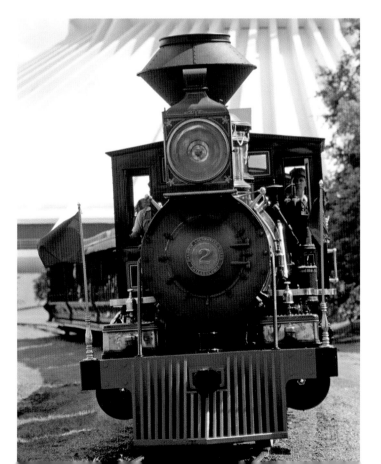

Livery: Dark green cab, green boiler jacket

Wheel Configuration: 2-6-0

Smoke Stack: Diamond stack (small)

Built: 1928 by the Baldwin Locomotive Works in Philadelphia

Named after Walt's wife, Lillian, it was also the name given to Walt's first scaled-down steam locomotive that ran in his home's backyard.

INSIDE TRACK: *The* Lilly Belle *was built the same year that Mickey Mouse debuted in* Steamboat Willie.

Left: The Lilly Belle *passes Space Mountain. More than 1.5 million guests ride on the Walt Disney World Railroad annually.*

Original concept for the Roger E. Broggie. The name and number where later changed, but the color scheme remained the same.

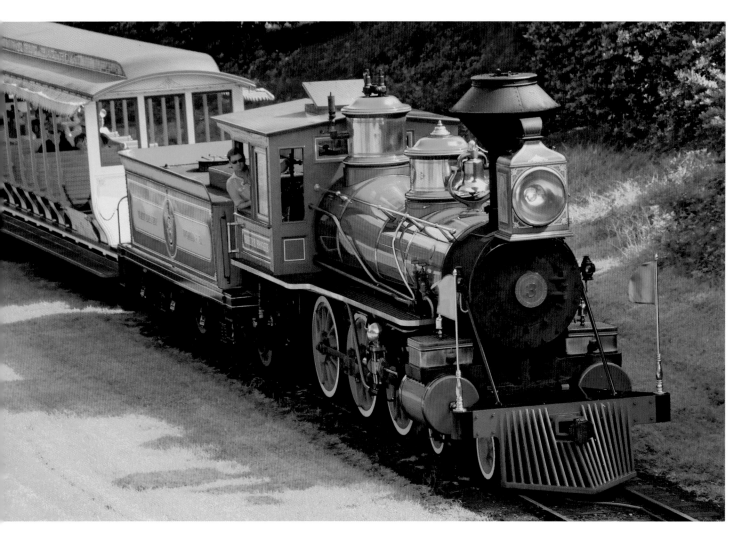

A fun way to tell Walt Disney World trains apart is by what coaches they pull. Most of the time Walt pulls the red coaches, Lilly the green, Roger the yellow, and Roy the blue.

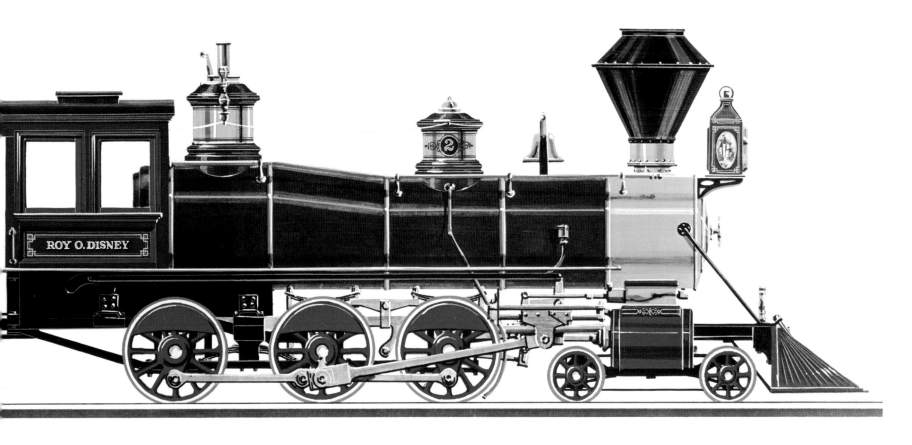

ENGINE NO. 3
ROGER E. BROGGIE

Livery: Red cab, green boiler jacket
Wheel Configuration: 4-6-0
Smoke Stack: Diamond stack (small)
Built: 1925 by the Baldwin Locomotive Works in Philadelphia

Roger Broggie was Walt's chief mechanic at the Disney Studio. He helped with construction and restoration of the Disneyland locomotives and was responsible for finding the steam locomotives for the Walt Disney World Railroad. He was also one of the original Imagineers that worked on the Epcot theme park.

Roger originally purchased a fifth locomotive, but in the end it was too far gone to be restored.

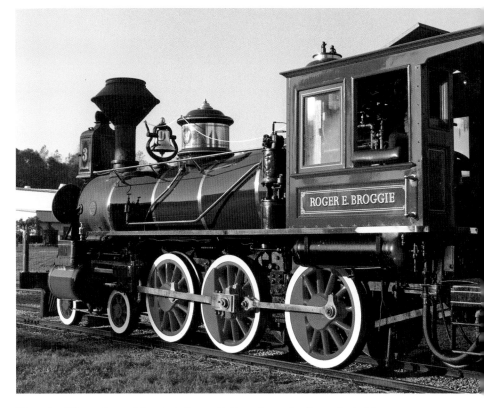

Named a Disney Legend in 1990, Roger E. Broggie received a train in his honor since he was one of the driving forces behind the Disney railroads.

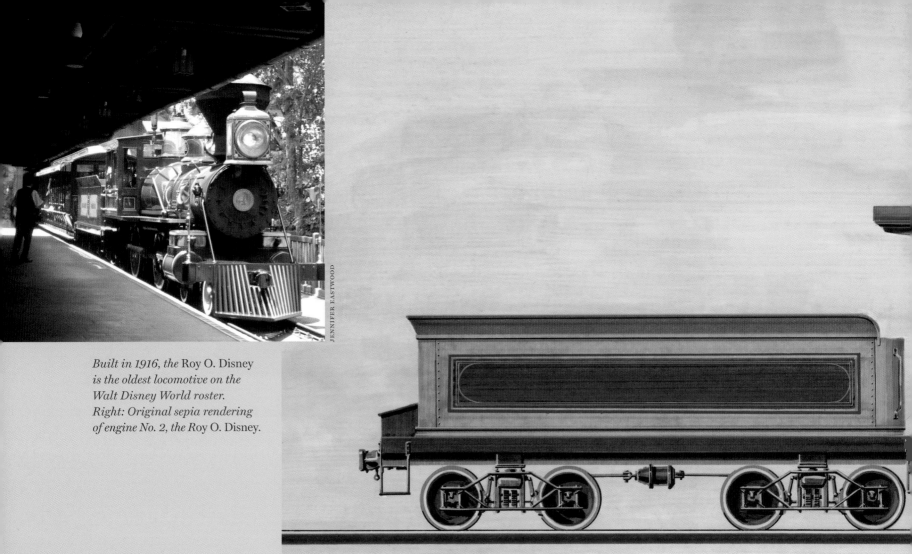

Built in 1916, the Roy O. Disney *is the oldest locomotive on the Walt Disney World roster. Right: Original sepia rendering of engine No. 2, the* Roy O. Disney.

WA

ENGINE NO. 4
ROY O. DISNEY

Livery: Green cab, red boiler jacket,
Smoke Stack: Balloon stack (large)
Wheel Configuration: 2-4-2
Built: 1916 by the Baldwin Locomotive Works in Philadelphia

This engine was named after Walt's older brother and business partner, Roy Oliver Disney. After Walt's death in 1966, Roy saw through the creation of what was then known as Disney World. Roy changed the name slightly to Walt Disney World in honor of his younger brother.

INSIDE TRACK: *Roy was originally offered Engine No. 3 as the bearer of his name. The thought was that both locomotives No. 1 and No. 3 would be alike, since they had the same wheel configuration and were constructed the same year. Roy politely declined, stating that he "didn't want to be compared to all the great things Walt has done."*

The steam whistle on the Roy O. Disney *has a deeper tone than the other locomotives' whistles, so it is easy to recognize as it approaches.*

Opposite: Roy E. Disney, *past chairman of Walt Disney Feature Animation, poses with a friend in the cab of the locomotive that bears his father's name.*

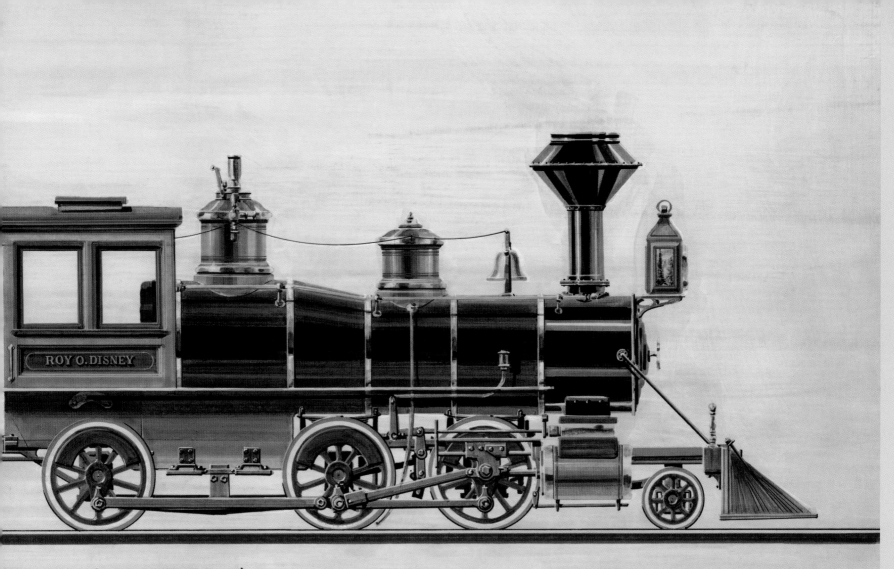

NEY WORLD (LOCOMOTIVE No.2)

DISNEY'S ANIMAL KINGDOM WILDLIFE EXPRESS TRAIN

THE THREE English-looking vintage steam locomotives of the fictional Eastern Star Railway pull the Wildlife Express Train from Harambe, Africa, to Rafiki's Planet Watch. Although they are not technically steam trains, but rather diesel-hydraulic locomotives housed in steam train shells, they still have an interesting story to tell.

Built in 1997 by Severn Lamb of Stratford–up-on-Avon in England, the locomotives are numbered 02594, 04982, and 00174. The latter bears the name *R. Baba Harpoor*, in honor of Imagineer Bob Harpur. It was Harpur who oversaw the total restoration process of the four vintage steam locomotives for the Walt Disney World Railroad.

The locomotives and train cars are loosely based on the actual East African Railway system. The original idea was for the trains to travel through the savanna plains so guests could view the animals from the coaches. This idea was soon scratched due to concerns for the animals' safety.

Unlike the spit and polish of Walt Disney World locomotives, the Eastern Star Railway locomotives are purposely distressed, complete with dust, grime, loose baggage containers on the roof, off-center headlamps, and a water buffalo skull above the smokebox.

Opposite left and below: Early design concepts for the Eastern Star Railway. Bottom: The rusting corrugated water tower helps provide the perfect atmosphere for the fictional African town of Harambe. Right: Sporting a water buffalo skull and luggage piled on the roofs of her coaches, the R. Baba Harpoor *departs Harambe.*

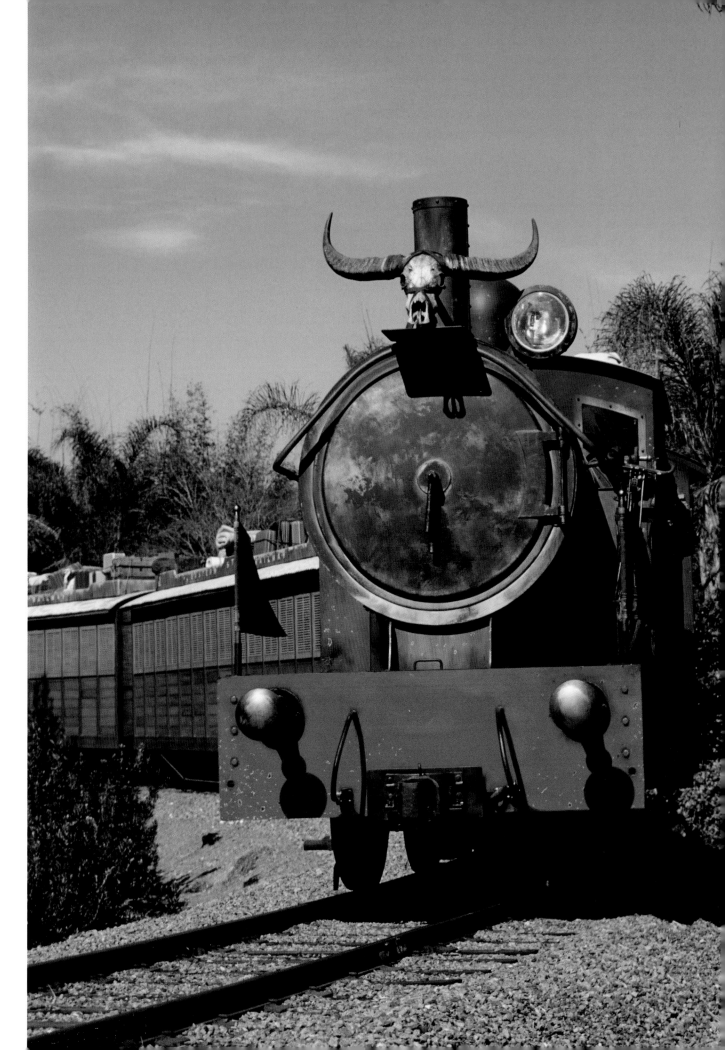

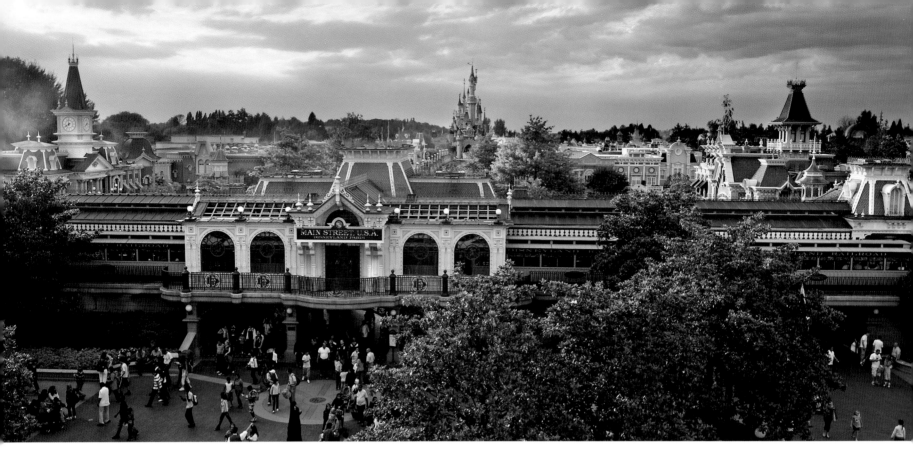

THE DISNEYLAND RAILROAD (PARIS)

Opening Day: April 12, 1992

Track Gauge: 3 feet

Length: 7,150 feet

Locomotive Power: Steam engines fired by
diesel fuel

Stations: (4) Main Street, Frontierland,
Fantasyland and Discoveryland

The Disneyland Paris railroad opened on April 12, 1992, to much fanfare. The steam locomotives featured on the railroad were actually newly built creations for the park; all were designed to emulate Disneyland's Engine No. 1 the *C.K. Holiday.* Because they were being built from the ground up, the Disney Imagineers had great freedom in exploring different types cab styles, smokestacks, colors, etc. making for four very distinctive locomotives.

The coaches that accompany each engine are unique as well, with each possessing finely detailed stained glass clerestory windows and a U-shaped seating configuration. Each coach is divided into six sections each housing one of these distinctive seating arrangements. Due to French weather, the coaches are a bit more enclosed than other Disney train coaches operating in warmer climes.

Opposite left: Main Street station at Disneyland Paris reflects a distinctly Parisian flair. Below: Original concept for W. F. Cody passenger coach.

ENGINE NO. 1
W. F. CODY

Livery: Brown cab, red boiler jacket
Smoke Stack: Balloon stack (large)
Wheel Configuration: 4-4-0

The locomotive is named after American Army scout, buffalo hunter and showman William Frederick Cody, better known as Buffalo Bill Cody. The locomotive is distinctive as it sports a large set of deer antlers and a magnificent painting of an American elk on the sides of the headlamp.

PASSENGER COACHES:

All are painted yellow with green trim reminiscent of the Denver & Rio Grande Western paint scheme. They are numbered as follows, No. 11 Silverton, No. 12 Durango, No. 13 Denver, No. 14 Wichita and No. 15 Cheyenne. All famous American cities that Buffalo Bill Cody's "Wild West" shows visited in its heyday.

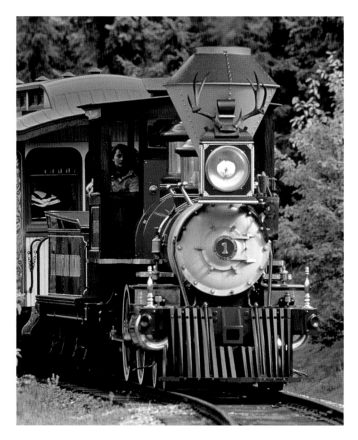

Note the antlers above the headlight of the W. F. Cody.

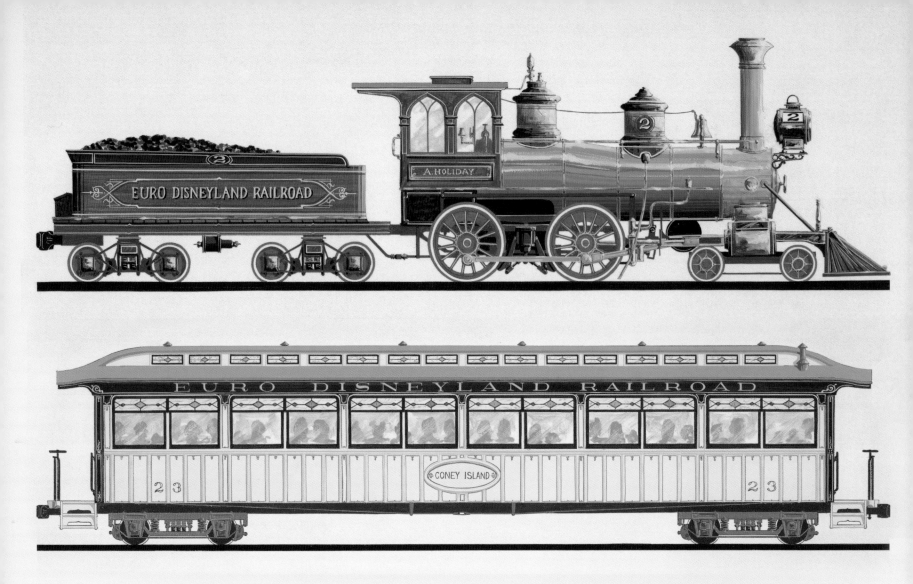

Above: Modeled after an elegant vacation train, the Holliday's coaches reflect popular turn-of-the-century travel destinations. Right: A typical passenger locomotive from the later 1800s. Locomotives like these were the inspiration for the Disneyland Paris Railroad.

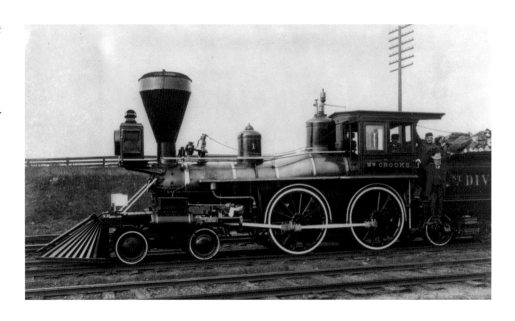

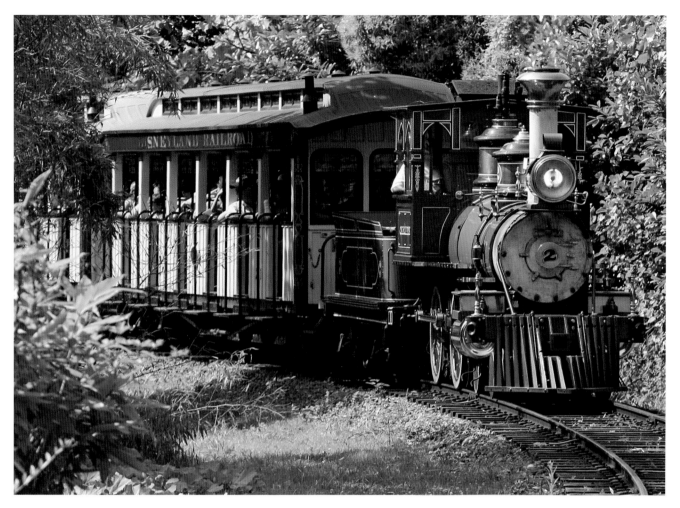

Not to be confused with the C. K. Holliday No. 1 that calls Disneyland home, is this C. K. Holliday No. 2, which is shown rounding the bend on the Disneyland Paris Railroad track.

ENGINE NO. 2
C.K. HOLLIDAY

Livery: Deep red cab, bright green boiler jacket
Smoke Stack: Straight cap
Wheel Configuration: 4-4-0

The locomotive's name honors C. K. Holliday, first president of the Santa Fe Railroad. The locomotive's deep red cab features cathedral-style windows piped in white.

PASSENGER COACHES:
Atlantic City, Chesapeake, Coney Island, Long Island, and Niagara Falls all reflect popular American East Coast vacation destinations from the late nineteenth century.

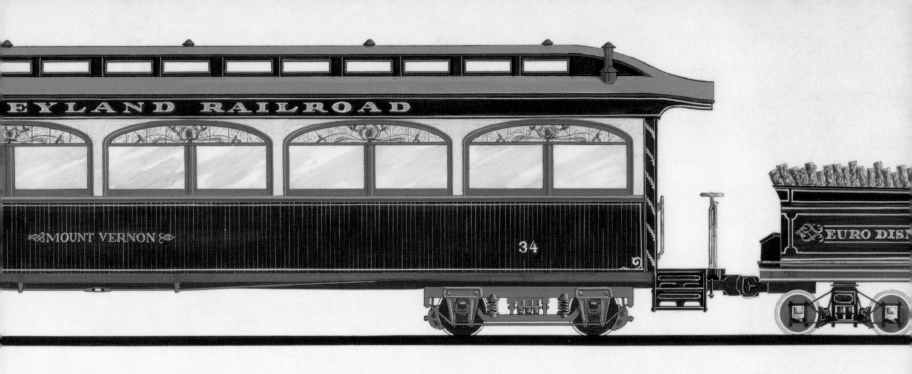

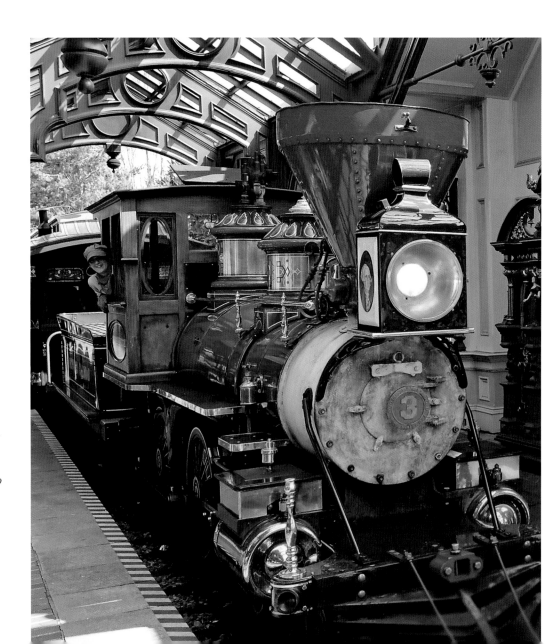

The George Washington *pulls into Main Street station. The station is partially enclosed due to the unpredictability of Parisian weather.*

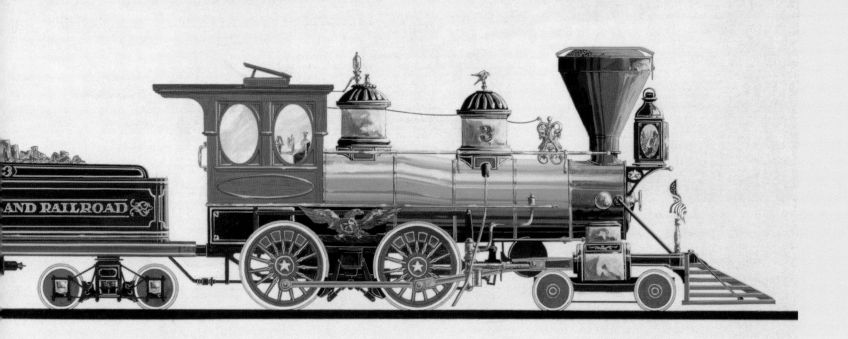

Concept art for the George Washington.

ENGINE NO. 3
GEORGE WASHINGTON

Livery: Red, white, and blue
Smoke Stack: Funnel stack (large)
Wheel Configuration: 4-4-0

The most elegant locomotive featured at Disneyland Paris is based on the military-type steam locomotives used by the Union forces during the American Civil War. The engine has a distinctive American theme, including a polished brass eagle perched on top of the steam dome, golden eagles molded above the drive wheels, white stars in the center of the wheels, and portraits of George Washington and the Marquis de Lafayette on the headlamp. Complete with a Russian blue boiler and mahogany cab with porthole-style glass windows, the locomotive is the most ornate on the line.

PASSENGER COACHES:

All are painted blue and red with white piping. They are named as follows. No. 31 Mt. Vernon, No. 32 Boston, No. 33 Philadelphia, No. 34 Yorktown and No. 35 Valley Forge. All represent famous locations associated with George Washington.

INSIDE TRACK: *The train's livery—red, white and blue—commemorates of the friendship between the French and American people, whose flags both share these colors.*

As a young man the Marquis de Lafayette, recently arrived from France, fought alongside General George Washington during the American Revolution. As commander of the American Army's Corps of Light Infantry, Lafayette became a devoted friend of Washington's. Many equate Lafayette to the child that Washington never had, a fact not lost on French guests.

PLAQUE

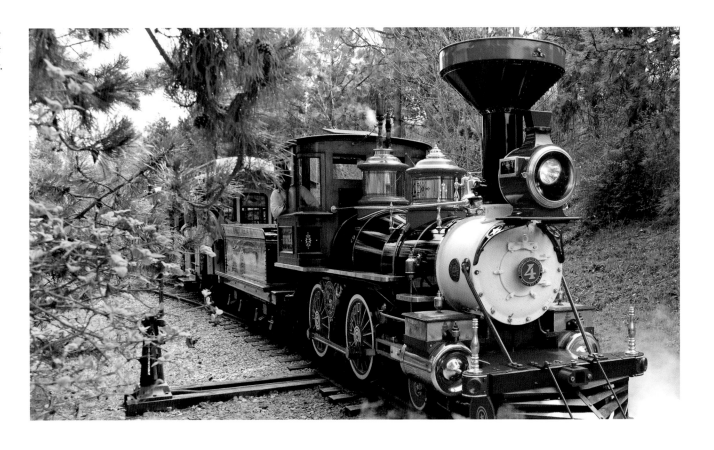

The Eureka's *white smokebox makes it easily recognizable.*

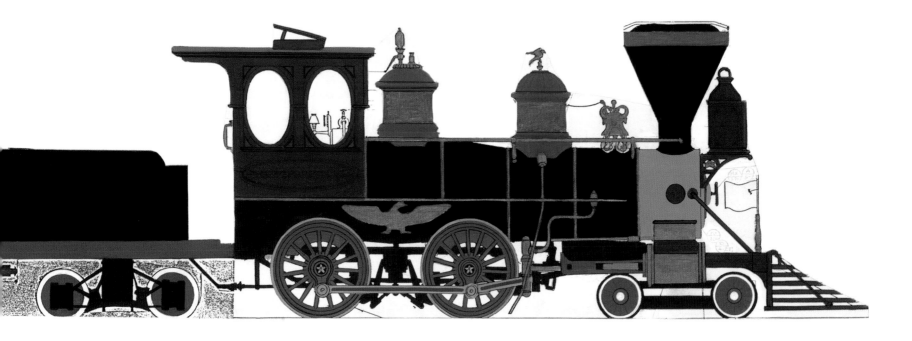

Concept art for the Eureka.

ENGINE NO. 4
EUREKA

Livery: Brown cab, midnight-black boiler jacket
Smoke Stack: Funnel stack (small)
Wheel Configuration: 4-4-0

Added to the roster in 1993 to handle the increased influx of guests, the *Eureka* is the newest of the Disneyland Paris steam trains. The locomotive's name refers to a term used by miners during the 1849 gold rush when the precious metal was discovered at Sutter's Mill in California. The miners, more commonly referred to as "49ers," would proclaim "Eureka!" literally, "I've found it" when gold chunks would appear in their pan.

PASSENGER COACHES:

Painted a warm gray, and accentuated with deep red piping the coaches are all named for cities in California: Los Angeles, Monterey, Sacramento, San Diego, and San Francisco.

INSIDE TRACK: *Eureka is also the state motto of California and is found on the great seal of the state.*

In 1957 state legislators attempted to replace the term with "In God we trust" but were unsuccessful.

The word eureka *can actually trace its origins back to Classical Antiquity to the Greek scholar Archimedes. While stepping into his bath Archimedes noticed that the water level rose; he correctly discerned that the amount of water disposed must be equal to the amount of his body submerged. Legend has it that he was so excited to share the news of his revelation that he sprang from his tub and ran through the streets naked proclaiming his new discovery.*

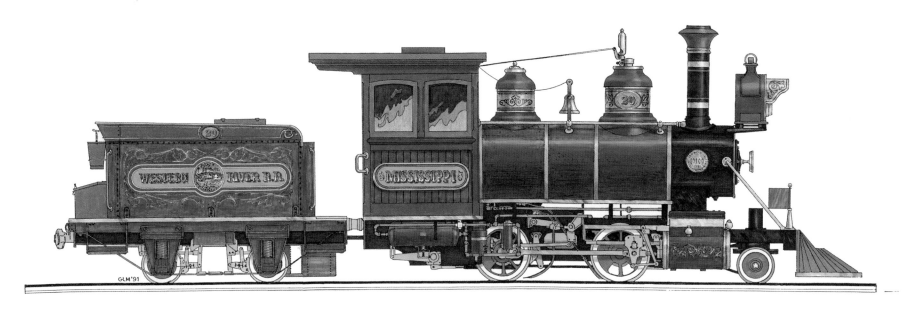

Above and opposite bottom: Concept art for the Mississippi. All four locomotives for the railroad were built from the ground up by the noted locomotive builder the Kyosan Kogyo Company.

WESTERN RIVER RAILROAD (TOKYO)

Opening Day: April 15, 1983
Track Gauge: 2 feet, 6 inches
Length of Route: 5,283 feet
Locomotive Power: Steam-powered
Stations: (1) Adventureland (above Jungle
 Cruise landing)

Tokyo Disneyland is unique from the other Disneyland parks, as it's stream train attraction, the Western River Railroad, does not circle the perimeter of the park as Walt originally intended it to. Although the Imagineers tried their best to accomplish this, under Japanese transportation ordinances the amount of track proposed and the locations of multiple stations along the route would have classified the park's railroad as "public transportation" and thus fall under government regulations.

So a difficult solution had to be reached, namely that the railroad would have just one station and its route would only encompass Adventureland and Westernland (known to the west as Frontierland; the Japanese language has no word for *Frontier*.) Although small in length, it still is an impressive little railroad that travels through the park as opposed to around it. Along the route guests get to view the Jungle Cruise, Big Thunder Mountain, The Rivers of America, Critter Country, and Splash Mountain.

All of the steam locomotives in Tokyo Disneyland are based on an 1871 design of the Denver & Rio Grande Western Railroad's 2-4-0 *Montezuma*. Each one is named after a famous American river; great attention was paid to the locomotive's livery and accoutrements to make each engine unique.

The passenger cars are very similar to the ones at Walt Disney World in that the guests face forward toward the locomotive. Each coach also has a small door at the end of each aisle that swings inward as an additional safety precaution for younger travelers. The passenger coaches are not named but numbered only.

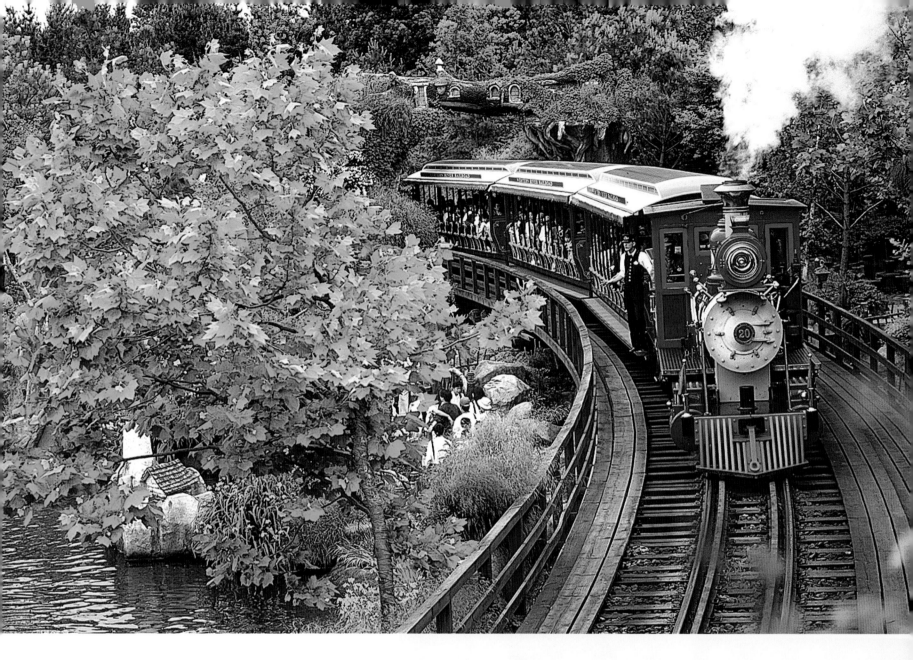

ENGINE NO. 20
MISSISSIPPI

Livery: Red cab, blue boiler jacket
Smoke Stack: Straight cap
Wheel Configuration: 2-4-0

Named after the river that neatly cuts the United States in half, the locomotive was added in 1991 to help with increased attendance. The great American bison is portrayed on the sides of the engine's headlamp.

Above: The Mississippi *travels over the curved wooden trestle, one of the highlights along the route at Tokyo Disneyland.*

Right and below: Various panels display the concept art for the Missouri. Note the TOMY flags above the pilot wheels.

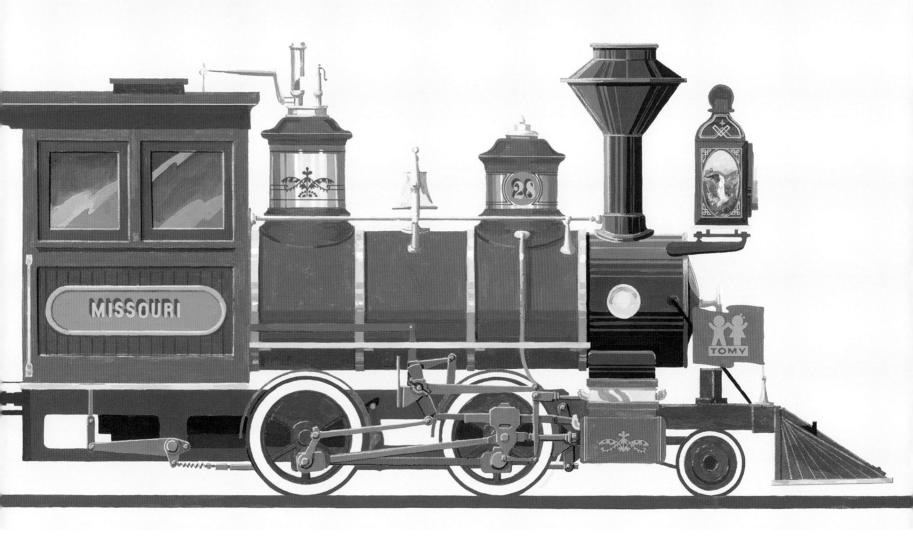

ENGINE NO. 28
MISSOURI

Livery: Green cab, green boiler jacket
Smoke Stack: Diamond stack (small)
Wheel Configuration: 2-4-0

Named after the river travelled by the Lewis and Clark expedition, the locomotive's headlamp sports paintings of the Great Falls found on their historic journey.

TOMY (which is on the flag fluttering in front), the railroad's corporate sponsor, is a toy manufacturer in Japan and produces all four of the park's trains in miniature.

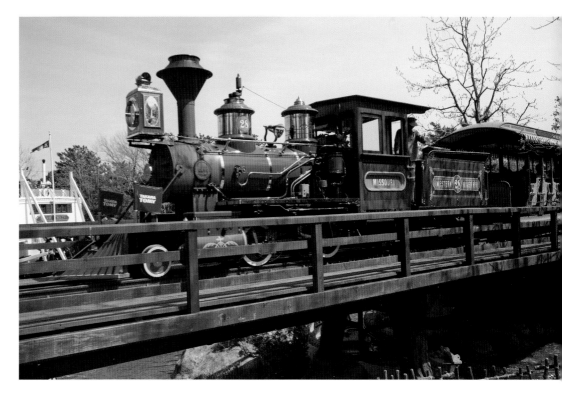

ENGINE NO. 25
RIO GRANDE

Livery: Red cab, red boiler jacket
Smoke Stack: Diamond stack (small)
Wheel Configuration: 2-4-0

Named after the river that acts as the natural boundary between the United States and Mexico, the Rio Grande empties powerfully into the Gulf of Mexico. The locomotive's headlamp depicts a grizzly bear on each side.

Opposite far right: The track's raised wooden trestle offers guest along the railroad a unique close-up experience as the locomotive passes overhead.

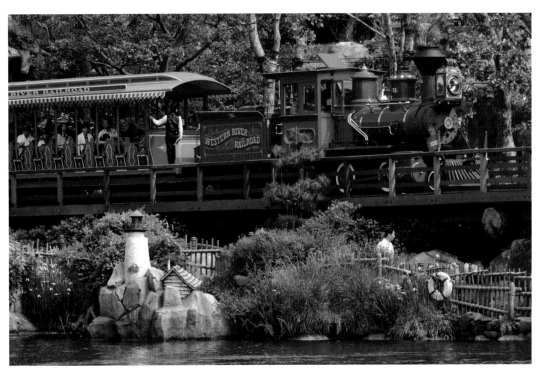

Above and opposite top: Concept art for some of the cars that make up the Colorado.

ENGINE NO. 53
COLORADO

Livery: Reddish-brown cab, reddish-brown
 boiler jacket
Smoke Stack: Diamond stack (small)
Wheel Configuration: 2-4-0

Named for one of the oldest rivers in the Western hemi-sphere, the fast moving Colorado River winds through the heart of the Grand Canyon on its way to Mexico.

On the sides of the locomotive's headlamp are painted images of an elk.

INSIDE TRACK: One of the most enchant-ing locations in Tokyo Disneyland is the long railroad trestle between Rivers of America and Critter Country. The panoramic views from the train are impressive and the views from the ground as the locomotives snake their way through the different lands is breathtaking.

There is another station located along the Western River Railroad route, but it is for show only and the train does not stop there. Still it is a great little railway station complete with a vintage handcar and caboose.

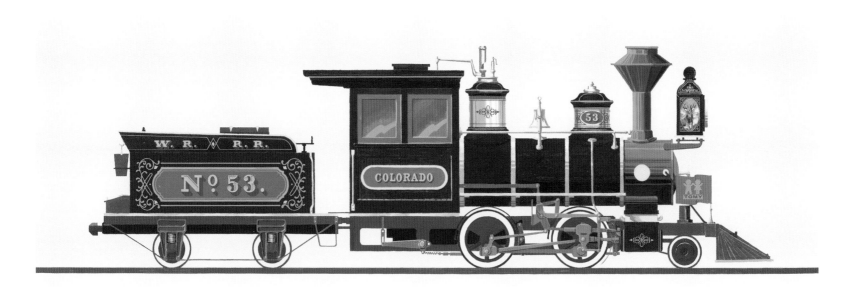

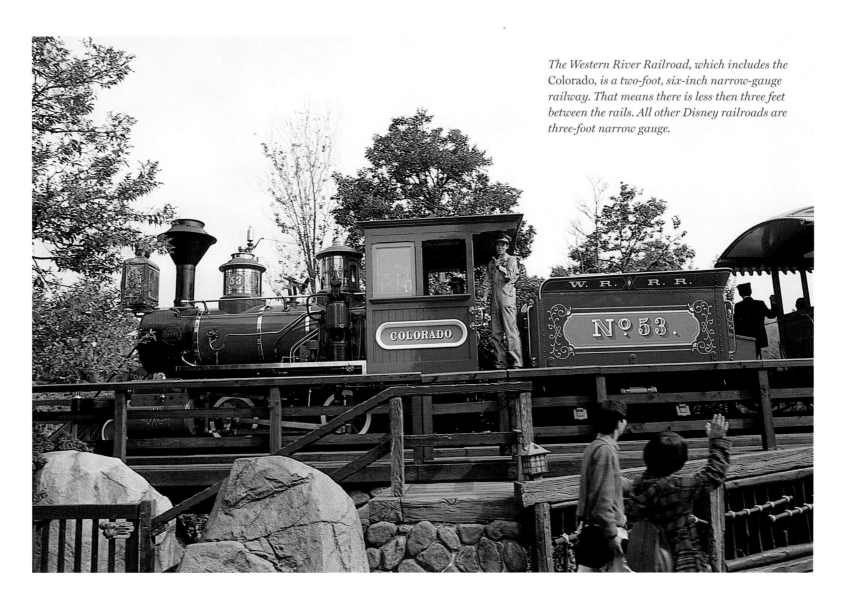

The Western River Railroad, which includes the Colorado, is a two-foot, six-inch narrow-gauge railway. That means there is less then three feet between the rails. All other Disney railroads are three-foot narrow gauge.

HONG KONG DISNEYLAND

Opening Day: September 12, 2005
Track Gauge: 3 feet
Length of Route: 5,000 feet
Locomotive Power: Diesel powered tender pushes locomotive.
Stations: (2) Main Street and Fantasyland

Although the locomotives on this line are not steam operated, they are in fact diesel powered, they still are a representation of the golden age of railroading, and keep a version of the Disney train experience alive in this far-off park. Of all the Disney theme parks, Hong Kong Disneyland has the smallest roster of locomotives—only two trains are operated at the same time.

The coach seating is arranged sideways with all passengers facing in towards the park rather than forward towards the engine.

ENGINE NO. 1
WALTER E. DISNEY

Livery: Brown cab, Russian iron boiler jacket
Smoke Stack: Diamond stack (small)
Wheel Configuration: 4-4-0

PASSENGER COACHES:
Anaheim, Burbank, Glendale, Los Angeles, and California; all were places that played an important part in Walt Disney's life.

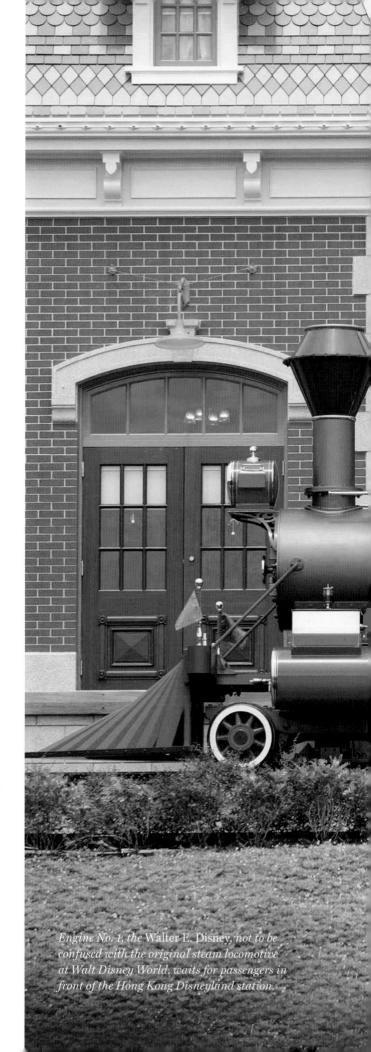

Engine No. 1, the Walter E. Disney, not to be confused with the original steam locomotive at Walt Disney World, waits for passengers in front of the Hong Kong Disneyland station.

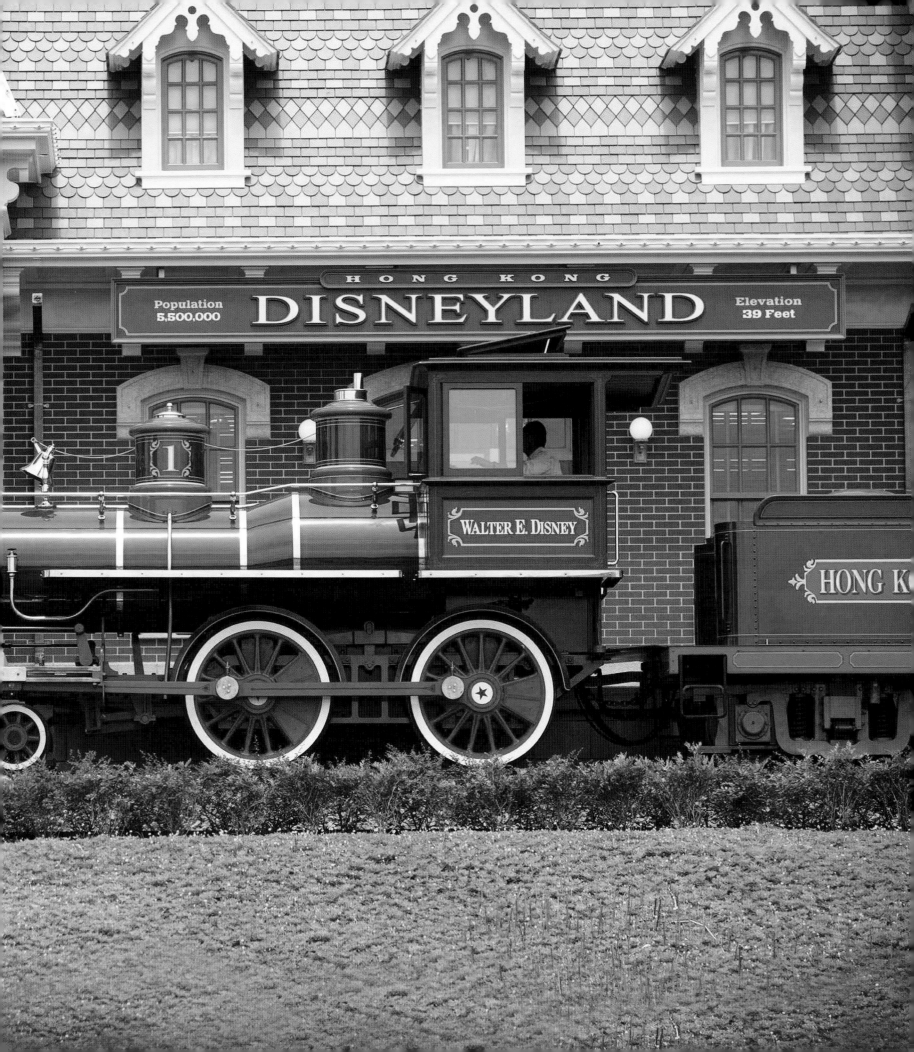

Locomotive / Tender #1

Locomotive / Tender #2

Above: Color swatches for the Walter E. Disney *and* Roy O. Disney.

ENGINE NO. 2
ROY O. DISNEY

Livery: Green cab, red boiler jacket
Smoke Stack: Funnel stack (large)
Wheel Configuration: 4-4-0

Named after Walt's older brother and co-founder of Walt Disney Productions.

PASSENGER COACHES:

Chicago, Marceline, Kansas City, Hollywood and Orlando, which, again, all significant places in the life of Walt Disney.

Walter E. Disney

Roy O. Disney

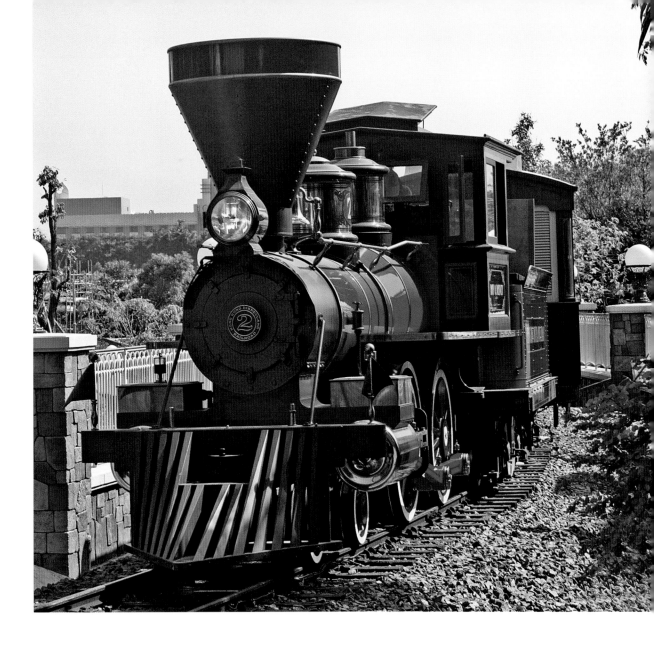

Top and right: The Roy O. Disney, *again not to be confused with the first steam engine in Walt Disney World,* sports a circular headlamp, indicating that the light is provided by electricity rather than oil.

The Frank G. Wells *does not have specific passenger coaches assigned to it; instead it pulls cars from the other locomotive consists if they are off the line that day.*

ENGINE NO. 3
FRANK G. WELLS

Livery: Brown cab, midnight black boiler jacket
Smoke Stack: Straight cap
Wheel Configuration: 4-4-0

Named on honor of Frank G. Wells, president of the Walt Disney Company from 1984 until his death in 1994.

INSIDE TRACK: *The railway station at Fantasyland is based on the train station from the 1954 animated short* Pigs is Pigs.

Once the train arrives in Tomorrowland just as you are passing Space Mountain, be on the lookout for the Little Green Men from Toy Story *as they peek out and wave at the passing train as you approach the Buzz Lightyear Astro Blasters attraction.*

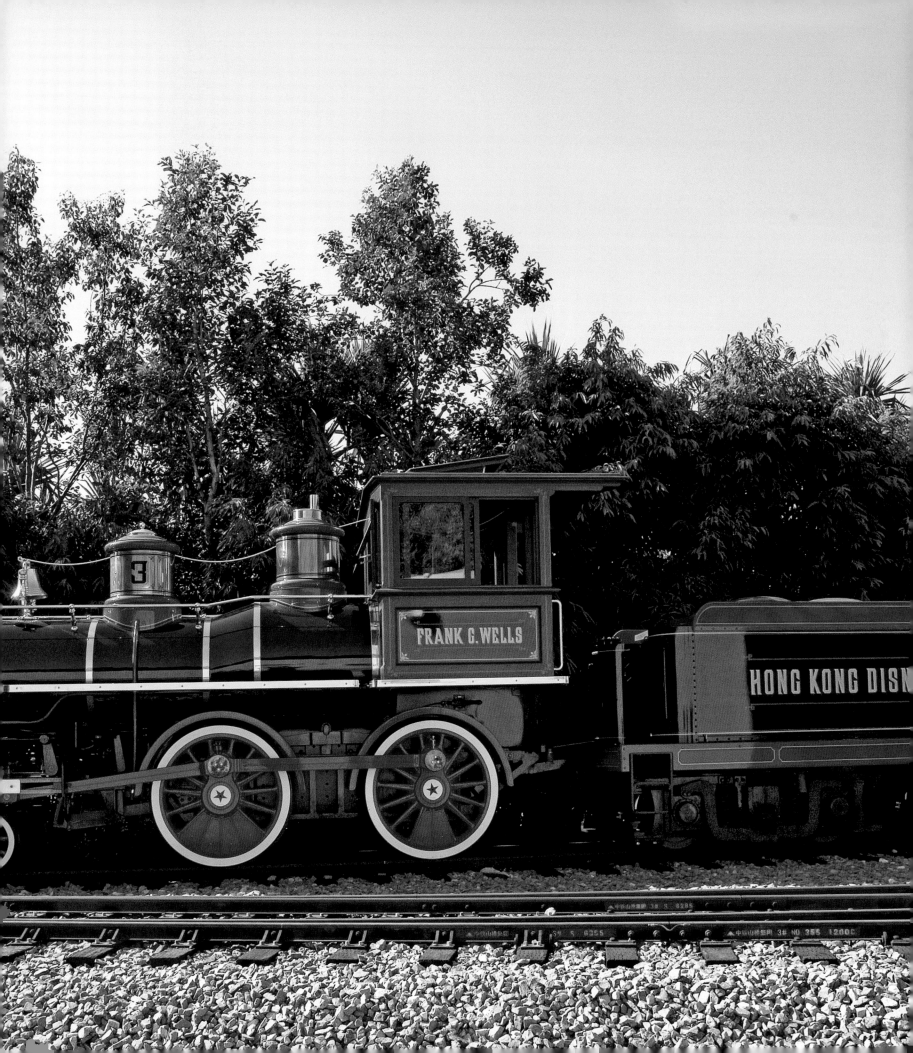

6 Trains in the American Vernacular

Appendix

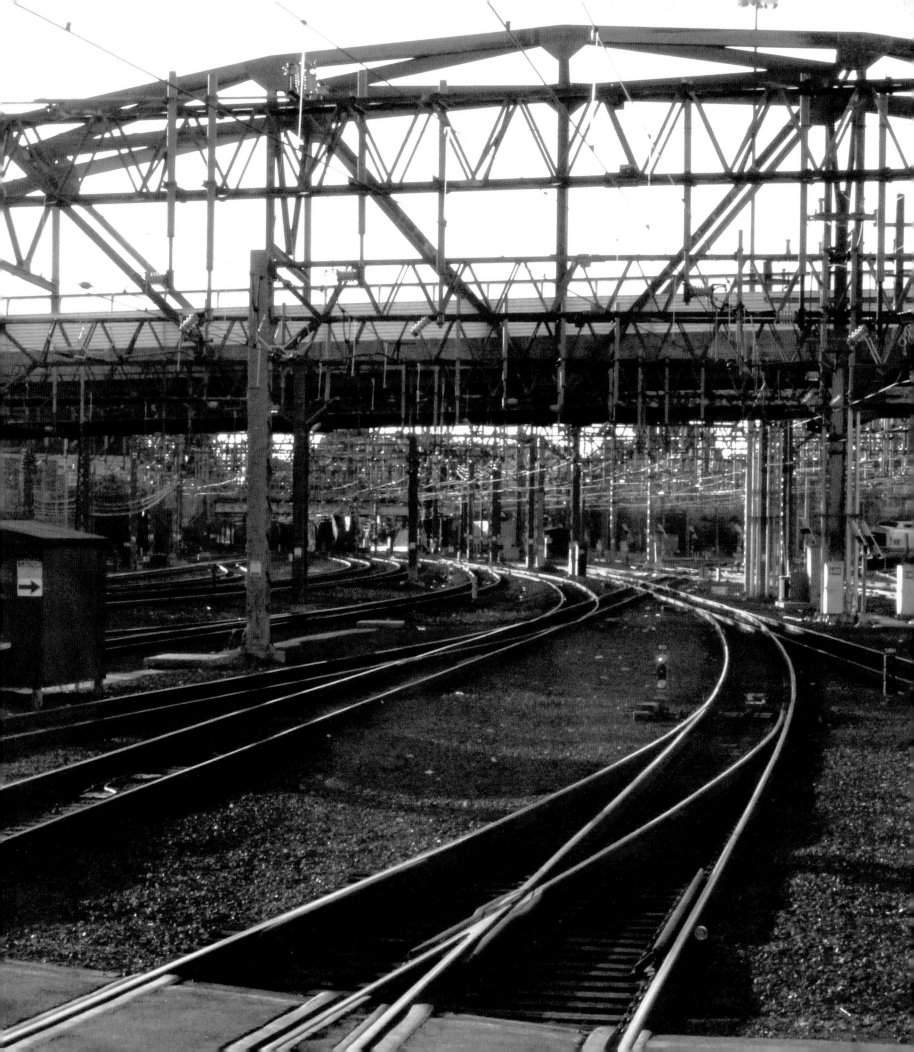

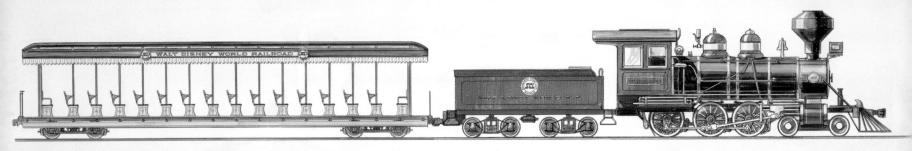

Early concept drawing for the Walt Disney World Railroad.

SINCE THEIR INCEPTION in the 1830s railroading terms have slowly chugged their way into the world's collective consciousness. Nowhere is this more predominant, however, than in American slang.

This only makes sense, since it was the railroads that opened the American West, established worldwide time zones, and led us, full-steam ahead, into the Gilded Age. From the fashion world to beverages, and rock and roll to the Internet, railroad terminology is hidden away in the American dialogue.

BELLS AND WHISTLES This phrase refers to the brightly colored and highly polished steam locomotives of the 1860s. Truly works of art festooned with brass bells and silver whistles. On May 10, 1869, to commemorate the completion of the Transcontinental Railroad, the Central Pacific line had some "30 locomotives gaily decked, and at the signal of a gun announcing the driving of the last spike on the road the locomotives opened a chorus of whistles, bells and steam whistles."

BROWNIE POINTS A point system of merits and demerits conceived by Superintendant George R. Brown for the Fall Brook Railway in 1886. The innovative system actually chose to praise as opposed to only punish their employees. The more "Brownie Points" a railroad worker would accumu-

late the better his conditions would be. The system quickly made its way to other railroads and eventually into American culture.

CARRYING THE BANNER With the rapid expansion of the railways in the 1870's railroad workers were one of the first groups to be unionized, with brotherhoods reaching from New York to San Francisco. The term *Carrying the Banner* was used to describe an active union supporter, not necessarily carrying an actual banner but decked out in union regalia with buttons and ribbons attached to his jacket.

CATWALK About as far removed from the fashion runway as possible, this was the narrow plank walkway on the tops of boxcars that brakemen would traverse. Done day or night and in all types of weather one surely would need the nimbleness of a cat to negotiate this shaky path.

CHUGGING ALONG To move at a slow and steady pace. This refers to steam locomotives making the "chug, chug" sound.

CRUMMY The word crummy meaning dirty, unpleasant, or of poor quality traces its origins to the humble little caboose. The caboose was the last car of a freight train and was also where the crew

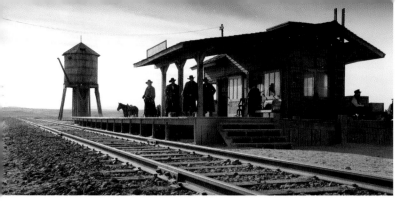

Film capture from The Lone Ranger.

Design concept for the R. Baba Harpor.

cooked, ate, and slept. Called the "crummy," it was also known as the crumb wagon, the hack, and the bobber to name a few.

DEADBEAT This term, which describes someone who doesn't pull his or her full share or doesn't pay his or her debts, has railroad roots going all the way back to the 1800s. An experienced brakemen could easily tell the difference between an empty and fully loaded boxcar by the sound it would make. An empty freight car would make a "dead beat" sound when it passed over the rail joints that alerted the crews that the car was not carrying its fair share of the load.

DEADHEAD Eighty years before Jerry Garcia was born, this railroad term simply meant a non-paying passenger or railroad executive riding on a free pass. It also refers to an unpowered engine being towed.

DERAILED This word, which is associated with a business project failing, literally means coming off the tracks. This is a messy, time-consuming problem that all railroads dread. Putting a 150-ton locomotive back on the tracks is no easy task.

DOUBLE HEADER Although commonly thought of as originating in baseball, this term

actually began with American Transcontinental Rail travel when it was necessary to have trains hauled by two locomotives to negotiate the steep inclines of the Rocky Mountains.

EASY MARK This is a hobo expression used to describe a household that would readily give out food and shelter to a hungry traveler. Directions to the house were usually scrawled on a water tank or a barn near the residence. Hobos would literally look for the "easy mark" symbol, usually portrayed as a smiling cat, indicating a "kind-hearted lady lives here."

EXPRESS SERVICE / EXPRESS MAIL / EX-PRESS SHIPPING All harken back to the REA or Railway Express Agency. A U.S. monopoly created in 1917 for the safe and speedy transportation of parcels. The REA was the major express parcel agency for many years until the advent of highways when United Parcel Service, better known as UPS, replaced it.

GOING ON LINE Yes this is in fact a railroad term with two separate meanings. The first refers to going on the main line or regular route of the railroad, while going *Off-Line* meant a train servicing a stop not on the regular schedule. The second definition is even older and refers to the

Early design concept for Disneyland Railroad.

The short-lived Disneyland Tomorrowland Viewliner pulls up next to the C. K. Holliday. *The* Holliday, *although a small narrow-gauge engine, towers over her small companion from the "future."*

telegraph system composed of wires or *lines* that would accompany the railroad in the early days of railroading. Many times illegally strung through Native American lands, the term "the line is down" was not something that nineteenth century tech support was fond of hearing.

GREASE MONKEY Long before the automobile was invented, this term was commonly used for a railroad employee whose responsibility was to grease the switches, interlocking tracks, and basically all machinery in a railroad yard. This low paying job required the workman to jump from one track to the other for most of the day, taking on the movements of a monkey.

GREASY SPOON Cookhouses located near the railway, where sanitary practices where not necessarily enforced. This is where a railroad man could get *blind gaskets and torpedoes* (hot cakes and beans.)

HELL ON WHEELS This is a fun one. This term describes the fly-by-night saloons, gambling houses, brothels, dance halls, and flophouses that accompanied the Union Pacific railroad workers as they constructed the Transcontinental Railroad heading west. In describing the immoral band that followed the railroad, Springfield, Massachusetts, newspaper editor Samuel Bowles also created a new phrase in the American vernacular, the *Hangers-On*.

HIGHBALL This "mixology" term traces its origins back to the lounge cars of American steam trains. When a locomotive got up to speed, the ball that indicated boiler pressure would be raised to a high point; the train would then be travelling at its fastest rate of speed known as "high balling." Another theory refers to the old ball signals found on New England railroads in the 1860s. When the red ball was hoisted to the top of the signal it indicated "clear tracks ahead," meaning the engineer could really make time. The lingo gradually made it into the bar cars describing a high-end mixed drink now more commonly known as "scotch and soda".

HOBO A term that originated on the Burlington Route as a corruption of "hello, boy!" which railroad workers used in greeting each other.

Grizzly Flats Railroad

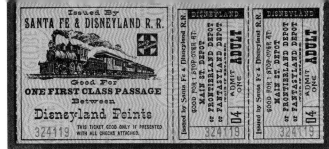

Original ticket from the Santa Fe & Disney Railroad

HOTSHOT A fast moving express train. Usually carrying high-end merchandise or perishables.

JERKWATER TOWN Between regular stops a steam train would occasionally need to take on additional water. This would be accomplished by pulling up to a large wooden water tank, inserting the nozzle into the tender (this is the car directly behind the locomotive), and jerking down on a chain that would release the water. The locations of these water tanks were usually in areas of little importance to the railroads, hence the term *Jerkwater town.*

JUNCTION Railroad term, literally a place where two or more railroad tracks meet.

KANGAROO COURT Originally an impromptu hearing or investigation conducted by railroads wherever most convenient, anywhere along the line hence jumping around like a kangaroo.

LAYOVER Before airline travel this railroad term simply referred to the time spent waiting for a connection to another train.

LETTING OFF STEAM Steam engines had to release steam pressure to keep their boilers from bursting. This was noisy but necessary.

MAKING THE GRADE Railroad term used in describing a locomotive ascending a steep slope of a rail line. A fireman would need to stoke the boiler fire to white-hot conditions to make it up some of the steeper grades.

ON THE FLY This is another hobo term describing the act of jumping off of a moving train.

ON THE RIGHT TRACK / ON THE WRONG TRACK / STAYING ON TRACK / SIDE-TRACKED / ONE-TRACK MIND / WRONG SIDE OF THE TRACKS/ BACKTRACK All have their origins in railroading. Specifically railroad tracks.

PINHEAD Originated as a derogatory term for a brakeman whose job it was to lift the pins from couplers that connected the train cars. While the engineer and fireman were stationed in the locomotive, the brakeman would usually be found in the caboose. This made him the subject of many jokes.

The California Zephyr *as it appeared at Disney California Adventure. It has since been donated to the Western Pacific Railroad Museum.*

Filming action sequence for The Lone Ranger.

The Disneyland Railroad herald as it appears on the wooden water tank.

RAILROADED Refers to the heydays of railroad construction when rail lines where being built at lightning speed with blatant disregard to safety, working conditions, indigenous peoples, or anything else that stood in the empire builder's way.

REALIGN First used in the 1860s to describe the laying down of railroad tracks.

ROAD HOG Derogatory term first used for interstate truckers and buses that cut into the railroads, revenue.

SABOTAGE This term actually finds its origins in French railroading where striking French railway workers would cut the metal shoe or "sabot" that held the tracks in place. This would cause major delays and in some cases a derailment. The word appears in English first in 1910 referring to French railroad strikers.

STREAMLINE / STREAMLINER / STREAMLINED Gained worldwide consciousness in 1934 on the opening day of the Century of Progress World's Fair in Chicago with the arrival of the *Burlington Zephyr* passenger train. The *Zephyr* made the trip from Denver in 13 hours and 5 minutes, beating the previous record by more than half. The credit for the fast run was given to its "streamlined" design. Soon after cars, powerboats, desks, chairs, dinnerware, even typewriters, began to feature a streamline design. In reality the streamlined design was more of an art statement than an actual technological advance. It was not until the advent of aerodynamics that form truly followed function.

WHISTLE-STOP TOUR Originally the practice of a train stopping at a small rural railway station in response to a steam whistle indicating a passenger pickup. As the railroad became the most common means of long-distance travel in the United States, politicians quickly seized upon the idea of delivering campaign speeches from the rear platform of a train. With quick and to the point speeches, the politician wouldn't even have to step off the train; some went as far as to install a small button to signal the engineer to start steaming out toward the end of the speech. This came in handy if the politico had to answer a tough question from the press, the sound of his response being drowned out by the steam whistle.

WINGDING Long before it was a font on your computer, this was a hobo term describing the act of counterfeiting a seizure to attract sympathy in hopes of securing some food or a place to sleep.

Index

Casey Jr. Circus Train attraction as it appeared when it opened in 1955.

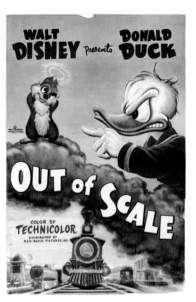

Movie poster for Out of Scale

Acknowledgments

WHEN I FIRST began to pen a book about Disney trains, I had no idea where this rail journey would take me and how many new friends I would make along the way. For some all I had to do was mention the word *train* and I had their undivided attention—a testament to the power of the subject. Others, who hadn't been interested themselves in railroading, have since become true rail fans. The enthusiasm and support I encountered all along my trek was unexpected. Doors were opened everywhere and the infamous red tape mistakenly associated with Disney was nowhere to be found as archivists, park personnel, curators, and Imagineers all freely gave of their time, information, and passion.

There are so many people to thank, and I could not possibly list them all but there are a few I must acknowledge for making this book possible.

To my dear friend Thomas Schumacher whose creativity and true love of theater has always inspired me to take on new challenges. I thank him for his support, encouragement, and allowing me to spread my own creative wings.

All of my friends at the Disney Archives, especially Becky Cline and Joanna Pratt, who were so giving and cooperative tracking down every photo I requested.

My sincere thanks go to Diane Scoglio, Vanessa Hunt, and Denise Brown, who tirelessly searched the Imagineering art library for the perfect images for the book.

Special thanks to my friends in Japan, Miho Tomotsuka, Tomoko Sawada, Ito Akihiro, Shane Hunt, and Royo Tanuma, for their photographs and insights to the Disney trains of the Far East.

Thank you to my French connection, Marie Pierre Varin, who took off her human resources chapeau from time to time to serve as my translator (my seventh-grade French hardly up to par). My gratitude to Damien Varin, *mon ami* who was able to provide rare photographs of the Disneyland Paris trains, and, of course, the multi-talented Pascal Witaszek who allowed me to use his gorgeous poster of a young Walt Disney sketching on a train.

My friend Michael Campbell, president of the Carrolwood Pacific Railroad Society and guest curator at the Disney Family Museum, is a keeper of the eternal railroad flame. His exhibit *Walt's Trains* recently opened to rave reviews. Michael, along with Matthew Walker, Ray Spencer, and Edward Medina, was so generous with detailed knowledge of the Disney parks railroads, as was Sean Bautista, who provided so many insights and behind the scene stories, enough to fill another book.

I would have been lost without the tireless assistance from my friends at Pixar: Molly Jones, Kelly Bonbright, Debby Coleman, and Heather Feng. A particularly special thank-you to the wonderful Michelle Moretta, who was my champion through thick and thin.

And for our beautiful cover shot, thank you, Morgan Feng-Schmidt, for capturing the iconic photo of the *Marie E.*

Thank you to Ken Shue, Brent Ford, Alan Kaplan, Jennifer Eastwood, Warren Meislin, Jennifer Black, and all of my dedicated friends at Disney Publishing who kept me on track and on schedule. And without Bill Scollon doing his tireless art and photo research, this book would not be filled with the beautiful imagery it is.

At Walt Disney Animation Studios the amazing Howard Green was invaluable to this project. And thanks to Dave Bossert and Cameron Ramsey for some of our final film scenes.

And a heartfelt thanks to the families of Ollie Johnston and Ward Kimball, who showed so much support of our project.

Thank you to Mark Kirkland for generously allowing us to use his photograph.

My designer and art director and fellow train junkie, the incredibly gifted Hans Teensma, embraced my concept from the start and created a truly sumptuous feast for the eyes.

My editor, confidante, taskmaster, partner in crime, and dearest friend, Wendy Lefkon. Thank you for your Herculean patience, heartfelt understanding, and for encouraging me to tell this story in the first place.

Of course, how could I have ever completed this book without the invaluable assistance of John Lasseter himself? He opened his home, his backyard rail empire, and his heart to me. After visiting with John and inspecting the restored *Marie E.*, I came away with such a secure and wonderful feeling that Walt's dream of keeping the soul of railroading alive for everyone resonates so soundly in him. I only hope that this book does that spirit the same justice.